*New World Visions
of Household Gods
& Sacred Places*

New World Visions of
Household Gods

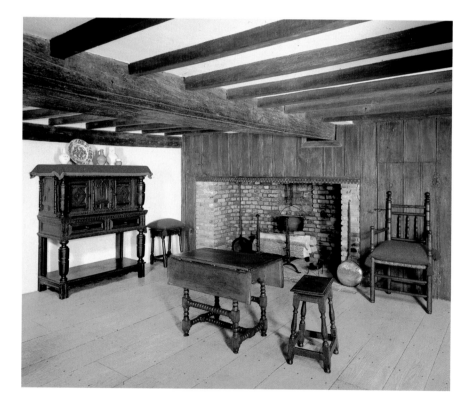

Vincent Scully

& Sacred Places

American Art and the
Metropolitan Museum of Art
1650-1914

A NEW YORK GRAPHIC SOCIETY BOOK
LITTLE, BROWN AND COMPANY, BOSTON

First edition

Library of Congress Cataloging-in-Publication Data
Scully, Vincent Joseph, 1920–
 New World visions of household gods and sacred places.

 "A New York Graphic Society book."
 Bibliography: p.
 Includes index.
 1. Art, American—Themes, motives. 2. Art—New York
(N.Y.) 3. Metropolitan Museum of Art (New York, N.Y.)
I. Metropolitan Museum of Art (New York, N.Y.)
II. Title.
N6505.S38 1988 709'.73'07401471 87-37860
ISBN 0-8212-1647-3

New York Graphic Society books are published by
Little, Brown and Company (Inc.).

Published simultaneously in Canada by
Little, Brown & Company (Canada) Limited.

PRINTED IN ITALY

*Title page: The Hart Room, woodwork from the "hall," the principal
room in the house of Thomas Hart, built before 1674, Ipswich,
Massachusetts. Shown as installed in the American Wing.
The Metropolitan Museum of Art, Munsey Fund, 1936 (36.127).
Photograph by Richard Cheek.*

Preface

The text of this book is based on the scripts of the two television films, produced by Lorna Pegram, that I wrote and narrated for WNET and the Metropolitan Museum of Art. Some material that had to be cut from the films because of time limitations has been reintroduced here and edited to cast it a bit more into written rather than spoken English. In this my editor, Betty Childs, and copyeditor, Dorothy Straight, were of immeasurable help. A good deal of additional material, mostly related to pre-Columbian and Classical architecture, has been included, but I have tried to keep references to phenomena such as the Stick and Shingle styles and the work of Frank Lloyd Wright and Robert Venturi, about which I have written elsewhere, to the necessary minimum. The general structure remains identical to that of the films themselves, and for this reason there is also very little here about the Ashcan School, or the Eight, and nothing about the Armory Show of 1913 and later developments in American painting. But the traditions of American Realism and Classicism with which the films were concerned, and which are especially well represented in the Metropolitan's collections, were so profoundly modified by the Armory Show and by the whole series of changes in American culture brought about by World War I that there seemed good reason to end this particular story more or less at that point. It is true that the Realist and Classical traditions have had several revivals since that time and have in fact never entirely died out. They are indeed the subject of an intense revival by American artists today. Post-Modernism, so called, turns toward them, and seems in many ways to be reenacting the course of the Colonial

Revival of the later nineteenth century. Indeed, this essay itself seems in considerable measure to be a Colonial Revival document, one more product of the continuing interest shown by Americans (and so infuriating to the English) in trying to identify themselves. If there is as much sorrow as joy in these pages, that is part of the story. The selection is, in any event, a personal one.

I would like to say here how much I enjoyed working with Lorna Pegram and her splendid crew. I am also grateful to George Page of WNET, to Karl Katz and Caroline Kennedy of the Metropolitan, and to all the curators of the many collections involved. They were never anything but helpful and supportive in every way, as was Philippe de Montebello, director of the museum. Margaret Duke typed and worked on the illustrations. Helen Chillman, Librarian of the Yale Slide and Photograph Collection, was of enormous help. For the term "household gods" I am indebted to John Russell, who first used it in a *New York Times* review of a show of American furniture at Yale University. I am especially grateful to my wife, Catherine Lynn, who helped decisively with the illustrations and the captions. Without her tutelage in the decorative arts large sections of this book would have taken me much longer to write and others would, in all likelihood, never have been written at all.

*New World Visions
of Household Gods
& Sacred Places*

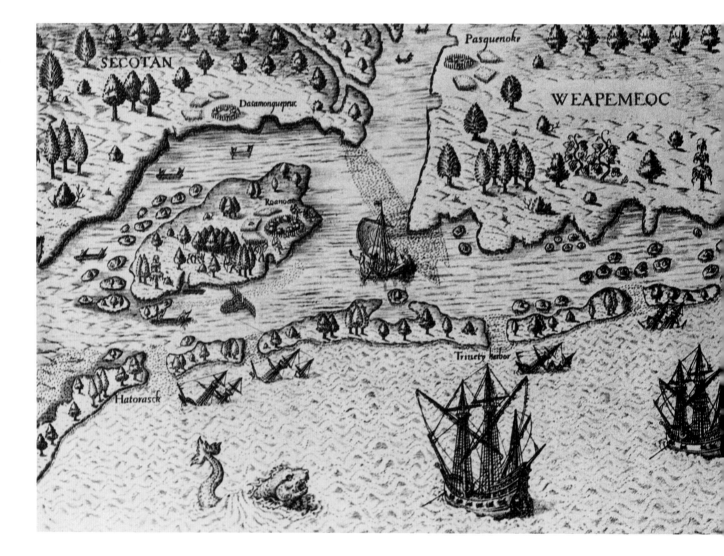

New World Visions
of Household Gods
& Sacred Places

One American writer called it a fresh green breast, the shore of the new world. The place was fresh enough, a garden of forests and Indian farms. Its culture was old, but it was new to the European, and he soon came to think of himself as a new Adam, born into another Eden, with a new chance for paradise right here. To that end, he ruthlessly exterminated the old Adam, the Indian, and took his place in Eden, rewriting history to call it a virgin when it was in fact a widowed land.

But as the years went on, and especially after the Civil War, the American, the triumphant Adam, began to suspect that he might indeed have spoiled Eden, crushing it under the weight of men, money, and machines. He felt a need to look back into his own past, and into that of all human civilizations.

Out of that impulse, the Metropolitan Museum of Art, along with many other institutions of its kind, came into being. American artists played a large part in its foundation, and from the very beginning of the museum's history their works held an important place in its great collections of the arts of all the ages from all over the world. Now those works are gathered together in the new quarters of the American Wing: architecture (in the period rooms), sculpture, furniture, and painting, from the Colonial period to about 1914. And they can be seen in close proximity to the galleries of European art, from which, at the beginning, they derived.

For an American, a visit to the American Wing is a journey of discovery into the self. This is so because art can teach us things about ourselves and about human history as a whole that we cannot learn in any other way. American art is

The arrival of the Englishmen in Virginia, *engraving published by Theodor de Bry in* A Briefe and true report of the new found land of Virginia *by Thomas Harriot (Frankfurt-am-Main, 1580). Map of the Virginia coast showing Roanoke Island and the Outer Banks of what is now North Carolina, based on drawings by John White (ca. 1540/50– ca. 1606) from surveys made by White and Harriot in 1584–1587.*

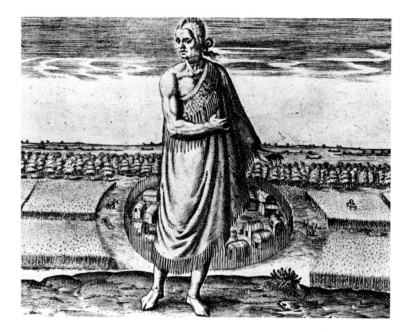

An ageed manne in his winter garment, *engraving published by Theodor de Bry in Harriot,* A Briefe and true report. . . . *Based on John White's drawing showing, in the background, the town of "Pommeioocke" (or Pomeiooc).*

the closest to us and so the most informative of all. But it is no less mysterious for that. Its history is a curious one; it started afresh on a new continent, but with old memories, so that from the very beginning it has been haunted more than the arts of most other nations by the hard question of what is real. It kept on asking that question. It is still asking it today, still inexhaustibly fresh and inquiring.

First of all is the question of the place, still only partly our own and which, in some strange way, we tend to feel is threatened by us. We do not trust ourselves in relation to it. Twenty years ago we began to become aware that our modern architecture and urbanism were ruining it with enormous rapidity. Redevelopment followed, with what came to be one social and urbanistic horror piled on another, slashing cruel wounds in our cities and our people that have not yet been healed. In most of our cities, that is, especially in those of our own Northeast. But elsewhere, as in the famous Sunbelt, a clear new pattern has emerged out of the turmoil of the past twenty years. Dallas shows it; Houston even more so. Their shining curtain-wall towers and rings of freeways are of course direct legacies from the International Style of modern architecture and planning, which was obsessed with the free passage of the automobile. But the result has been a peculiarly American structure, growing out of longstanding American attitudes and conditions. Only in America, for example, do the towers rise with no one in the streets. The cars circle endlessly on the freeways around the blank and glittering slabs. The suburbs

stretch out without end; new battalions of towers suddenly shoot up among them. Is it a city or several cities? The energy is enormous, the power overwhelming; everything of any age that stands in its way is swallowed up by it. The old, along with the poor, are helpless before it. There is no center. The point of it all is hard to grasp, because the relationships all seem to be by car, plane, and computer with other towers far off, in other cities out of sight and awareness. With the landscape, there seems to be no relationship at all. And here we become most uneasy. North of Dallas, a gentle, dry, parklike country rolls out, ideal for horses, studded with thin groves of live oak, beautiful in scale. What does the city have to do with that Arcadian landscape? Nothing, though it would like to build a racetrack there. But it, like every other place on the continent, is haunted by melancholy ghosts, because each of us holds, in greater or lesser degree, the memory of those who were here before us and whom we displaced. We are all recent immigrants, European aliens, all belonging from the beginning to a European International Style. There has never been a culture so "alienated" as ours. Francis Jennings has finally

Houston, downtown from the freeway, 1985. Photograph by Blair Kamin.

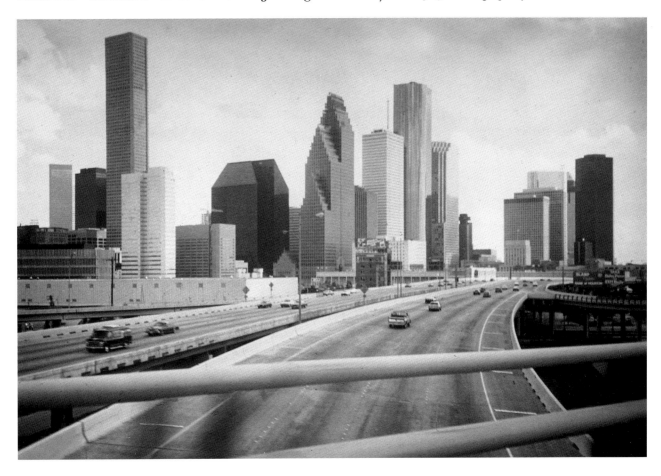

convinced us that we did not "discover" this continent but invaded it and committed genocide upon its inhabitants. None of this was very long ago. We in New England think of ourselves as long settled and ensconced in a harmonious relationship with our incomparable landscape. In a relative sense this is true – relative to Houston or even to poor old Dallas, for example. But our Puritan ancestors – ancestors whom even we more recent immigrants may be presumed in some measure to share – were among the most ruthless genocides of all, and surely the most sanctimonious. The culture they brought with them had nothing to do with the culture that had existed on this continent before they came. Nor, unlike the more overtly brutal Spanish to the south, did they make any kind of pact with that culture. They incorporated none of it into their own; they set out instead to deny that it had ever existed. The Spanish knew they had conquered a great civilization, and they adopted various positive attitudes toward its survivors, some harsh, some extraordinarily loving. The English simply assumed that the Indians had never been of any significance and would, in any event, soon disappear, and they helped that process along as the occasion arose. Historians of New England were still writing in the 1980s that the Indian had, in all Darwinian justice, been forced to go because he had not utilized the land intensively enough.

Nothing is served by wallowing in a guilt that, if the truth be known, none of us feels very deeply anyway. The feeling itself diminishes the further west one travels, the closer in time to the crime. In Dallas, everybody's whipping boy, the genocide took place in the nineteenth century rather than in the seventeenth. In fact, Dallas was founded when John Neely Bryan, having traveled down from Arkansas to trade with the Caddoe Indians, who lived along the banks of the Trinity, discovered that they had just been wiped out by a couple of gangs of Texans, and decided to lay out a city instead. Today Dallas is constantly cited by its own inhabitants as the exemplary product of a culture alienated from its place, and in that sense wholly colonial. Everyone comes from somewhere else, they say, and only to make money. The deeply rooted, dedicated artists and intellectuals of the Dallas Humanities Institute write most tellingly about this phenomenon – and in doing so cast some doubt as to its reality. Let Dallas stand nevertheless as the archetype of a colonial culture in modern form. Let us admit that the

values that created it are entirely different from those of the earlier Americans who once tended their fields (not "roamed the plains") where it now stands. Let us focus on that major fact: the two cultures – that of the continent, of the conquered, and that of the colonizers – were as utterly dissimilar as any two cultures could be.

Their architecture can tell us about that difference with enormous precision. If we start therefore by considering the architecture of the original Americans in its most significant aspect, which is its close relationship to the place, it will follow that we should then look at the Colonial culture of the seventeenth and eighteenth centuries in terms of its own most significant aspects, which are the environment it created for itself on an alien continent and the image of itself in which it eventually came to believe.

The original Americans had an enormous psychological advantage over the European colonists. They had not been uprooted from their homes and transported across the seas; they regarded themselves as having been born out of the body of this continent itself. The Pueblo people of the Southwest believe that they emerged into this Fourth World of earth from the depths of the Grand Canyon of the Colorado, and their early house types were dug down into the earth, with the round hole of a *sipapu* in the floor to commemorate that fact of emergence. Their earth-covered roof-lines, too, generally reflected the forms of the mesas around them. They were wholly of the place. The Navajo hogan retains that character; its materials and massing closely echo the profiles and colors of the buttes that shape the horizon. Far out and alone in the desert, each hogan is thus tied to the great forms of the land. It is drawn to the sun as well. The entrance faces east; as the sun rises, it hollows out the hogan with its light and so links it to a celestial as well as a terrestrial order. In all these small dwellings, therefore, the principle at work involves an at least instinctive imitation of nature's forms and a clearly conscious attempt to lock into nature's powers.

When monumental architecture at full landscape scale came into being, it was shaped by that same principle. We can see it at work in the Valley of Mexico. At Teotihuacán, which was surely the greatest ceremonial center this continent has ever known, the long, straight Avenue of the Dead (the ancestors built the city; we converse with them there) leads directly to the Pyramid of the Moon, whose profiles

7

pick up those of the mountain behind it. On that axis, that act of recognition and acceptance, the summit of the mountain is notched in the middle, directly behind the pyramid's mass. The mountain is running with springs; water is being squeezed out through its internal fractures. The pyramid helps that process along. It clarifies and compacts the mountain's shape. Its strong, horizontal shadow lines intensify the image of horizontal fracture through which the groundwater is brought forth. In this way, human beings not only give themselves up to the natural process but also try to assist it along, since it is, in their view, constantly in danger of being let down by those beings whom Kubler most terribly calls "the idle gods," who are capable of initiating action but too feeble of purpose to carry it through. Hence human sacrifice: men must feed the machine; it is their responsibility in nature. Once again, as has been the case time after time in history, a human ideal produces mankind's most formidable horrors.

The architecture of the Americas is otherwise wholly realistic, as magic must be. So the notch in the mountain is

Temple of Quetzalcoatl, Teotihuacán (detail). Yale University Photograph and Slide Collection.

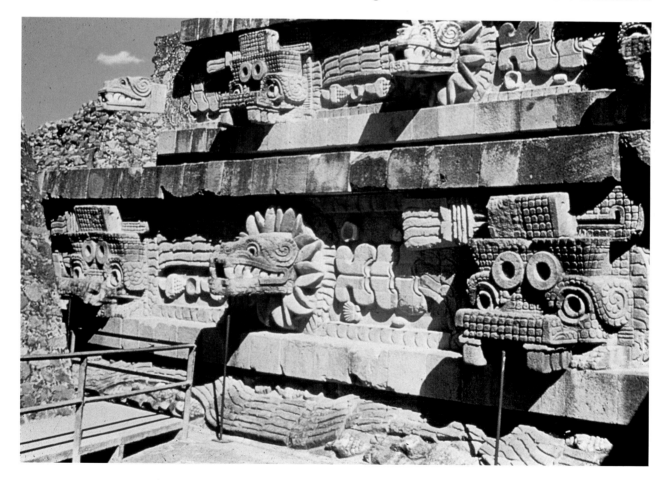

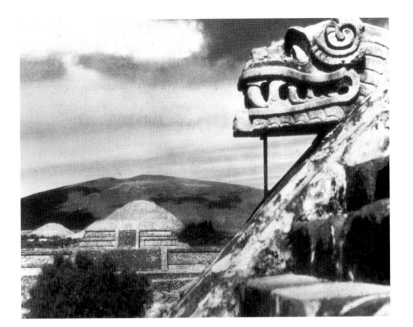

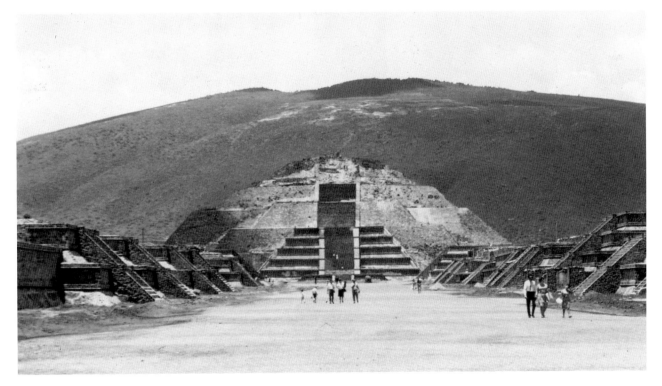

reflected in the notch in the center of the headdress of the water goddess from Teotihuacán. It is as if a cleft mass of rock has been dropped upon her from a great height, compressing her body and fracturing it horizontally, while water is being squeezed out through her hands. The whole site at Teotihuacán is organized around that image. First on the right, on the approach along the Avenue of the Dead, stood the temple of Quetzalcoatl. The *tablero* structure of the stepped sides of its base dramatizes the act of compres-

The Pyramid of the Moon, begun ca. 200 A.D., in the Valley of Mexico, with Cerro Gordo in the background.

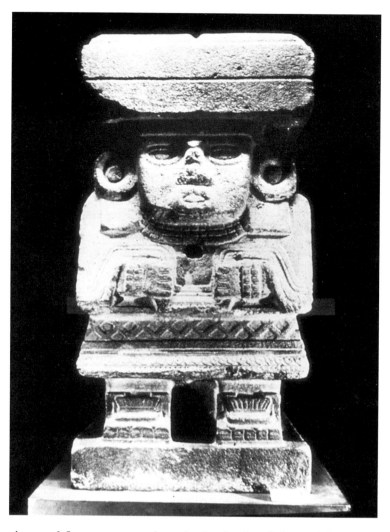

Water goddess, Teotihuacán. Museo Nacional de Arqueologia, Mexico City.

sion and fracture, exactly as in the body of the goddess, and so forces out head after head of feathered serpent in great spurts like springs. Horned and feathered, it is Quetzalcoatl himself, the great American divinity, god of the very blood of civilization, the water from the earth and the water from the sky. So it is his great broad head, its fangs swelling with power, that stands out before the grand deployment of pyramids and the mountain beyond.

It is the same divinity, now called Avanyu or Palulukang, who is carried high in the air in the snake dances of the Southwest, touched by the feathers of birds and allowed to squirm around in the dust of the plaza. And it is the same principle of invoking nature's shapes and helping nature's processes along that forms the pueblos themselves. We see it at its most beautiful at Taos. North House is an asymmetrical pyramid. Unlike the pyramids of Mexico, it is the communal dwelling as well, but it still picks up and clarifies the shapes of the sacred mountain behind it, within whose

10

horned peaks sacred Blue Lake is cradled and from whose majestic body clear water gushes out to run down through the center of the pueblo in a never-failing stream. To the right, across the stream, South House is also basically pyramidal in form, and it too reflects the profiles of those slopes of the Sangre de Cristo that lie directly behind it. But the great dances all culminate at North House, whose nature is double. Approached from the courtyard below, its profile is straight-backed and stepped in pure silhouette. It is the typical Pueblo sky-altar, reaching up to and geometricizing (humanizing) the shapes of the clouds. The final sets of the dances all take place in front of North House; the beat of the stepped-back masses of the house itself reflects that of the shoulders and summits of the mountain (which are called by the same names) but picks it up, helps it along. So the building, which is ostensibly only a dwelling and which in the Pueblo way avoids the monumental symmetries and the specialized function of the Mexican forms, is still as much an evocation of the sacred mountain as those forms are, and is perhaps even more eloquent in drawing the sky into the man-nature harmony as well.

The dances complete that union of the natural, the man-made, and the human act. It is they that cement the

North House, begun before the sixteenth century, with successive rebuildings, Taos, New Mexico. Photograph by Wayne Andrews.

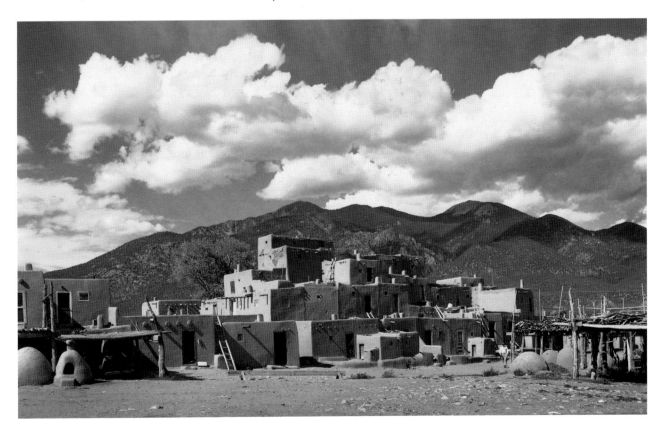

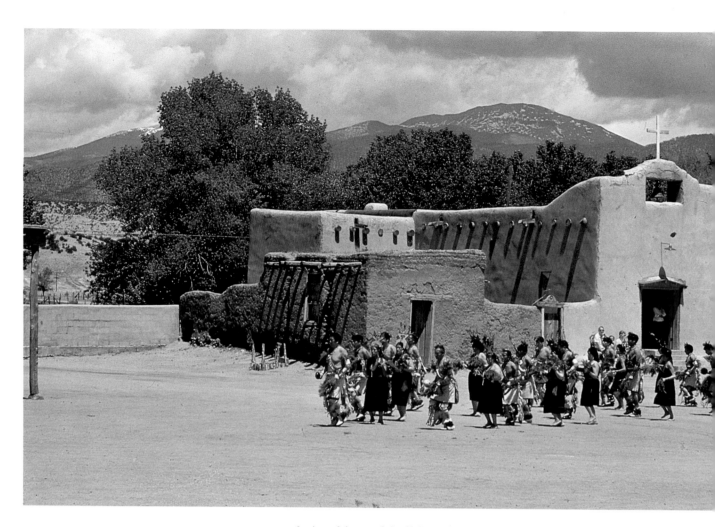

relationship and build up its power as the dancers beat on with their deep-voiced chanting throughout the long day. The sacred dances cannot be photographed at Taos, or in the Keres or Hopi pueblos, but they can be in the Tewa towns, as, for example, at Tesuque, just north of Santa Fe. There the profiles of the pueblo subtly reflect those of Lake Peak, the sacred mountain of the East, beyond them. The only intrusive, European element, the flat, vertical facade of the church, is painted white in conscious contrast to the earth-colored adobe of the other buildings. It stands out, but, unlike the churches of Hispanic towns such as Ranchos de Taos, it has no towers. Those aggressively European flourishes, so eloquent in Mexico, have been sheared off at Tesuque in favor of a simple parapet that is at once a sky-altar and an echo of the shape of the mountain beyond it. So the church, too, embodying though it does the intrusive European religion, is gentled into the Pueblo pantheon of belief. Then, when the long lines of the Corn Dance at Tesuque pass through each other and turn in a

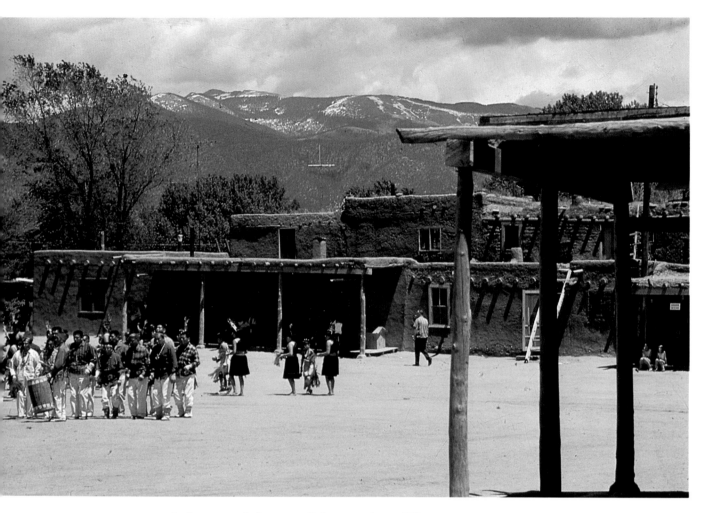

Corn Dance at Tesuque, New Mexico, 1968, with Lake Peak and Old Baldy in the distance. Composite photograph by the author.

great wave toward the sacred forms, all is complete. The natural, the man-made, and the human ritual are one. As the feet of the men pound the earth and those of the women caress it, we can feel the power building. Nature's energy is being recharged, to be released in vast, strong waves of human joy. It is the human city at its best, however small or impoverished it may be. It is the place where men have power enough, through their communal life, to act with some effect in the face of nature, but also the place where, most of all, not confronting or insulting but rather praising and abetting her being, they can play a willing, vital part in her vast scheme.

All of this once culminated, of course, in Tenochtitlan, which was in all likelihood the most completely beautiful city this continent has ever seen. It lay in the bosom of a lake surrounded by great mountains, a creature of earth and water but wholly a work of man. The words of the brave and loyal Bernal Diaz del Castillo, one of its conquerors, evoke it marvelously:

13

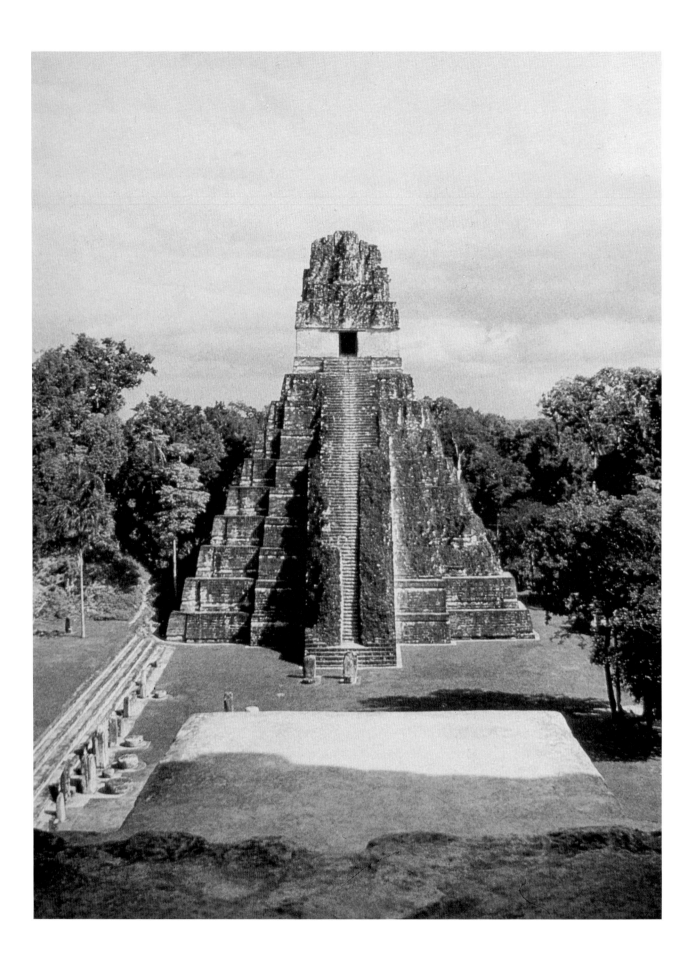

14

During the morning we arrived at a broad causeway and continued our march toward Iztapalapa, and when we saw so many cities and villages built in the water and other great towns on dry land and that straight and level causeway going toward Mexico, we were amazed and said that it was like the enchantments they tell of in the legend of Amadis, on account of the great towers and cues and buildings rising from the water, and all built of masonry. And some of our soldiers even asked whether the things that we saw were not a dream. It is not to be wondered at that I here write it down in this manner, for there is so much to think over that I do not know how to describe it, seeing things as we did that had never been heard of or seen before, not even dreamed about. . . . I say again that I stood looking at it and thought that never in the world would there be discovered other lands such as these. . . . Of all these wonders that I then beheld, today all is overthrown and lost, nothing left standing.

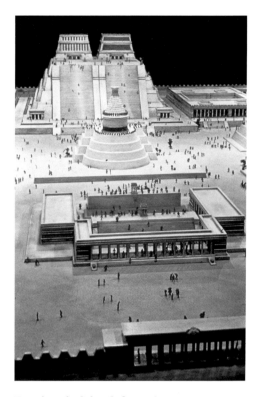

Temples of Tlaloc, left, and Huitzilopochtli, right, with Temple of Quetzalcoatl, Tenochtitlan. Model by Ignacio Marquina. Museo Nacional de Arqueologia, Mexio City.

Diaz's words amply justify Fitzgerald's peroration at the end of *The Great Gatsby*, where he writes:

> *. . . for a transitory enchanted moment man must have held his breath in the presence of this continent, compelled into an aesthetic contemplation he neither understood nor desired, face to face for the last time in history with something commensurate to his capacity for wonder.*

The order that was invoked at Tenochtitlan was indeed based on principles no European of that period could quite understand, and it created relationships with the landscape that most Europeans have not to this day been prepared to perceive and decipher. The sacred precinct at Tenochtitlan, as we see it in Marquina's splendid reconstruction in Mexico City, was focused upon a central group: the temple of Quetzalcoatl, shaped like an enthroned figure with a distinct, erect head, looking straight at the triangular gap between the Temple of Tlaloc on the left and that of Huitzilopochtli on the right. The sun of the equinox rose in that niche between the two temples. When it moved to the left, behind the Temple of Tlaloc, god of rain, it was the season of rain and agriculture. When it moved to the right, behind the Temple of Huitzilopochtli, god of war, it was the dry season of hunting and war, which itself was the hunting

Temple I, ca. 727 A.D., Tikal, Guatemala. Photograph by Nicholas Hellmuth.

15

of men. Then, far out on the arc of vision set up by these relationships, rose the two major old volcanoes that define the Valley of Mexico on those bearings: Popocatepetl (the name, which means "Smoking Mountain," sounds like boulders being shot off) on the right and Ixtaccihuatl ("White Lady," but like hot lava rushing down) on the left. The model for this vast architecture was still the kind of temple-to-mountain relationship that had been set up at Teotihuacán, and the Aztec kings paid ritual visits there throughout the year, looking back to the old city, long abandoned, to help lock their new city into nature's order.

If we turn southward to the Classic Mayan area, as at Tikal, we find a pattern that at first seems to be based on principles different from those at work in the Mexican area. At Tikal, the temples are not chunky like mountains, of which in fact there are none to be seen, but tall like men. Their high bases leap up above the rain forest to the temple with its roof-comb, in a way that empathetically suggests to us the standing figures of noble human beings, perhaps even the richly caparisoned priest-kings of the Maya, who are buried within them. They embody that curiously humanistic image that we find, along with exquisite cruelties, in all Mayan art. Man is most himself, and most beautiful, when he is most suffering, or so all Mayan painting and sculpture would say. But if we look more closely we find that the Mayan temples also invoke nature no less than those of Mexico. They do so in their own special way. The Mayan temple is of concrete, unlike those of Mexico, which were of less permanent materials. The tiny, corbel-vaulted spaces within the thick, concrete masses therefore remain cool and dank despite the heat outside. As we stand at the foot of the stair, we see only the roof-comb, lifting up in soft, cloudlike profiles against the sky. And when we climb the frighteningly steep stairs to the level of the temple, its doorway breathes out upon us the cool rain-breath of its companion clouds. It is the greatest magic of all.

The temples of Tikal are true sky-scapers, the first in America. Their bases serve as springs to lift them up, where they gather the rain. They ride above the trees and once rode above the other buildings of their city as well, as the skyscrapers of New York came to ride above theirs, in richly set-back masses, leaping to the sky. It is no accident that New York's zoning laws of the teens, suggesting setbacks, soon produced buildings that closely recalled the Mayan

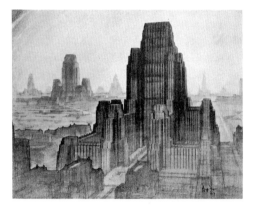

The Business Center, *drawing of 1927 by Hugh Ferriss (1899–1962), published in his book* The Metropolis of Tomorrow *(New York, 1929).*

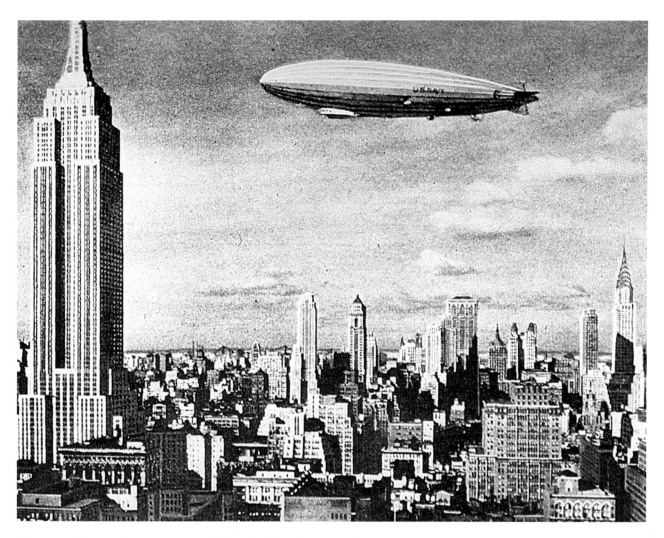

forms and were in some cases derived directly from them. The Paramount Building, by Rapp and Rapp, of 1926, was one of the first. It steps back to an elaborate roof-comb that is at once Art Deco and Classic Mayan. To touch the sky and to draw power from it: such was the image, now a romantic one but no less potent for that, which created the Empire State Building, to which the cloudlike forms of dirigibles were intended to cling. The Art Deco skyscrapers of New York indeed offer the most striking example in later American culture of the rebirth of early American forms. The work of Frank Lloyd Wright was being nourished by the same sources during that period, but it was in New York that the old sky-temples achieved their new continental scale. So when Hugh Ferriss, the visionary of the movement, proposed his Metropolis of Tomorrow in 1929, it was Tikal all over again, though on a much larger scale. As his frontispiece, Ferriss drew skyscrapers emerging from mountain shapes, calling them *Buildings out of Mountains.* And so his

New York City, as pictured in a postcard of ca. 1939. (From Rem Koolhaas, Delirious New York, *Oxford University Press, 1978, p. 118, 2.)*

17

The Towne of Secota, *engraving published by Theodor de Bry in* Harriot, A Briefe and true report. . . . *Based on John White's drawing of the village of Secoton.*

wholly American skyscrapers sailed, as vast as the mesas of the Grand Canyon and, in terms of the concept of the sublime that motivated them, consciously suggestive of its awesome power.

It is curious that the revival of pre-Columbian forms was called forth by the liveliest period of prosperity and originality that the new America had ever known. It was killed by depression and war, and the post–World War II, International Style skyscrapers of Houston and Dallas were at first conceived in a somewhat different way. They were abstract, flat-topped slabs, reflective in most cases only of each other and of the curtain-wall techniques that brought them forth. It is true that with Philip Johnson the skycrapers of Houston began to leap to the sky once more, influenced again by the older sources. Yet their grouping remains separate from everything, and we need to approach them not through pre-Columbian but through Colonial culture, of which they are in a fundamental sense the ultimate product.

When English settlers came to the Eastern Seaboard, they found not a howling waste or even a "sea of trees" but, in most cases, a thriving pattern of Indian villages and farms. It is no artificial conceit that causes Theodor de Bry, working from a drawing by John White, to cover the land behind his *ageed manne in his winter garment* (page 4) with enormous cornfields, filling the broad clearing around a village between the inland forest and the shore. And Le Moyne shows us Indian men breaking ground and hoeing (the hard work: white mythology has persistently suggested that male Indians did no work at all), while women sow in long, straight furrows that stretch to the horizon like those of a modern midwestern farm. John White's famous drawing of the town of Secota, and Theodor de Bry's engraving of it, shows a broad, straight central axis and several smaller cross-axes interspersed with dwellings, gardens, and ceremonial areas. It seems conceived as much according to ritual as a pueblo, although it is less dense in grouping. Jennings and others have persuasively argued that the colonists, rather than making their own clearings, took over existing fields when they could. But their pattern of settlement was totally different. They owned land as individuals rather than in common; they made use of that land less flexibly than the Indians in terms of farming, hunting, fishing, and gathering, and they fixed themselves in place with more specialized occupations. The plan they used least for their towns, but

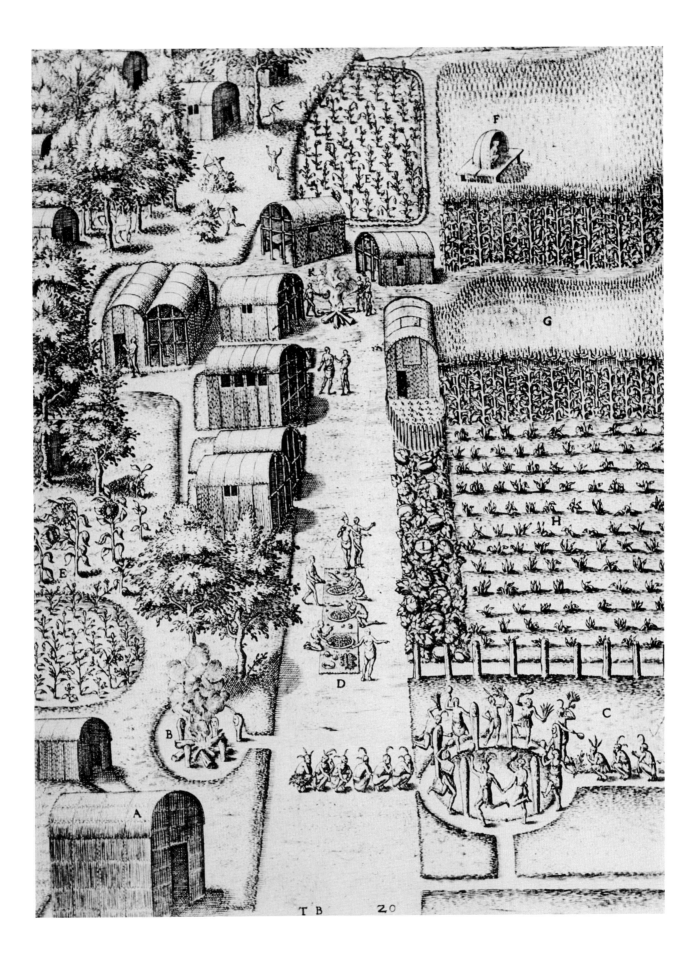

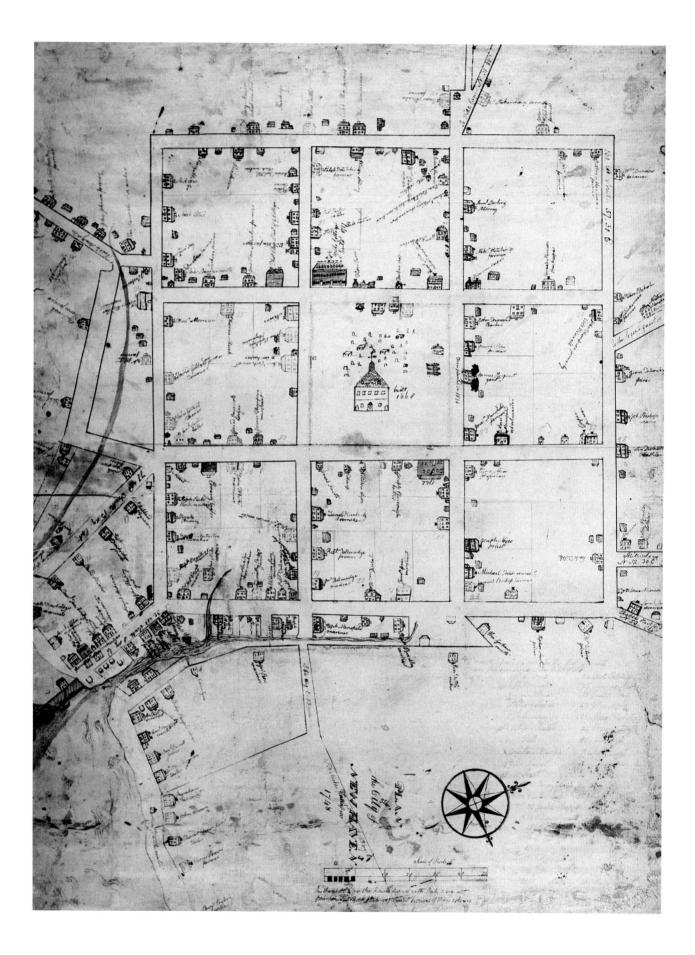

20

which was to become the archetypal American plan, was the grid. That of New Haven, Connecticut, is the purest example. Anthony Garvan and others have shown that it may be related both to ideal towns as described in the Old Testament and to the fortified towns (with "pales") that the British were building at exactly the same time, as colonies in conquered Ireland. Fundamentally it is a plan that derives from classical antiquity and which was, originally, a colonial one, imposed by the conquerors. The Greeks used grids in colonies such as Akragas as early as the seventh century B.C. It was an obvious way to lay out a new town governed by a structure of life imported from elsewhere. It then developed into the classic plan of Hippodamos of Miletus, and thereafter into the Roman camp and its resultant colonial cities, such as Timgad in North Africa. Finally, during the Renaissance, it became the type of the Ideal City, more or less suggested by a reading of Vitruvius. Here New Haven is indeed ideal: a perfect square, made up of nine smaller squares of which the central one is common land. It is wholly abstract and imported but not wholly unrelated to the place. Colonial drawings show the grid canted off a perfect north-south orientation, in order, apparently, both to fit between two small rivers running into the harbor and to afford straight views down its streets toward the spectacular red plugs of the two small mountains, East Rock and West Rock, that bound the site on its inland side.

The ritual life of the town did not, however, focus outward upon those natural forms. It turned inward, toward the center of the central square. There the original meeting house stood, itself a square, like the one that still exists at Hingham, Massachusetts. There the congregation, too, all faced inward toward each other and toward the preacher, who was unemphatically positioned to one side. A later schematic plan of New Haven, drawn up in the late nineteenth century from the records of the original settlement of 1641, shows that the lots of the town were assigned to individuals, alone or as the head of households. When the beautiful plan of 1748 was made (by James Wadsworth, an undergraduate at Yale), each family could be seen as ensconced in its single-family house, each on its own lot and set well back from its boundaries on what would, at some point, become its own lawn. Eventually there might be a picket fence and a sidewalk, beyond which would stretch another thin grass plot, planted with trees and bordering the street.

Plan of New Haven, Connecticut, 1748, drawn by James Wadsworth (1730–1817), then a senior at Yale College. Watercolor and ink on paper. The Beinecke Rare Book and Manuscript Library, Yale University.

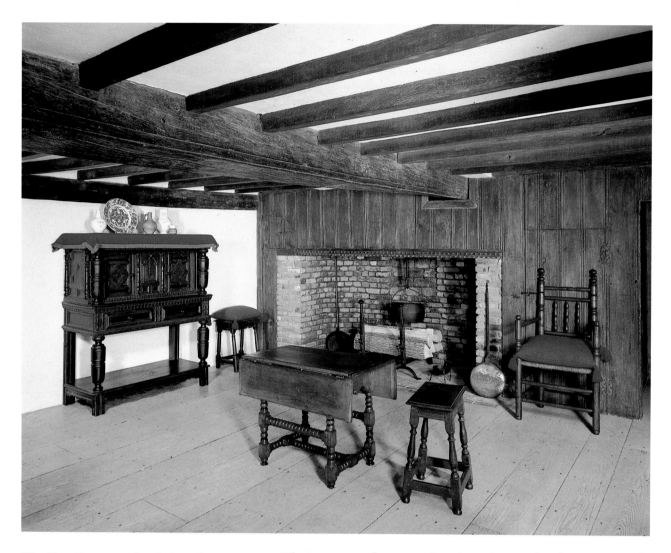

The Hart Room, woodwork from the "hall," the principal room in the house of Thomas Hart, built before 1674, Ipswich, Massachusetts. Shown as installed in the American Wing. The Metropolitan Museum of Art, Munsey Fund, 1936 (36.127). Photograph by Richard Cheek.

The pattern of a pervasive American urbanism was set. It would ultimately be built up densely in the center to squeeze upward into skyscrapers, and would open out in the suburbs with some picturesque variations and irregularities. But the type is clear and has remained the fundamental structure of the North American world, with the single-family house at its center.

The Hart Room in the Metropolitan is a good place to begin to understand those houses. It is an example not of the very first shelters, such as those built at Jamestown in Virginia and at Plymouth Plantation in New England, but of those of the immediately succeeding generations, when existing English models could be more easily and closely reproduced. In the Hart Room we can see how those models were adapted to conditions in New England. It remained a basic architecture, founded on basic needs. The first of

22

these was fire; it is cold in New England. The fire is given an enormous hearth, ideally placed in the very center of the house. The hearth is embedded in a great chimney mass, and that chimney stabilizes the rest of the structure, which is a wooden frame. In the Hart Room that frame is tied to the chimney by a heavy so-called summer beam that runs from the fireplace mass out to the girt on the outside wall, which is bending under its weight. The beam itself is now deflecting from the weight it has carried over the centuries. It is just high enough to stand under. The room is lighted by very small casement windows; the effect is dark and protective. It is protective and warm in a thermal sense, but it is psychologically protective as well. And it creates an image of fireplace and shelter that somehow never seems quite to die out of the American consciousness. It has been revived several times since, and its memory has haunted the

Parson Joseph Capen House, 1683, Topsfield, Massachusetts. Photograph by Sandak.

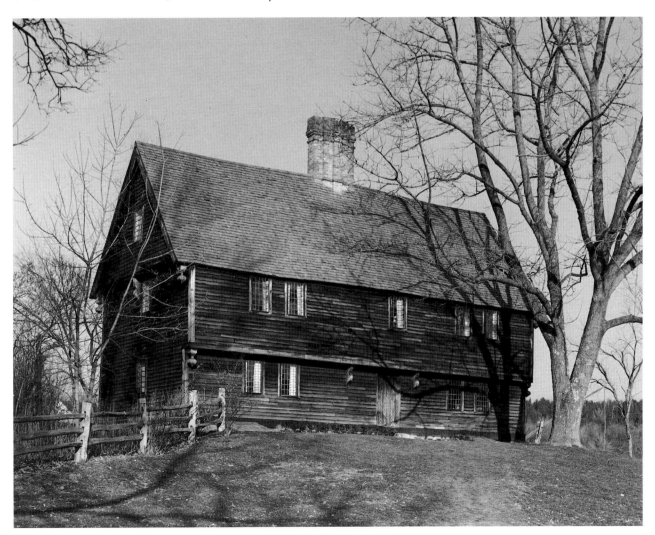

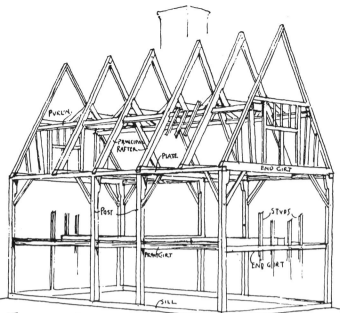

FAIRBANKS.

Schematic drawing of joined framing, Jonathan Fairbanks house, built ca. 1637, Dedham, Massachusetts. (From Norman M. Isham, Early American Houses, *Boston, 1928).*

American spirit from the time of the Hart Room onward.

The exterior of such a house is closed tightly against the climate. The use of clapboarding, common in parts of England, becomes almost universal here. The windows are pushed tight up against the frontal plane to complete the weather seal. They are small-paned; so they, too, assert a continuity of closed surface. The chimney mass in the center holds the heat, and the tight box of rooms tends to grow up symmetrically around it. The entrance is in the center of the long side, and the frontal gables and the porch chamber of English practice are all eventually discarded so that the long roof planes between the side gables can be kept closed and tight as well.

In this way, English, late Medieval, middle-class architecture is systematized and regularized in the Colonies. The Parson Capen House in Topsfield, Massachusetts, is one of the clearest examples of that: it is very much the creation of a Colonial craftsman culture. It has a central fireplace mass with a skeleton structure of wood around it, and the rooms that are created by this order are symmetrically placed around the front entrance. They, too, are low and comparatively dark.

In those low, dark interiors, painting played a minimal part. Silver was the prime object of pride. It was of course worked in all the major Colonial towns, some of which, such as New York and Philadelphia, were by no means Puritan. It

might be argued, however, that silver is the ideal Puritan art. It is first of all a material possession, the money of the household made into a work of art – of *useful* art. One could rationalize its beauty and justify its display. There is also the linearity, the coolness, the self-control of silver as a material: thin and ringing, clean and bright, so different from the dull, papist gleam of gold. There is something about silver that transcends the flesh. Though it may be heavy, it looks light, a creature of gleaming air. All of these qualities must have appealed to the Puritan mentality, embodying its deepest cultural preferences with enormous precision.

Moreover, and in part for these reasons, while Colonial painters as such at first hardly existed and were, when they did exist, merely provincial portraitists whose work was patently reflective of English styles, Colonial silversmiths were as skilled as any in the world; so it is they who must be regarded as the first great Colonial craftsmen and artists. Their forms moved rapidly toward increased monumentality and sculptural power, until the great Queen Anne tea-

Two-handled bowl, silver, 1700–1710, New York, made by Cornelius Kierstede (1675–1757). Height 5⅜ inches. The Metropolitan Museum of Art, Samuel D. Lee Fund, 1938 (38.63).

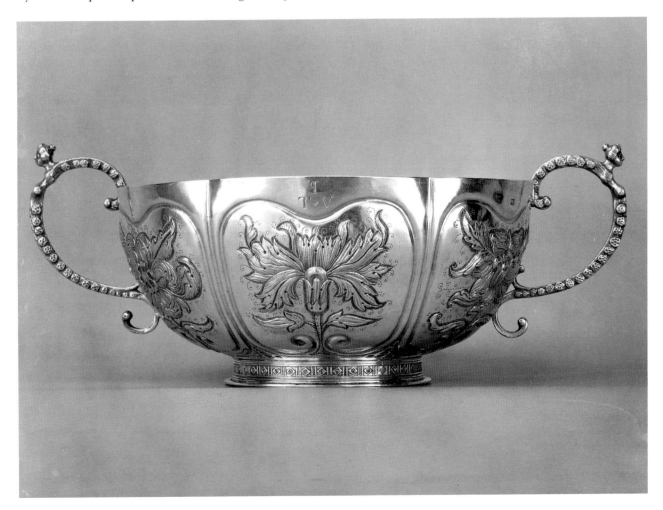

Beaker, silver, 1666, New York, made by Jurian Blanck, Jr. (ca. 1645–1714), and given to the First Reformed Church, Kingston, New York, in 1683. Height 7¼ inches. Joint property of the Reformed Dutch Church of Kingston and The Metropolitan Museum of Art, Bequest of A. T. Clearwater, 1933 (33.120.621).

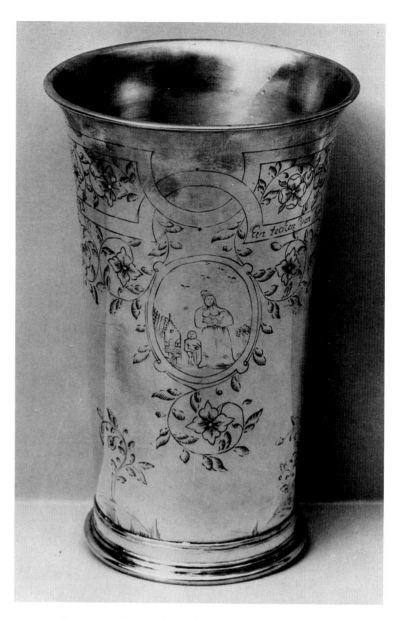

Cupboard, joined and turned oak, pine, maple, cedar, partly painted, 1670–1700, Plymouth, Massachusetts, area. Height 40 inches. The Metropolitan Museum of Art, Gift of Mrs. Russell Sage, 1910 (10.125.48).

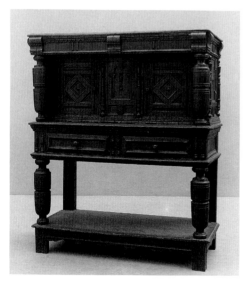

pots and cups of the early eighteenth century (pages 27 and 36) were as organic as living creatures crouching in space. They were true three-dimensional, figural sculpture in a society from which figural sculpture had otherwise been all but banished with nonconformist rigor.

It is when we see such silver displayed in the house that we begin to feel its true importance. It is set out on great cupboards that are almost as high as the rooms themselves – massive, monumental, aggressive pieces of furniture that fill the space (page 22). Then, on top of their dark forms, and sometimes in front of them, the silver gleams, intensely alive and giving off light. With the two together looming and shining beside the fire, we again feel the beginning of that American sanctification of the house – of the house as

the center of ritual – which never entirely leaves the American consciousness in later ages, and which indeed tends to direct its attention inward, toward private and familial values, rather than outward, toward public ones. The other pieces of furniture play a part in this as well. They tend to be few and very big in the space, and it so happened that in the seventeenth century, they, like the silver, were involved in the first important modern identification of themselves as unique household possessions and expressive forms. They, too, grew from a Medieval tradition of simple structure into a new, Renaissance concept of sculptural form. We can see how a piece of furniture such as the cupboard with its silver could be a powerful force, dominating a small room.

Some of the most important objects in the room were chairs. The first of these, other than stools, were heavy oaken thrones like the Wainscot chair, the seats of paternal authority and thus its major domestic symbol. Their function was status, not comfort. Then came the turned "great

Teapot, silver, 1700–1715, New York, made by Jacob Boelen (ca. 1657–1729). Engraved with Philipse arms. Height 6½ inches. The Metropolitan Museum of Art, Gift of Mrs. Lloyd K. Garrison, in memory of her father, Pierre Jay, 1961 (61.246).

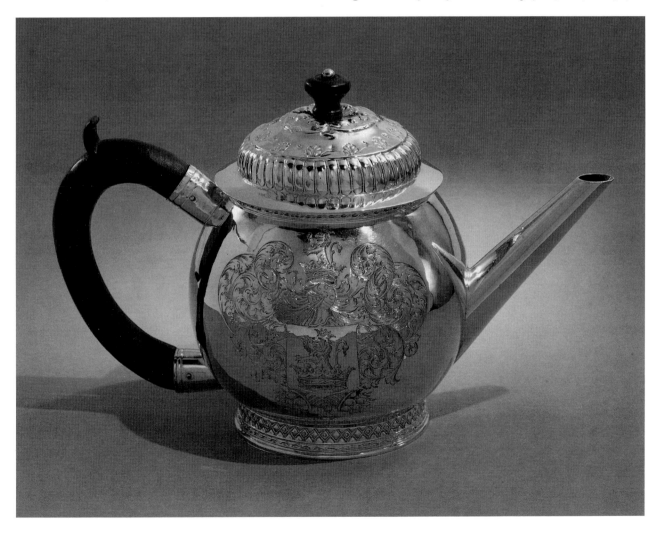

chairs" of the Brewster type. It is an architectural frame, put together, as was the ladder-back chair that followed it, like the skeleton structure that makes the house. We don't feel the sitter's body in its form; it is an environment inhabited by a person. We might note here that this is exactly the phase in the development of furniture to which Frank Lloyd Wright was later to adhere. His furniture, too, was wholly environmental, scaled to the beam structure of his low rooms and, like them, constructed with, as he himself often observed, no concessions whatever to figural form and thus no references to it. In that sense, Wright continued to work within the earlier, seventeenth-century phase of the Colonial Revival, which began in the 1870s. But Colonial furniture itself was to develop in a different way.

With the shift to William and Mary design, the typical Renaissance instinct to reflect the human shape begins to

Parlor in the Parson Joseph Capen House, 1683, Topsfield, Massachusetts. Photograph by Samuel Chamberlain.

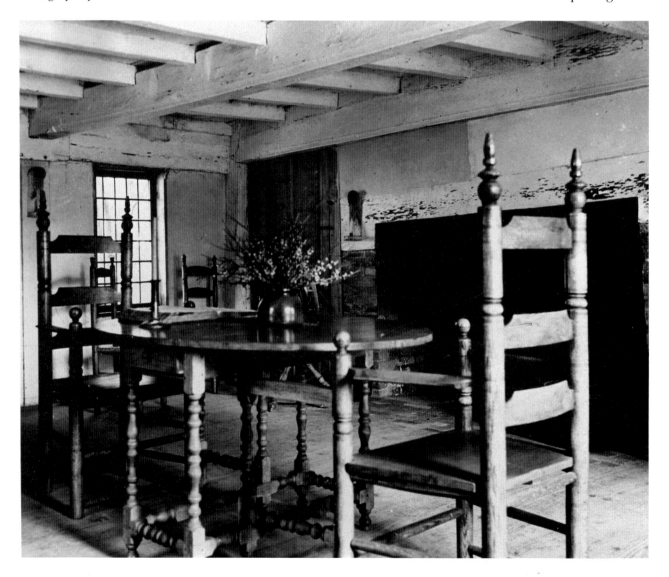

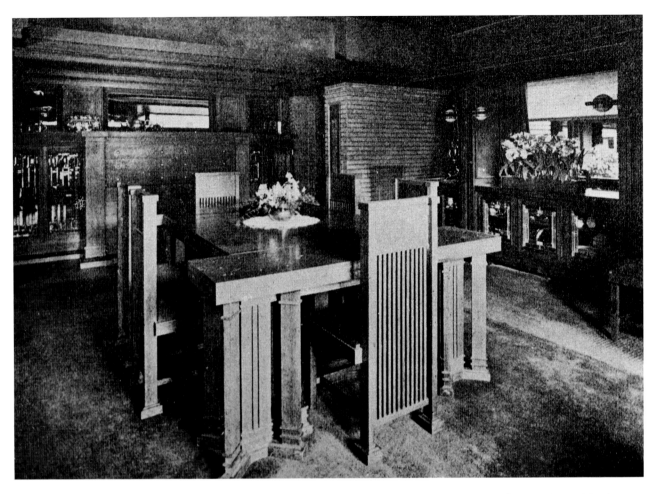

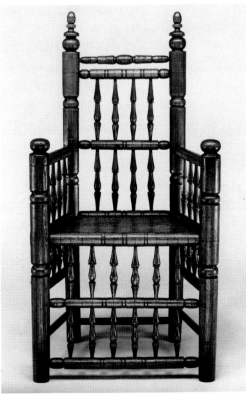

Dining room in the Darwin D. Martin House, 1904, Buffalo, New York, designed by Frank Lloyd Wright (1867–1959). (From Ernst Wasmuth, Frank Lloyd Wright: Ausgeführte Bauten, *Berlin, 1911).*

Turned great chair, Brewster type, ash, 1640–1680, Eastern Massachusetts. Height 44¾ inches. The Metropolitan Museum of Art, Gift of Mrs. J. Insley Blair, 1951 (51.12.2).

change the character of the chair. The arm itself, as it turns over and down, makes us feel the sitter. We begin to perceive the chair itself as embodying the person who sits in it.

Then, with Queen Anne furniture, around 1725, the whole chair becomes an active creature, an organic body. The arms curve; the splat lifts and gestures behind them. The back, with a wonderfully controlled curve, comes down and, often with a profoundly articulated hip joint, transmits its energies into the seat, which in turn transmits them to the legs. They are cabriole legs, and therefore they bend, almost crouch, and they terminate in feet of one kind or another. Eventually many of them become ball-and-claw feet, clutching and full of power. The whole chair becomes a kind of animal. Since the chair is a creature, the Colonial craftsman usually prefers to get rid of the stretchers that stiffen the legs, and in New York and Philadelphia, for example, he tends to do so consistently. But when, as often in New England, he retains the stretchers, they now have the wonderful quality of seeming to tie the legs together against their will, hobbling the creature, which wants to get free.

In the side chair, which derives from the stool rather than from the paternal throne, that animal quality continues. We are somehow made to feel that it is positively "armless," as if the arms had somehow been cut off. The wonderful bony joint above the seat, as of a pelvis, comes into its own. Why are the English examples not quite the same? It is true that the differences between Colonial and English chairs are seldom so obvious as selected examples would suggest, but the English chairs generally do not possess the creature quality of the Colonial versions. Their joints are more captious, their backs less active, their seats less integrally proportioned, their entire structure less sculptural in every way. I suspect that the reason for all this was that the England of the period was something more than a middle-class, materialist craftsman culture. It was aristocratic as well, and enjoyed other arts. It could decorate lavishly, indulge in every kind of combination and conceit. Hence it put less emphasis on the type, on the joint, on the pure comfort, on the intense middle-class probity of the whole. It is often said that the American examples are more linear than the English. They are that, but they are most of all more sculptural, more alive. When the legs struggle against the stretchers, the splats scream. How like Jacob Hurd's silver creatures these chairs are, ruffling and strutting with

life. But they are also persons, because they embody the act of the human sitter. When he is in the chair, it disappears behind him, so molded to his shape it is. But when he rises, it stands clear, a being which retains his physical aura. It is the figural sculpture of the Colonial interior. And it is one that brings a kind of seated household divinity, a household god, into the room.

It is also the climax of the Renaissance, now domesticated. Man, the measure of all things, is now seated, a middle-class figure in the parlor of the single-family house of which he is lord and master. It can therefore be no surprise that it is just

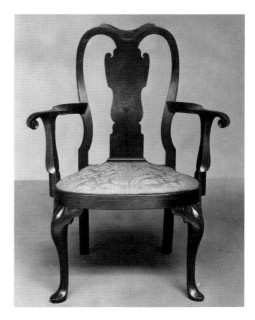

Armchair, walnut, upholstered in yellow silk damask, 1725–1750, Philadelphia. Height 41 inches. The Metropolitan Museum of Art, Rogers Fund, 1925 (25.115.36).

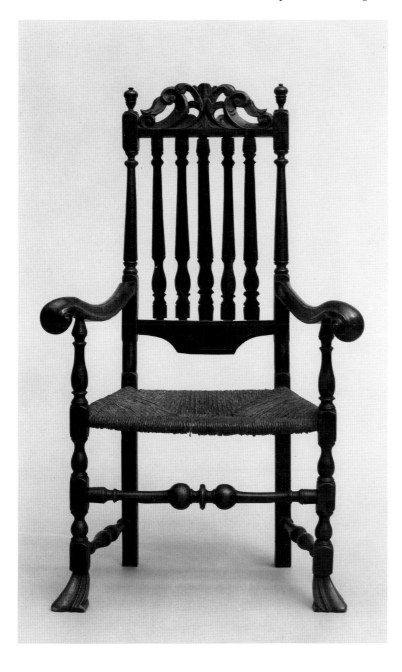

Banister-back armchair, maple, ash, 1700–1725, New England. Height 48 inches. The Metropolitan Museum of Art, Gift of Mrs. Russell Sage, 1910 (10.125.228).

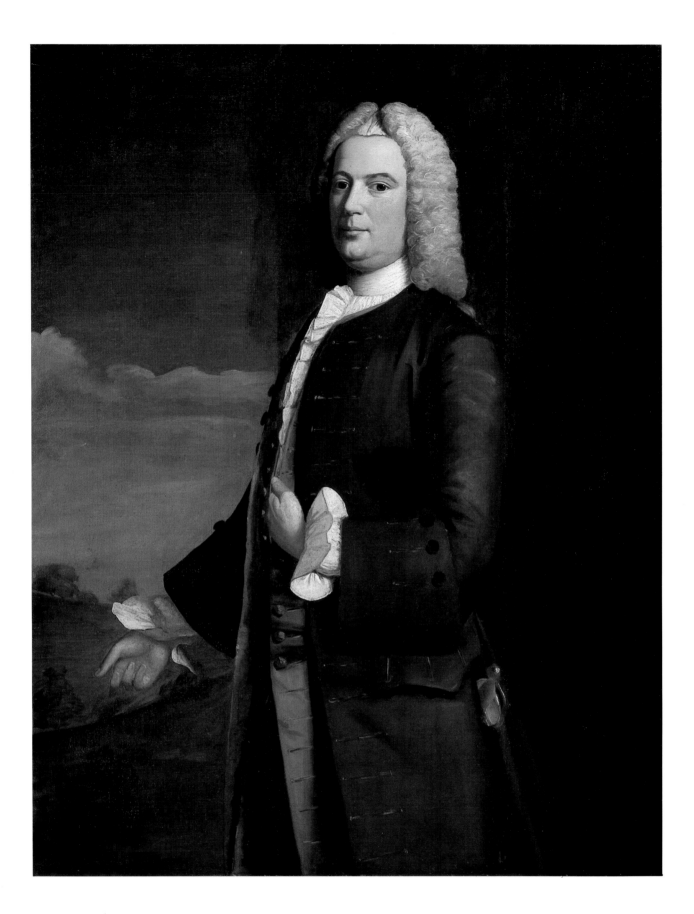

at this moment of rather marvelous sculptural energy in the Queen Anne furniture in the 1740s that what I think we can call the first American painting – and it is portrait painting – appears. It is the work of Robert Feke, shown here in his portrait of Tench Francis. Feke, like all Colonial painters, owes almost everything to the English portrait tradition. He is, after all, part of it. On the other hand, Feke's line is tense and taut, a crafted line. If we compare Feke with an Englishman painting in the Colonies, such as John Smibert, we find that the difference is enormous. Smibert is much looser, not nearly so strong, not nearly so tightly strung. He is an English provincial painter geographically displaced; Feke on the other hand is the product of Colonial culture. He has grown from the craftsman tradition of the Colonies and is proud of it. His painting is like Colonial furniture and silver. In it the elegance, the tautness, the beautifully made quality of the Queen Anne period, indeed even its sculptural stance, exemplified by Hurd's cup with its "arms" akimbo, are brought into Colonial painting for the first time. Feke may in fact have started out as a tailor. In any event, he paints clothes as if he knows exactly how they are put together. He paints them lovingly, with a craftsman-tailor's eye for their detail, for the way the buttons are put in, for the sheen of the waistcoat, for the shape of the pocket, unfastened and casting a shadow on the buttons underneath it, for the white stock against which the rather somber harmonies of brown and black and lavender are set off. It is an almost Spanish elegance, but it derives from a craftsman's pride, and a pride in those clothes, in those possessions.

Much later, Dreiser was to write in *Sister Carrie* that clothes, along with women and money, were a major way in which American men identified themselves. America had no titles. What mattered was how one looked in clothes. But here at the beginning of it all, with Feke, there is a kind of purity in that love of possession. It is real, and it radiates from the picture. It lends Feke his special integrity, the light that shines forth in his work, like the light off the silver; we feel the pride of Colonial craftsman culture wholly embodied in the forms. Most of all, we realize that Feke was the first painter in America to sense the special kind of taut, patterned, but sculptural structure that had become characteristic of the Colonial craftsman.

Portrait of Tench Francis, 1746, by Robert Feke (ca. 1707 – ca. 1752). Oil on canvas, 49 × 39 inches. The Metropolitan Museum of Art, Maria DeWitt Jesup Fund, 1934 (34.153).

Portrait of Francis Brinley, 1729, by John Smibert (1688 – 1751). Oil on canvas, 50 × 39¼ inches. The Metropolitan Museum of Art, Rogers Fund, 1962 (62.79.1). Photograph by Geoffrey Clements.

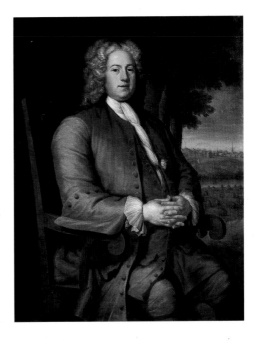

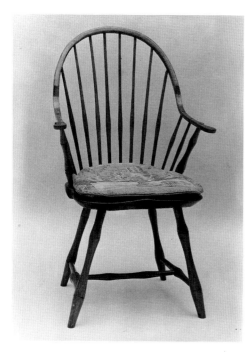

Windsor armchair, maple, ash, hickory, late eighteenth century, Connecticut. Height 36½ inches. The Metropolitan Museum of Art, Bequest of Mary Stillman Harkness, 1950 (50.145.361).

Then along comes the Windsor chair, peculiarly American and, with its proudly curving lines, much like Feke's work. It starts in England in the 1740s, but English Windsor chairs, I think it is fair to say, are grossly constructed objects compared to the beautifully crafted, very light, tensile, skeletal structures that the American Windsors soon became. And the American chairs continued to develop along those lines right into the nineteenth century, another example of the American instinct for frame structure and exact workmanship.

Or, still thinking of Feke, we might take chests. A seventeenth-century example, such as one from Ipswich, consists of a heavy frame with in-filling panels. The flat surfaces of the box are covered with thin, linear carving, of Mannerist derivation as interpreted by folk tradition, which can be related to such extremely rare seventeenth-century American paintings as that of Mrs. Elizabeth Freake and Baby Mary in the Worcester Art Museum. Here again an English Mannerist miniature tradition is at work, endowing the image with light coloring and intricate linear surface decoration. Later, the chests begin to become sculptural. They achieve legs and start to hoist themselves up. These early highboys all express compression downward onto the legs, which are multiplied and made to bulge with the weight they carry. Everything droops downward. Then, with the Queen Anne style, the whole chest leaps up. It

Chest, carved oak, 1660–1680, Ipswich, Massachusetts, attributed to William Searle (1634–1667) or Thomas Dennis (1638–1706). Height 29¾ inches. The Metropolitan Museum of Art, Gift of Mrs. Russell Sage, 1910 (10.125.685).

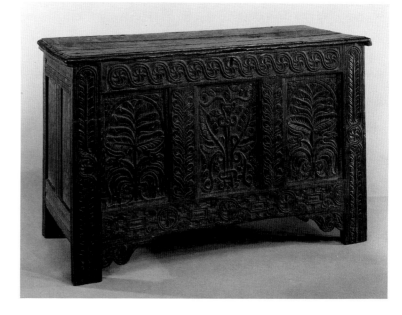

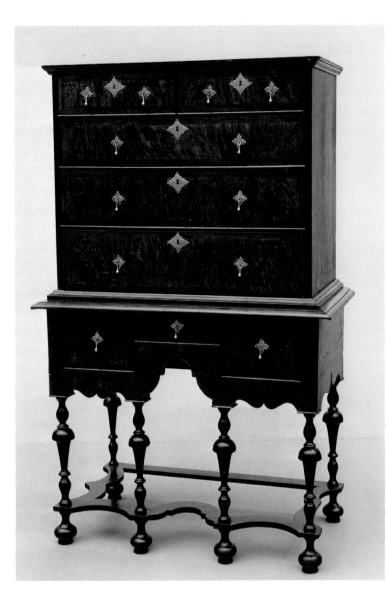

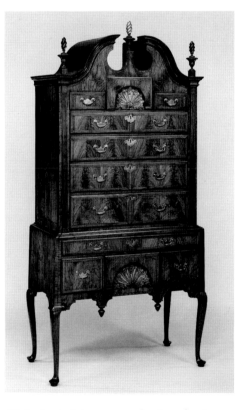

High chest of drawers, maple, walnut, with
maple veneer and walnut banding,
1700–1730, eastern Massachusetts.
Height 62½ inches. The Metropolitan
Museum of Art, Gift of Mrs. Screven
Lorillard, 1952 (52.195.2).

High chest of drawers, walnut, walnut
veneer on pine, white pine, 1730–1760,
Boston. Height 88¾ inches. The
Metropolitan Museum of Art, Gift of Mrs.
Russell Sage, 1909 (10.125.62).

stands on its legs like a person – a person by Feke. Like his people, it is frontal, elegantly dressed, with a wonderful sheen. Its brasses are like his pockets, its scrolls like his powdered wigs. And these highboys rapidly become wholly American. The English soon give over producing them at all, but the colonists love them and go right on making them all through the century, standing them up as shining gods in their modest rooms. So it all holds together: the Queen Anne style in painting, in furniture, and in silver as well.

A two-handled cup by Jacob Hurd has much the same lively body image that Feke's paintings and the chests possess, and these qualities are shared by the provincial Baroque architectural ornament with which Colonial houses of the eighteenth century came to be decorated. The doorway to Fowler's Tavern transfers its English models into wood and so endows them with that special American linearity. The relationships between painting and architec-

Two-handled cup, silver, 1725–1758, Boston, made by Jacob Hurd (1703–1758). The cup originally belonged to William Cave of Virginia and is engraved with arms of the Cave and Petit families. Height (with cover) 10⅜ inches. The Metropolitan Museum of Art, Morris K. Jesup Fund, 1952 (52.170 ab).

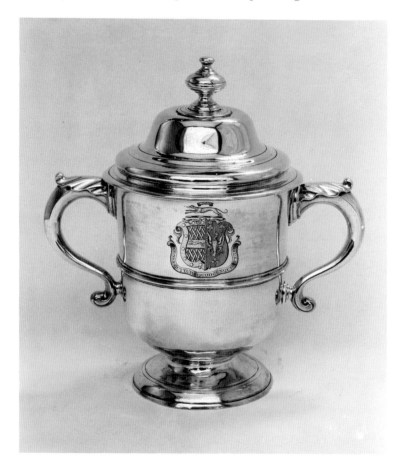

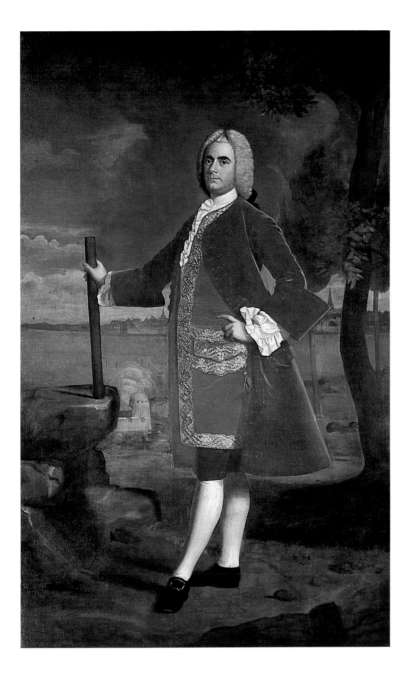

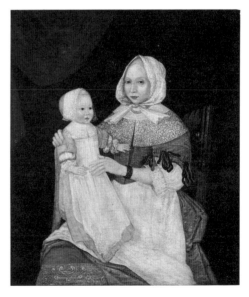

Portrait of Brigadier General Samuel Waldo, ca. 1748, by Robert Feke. Oil on canvas, 96¾ × 60¼ inches. Bowdoin College Museum of Art, Brunswick, Maine, Bequest of Mrs. Lucy Flucker Knox Thatcher.

Portrait of Mrs. Elizabeth Freake and Baby Mary, 1671–1674, by an unknown artist. Oil on canvas, 42½ × 36¾ inches. Worcester Art Museum, Worcester, Massachusetts, Gift of Mr. and Mrs. Albert W. Rice.

Doorway from Fowler's Tavern, painted
pine, ca. 1762, Westfield, Massachusetts.
The Metropolitan Museum of Art, Rogers
Fund, 1916 (16.147).

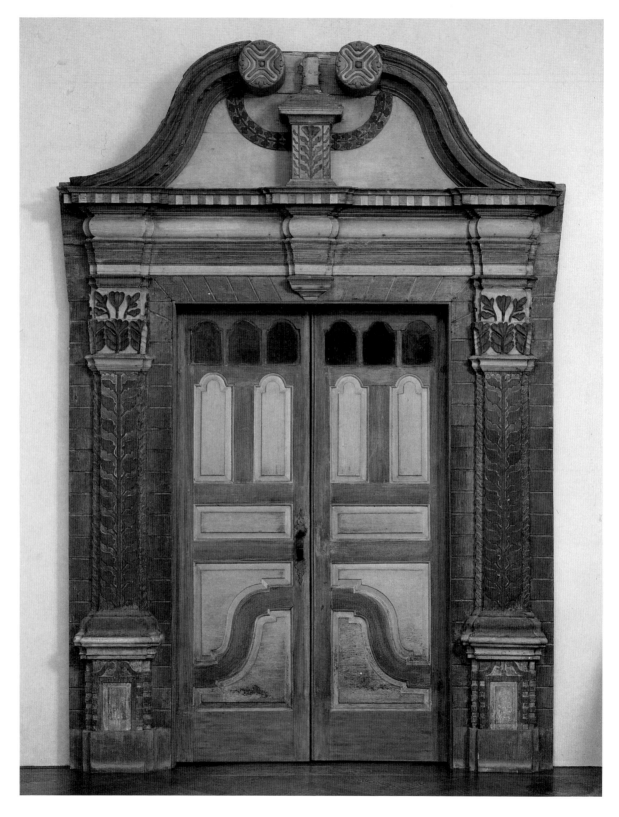

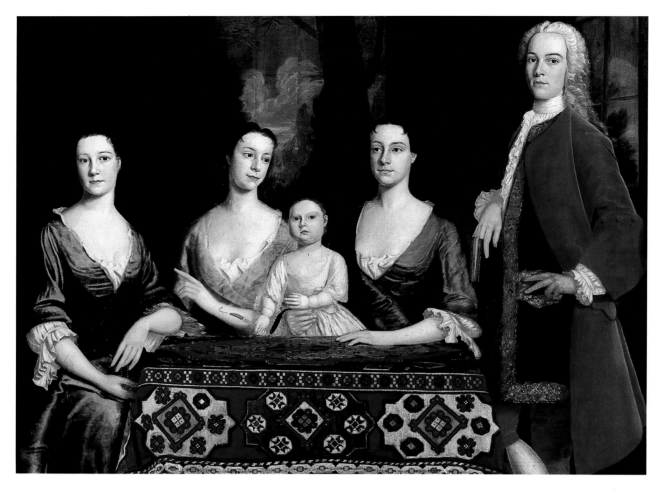

ture go even further than that. If we look at Feke's portrait of Isaac Royall and his family, in Cambridge, we can see how Feke, when he has a group of figures, presses them all forward to the surface plane of his canvas. Everything is flat and frontal and sharply patterned, but the painting also suggests strange depths. The master of the house is aristocratically worldly. But the women, whom he shows off here, like the bright Turkey rug over the table before them, as his possessions, have a peculiarly iconic cast. And the child they display is monstrous. Is this merely technical ineptitude, or is it some strange vision of the character of children (if not little adults, then . . . what?), like the one Copley was to apply to childhood in the decades to come?

But for this curious quality, the painting is exactly like the facade of Isaac Royall's new house, or that of the Gardner House in Portsmouth. They, too, are in the American Colonial style: flat in plane, linear, luminous, a craftsman's joy.

Isaac Royall and His Family, 1741, by Robert Feke. Oil on canvas, 56¼ × 77¾ inches. Harvard University Portrait Collection.

In this period of the midcentury, however, the furniture remains more wholly three-dimensional in concept than either the painting or the architecture. And around 1750 it tends to become even more so. The Newport block-front desks and chests with shells show that beautifully. They are made to look as if they have been carved out of a solid material, some thick mass of wood or even masonry. The blocks bring some of the sections forward, and the shells make us feel the depth. Most of all, where the shells are set back in the concave middle section, there is a little edge carved around them, so that they seem pressed into the wood and suggest considerable thickness. The whole comes to resemble an undulating Baroque church facade, of the kind that was never actually built in America. So the chests

Wentworth Gardner House, 1760, Portsmouth, New Hampshire. Photograph by Samuel Chamberlain.

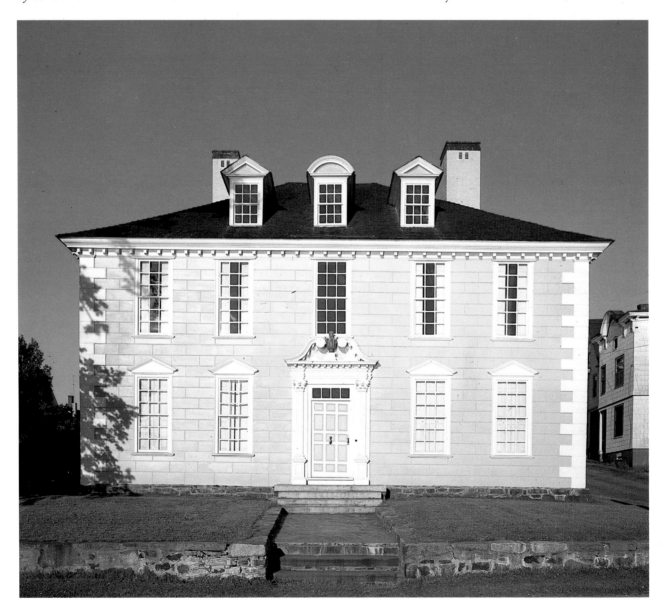

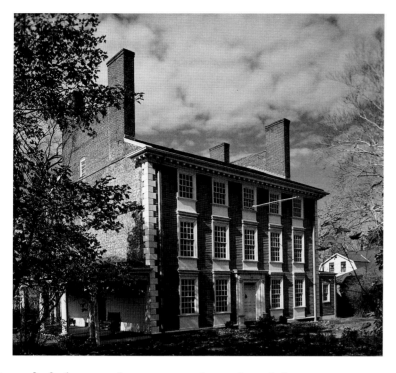

Isaac Royall House (east facade), as remodeled 1733–1737, Medford, Massachusetts. Photograph by Sandak.

and desks remain more sculptural and in a way more architectural than the buildings themselves.

All of this culminates in Chippendale furniture and Copley's painting. The former was named for Thomas Chippendale, whose book, *The Gentleman and Cabinet Maker's Director,* of 1753, assembled the elements (French, Gothic, and Chinese, he says) of the new style. It was never called Chippendale until 1876, during the early years of the Colonial Revival. Chippendale himself referred to it as modern taste, and it was, in fact, an adaptation of French Rococo, which the French had called *le goût moderne.*

In the Van Rensselaer hall we see the Chippendale style complete with its magnificent wallpaper, curvilinear and boldly scaled, the whole creating a generous spatial order inhabited by creaturelike tables and chairs. Chippendale is the most sculptural and the most active of all Colonial furniture. If we compare it with a Queen Anne chair, we find that the Chippendale chair is broader and lower. It crouches and spreads; English chairs rarely have that quality. Thomas Chippendale himself often designed chairs with straight rather than cabriole legs, and such were also built in America, but again, as was the case with Queen Anne, the cabriole leg is generally preferred, as are the ball-and-claw feet. The curve of the leg is Hogarth's "line of beauty," wholly alive, birdlike in its savage claw, clutching the ball on the bold Turkey carpets. Most ferocious of all is the splat,

Block-front desk and bookcase, mahogany, chestnut, white pine, 1760–1790, Newport, Rhode Island. Height 99½ inches. The Metropolitan Museum of Art, Rogers Fund, 1915 (15.21.2).

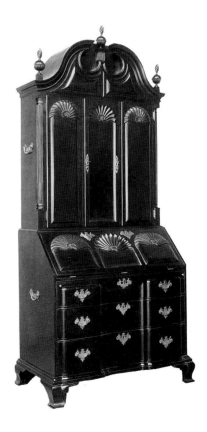

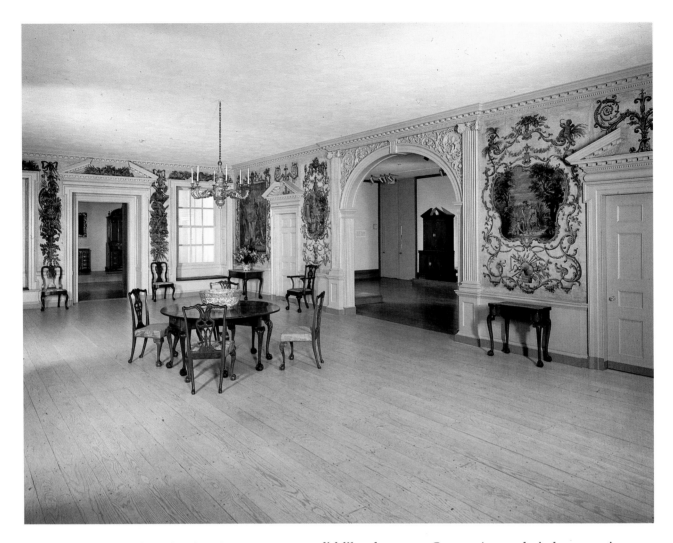

Entry hall with carved woodwork and painted English wallpaper, from the manor house, 1765–1769, built by Stephen Van Rensselaer II in Albany, New York. Approximate dimensions of the room 45 × 23 feet. Shown as installed in the American Wing. The Metropolitan Museum of Art. Woodwork: Gift of Mrs. William Van Rensselaer in memory of William Bayard Van Rensselaer, 1928 (28.143). Wallpaper: Gift of Dr. Howard Van Rensselaer, 1928 (28.224). Doors: Gift of Trustees of the Sigma Phi Society of Williams College, 1931 (31.95.1–.6).

not solid like that on a Queen Anne chair but opening out into demonic eyes above which, like terrible brows, the back flares up and out, exploding the profiles outward into space, in marked contrast to the gentle, rounded slope of the Queen Anne.

So Chippendale expands the sculptural aggressiveness of Colonial furniture. And Chippendale itself climaxes in the great high chests from Philadelphia, where the sculptural stance is complete. The whole presence is one of animal vitality and burgeoning power. It sprouts decoration, a building, a being, and a force of nature all at once, and the ultimate in household gods, clawed, high-headed, and horned.

What about painting in relation to this climactic expression of animal power? At first, most painters did not participate in it very much. For example, a portrait of Jeremiah Platt by John Mare, painted in the 1760s, is still in the tradition of Feke. The human subject of the painting

does not take up space as forcefully as the Chippendale chair he has his hand on; he is a flat plane against a flat background. It is in fact John Singleton Copley who first paints portraits that command three-dimensional space with the same Baroque self-confidence that Chippendale furniture possesses. In Copley's portrait of Joseph Sherburne, the upper body of the sitter turns in depth, swells in scale, and generally consumes the surface of the canvas. Here, for the first time, the Colonial painter achieves the complete technical virtuosity that the Colonial silversmith and cabinetmaker always enjoyed. The painter is now in total control of his medium; so he can create the convincing illusion of a great mass in space. Again, it is the confidence of material possession that brings the subject into being. He owns the chair and the dressing-gown, his symbols of leisure and success. And he is in every way the embodiment, in himself, as the furniture had been before him, of the virtuosity of the materialist craftsman culture.

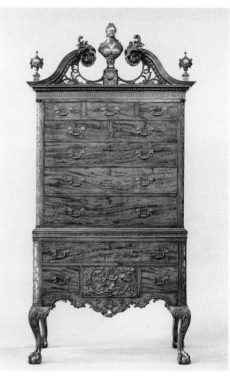

High chest of drawers, mahogany with secondary yellow pine, tulip poplar, and northern white cedar, 1762–1790, Philadelphia. Height 91¾ inches. The Metropolitan Museum of Art, John Stewart Kennedy Fund, 1918 (18.110.4).

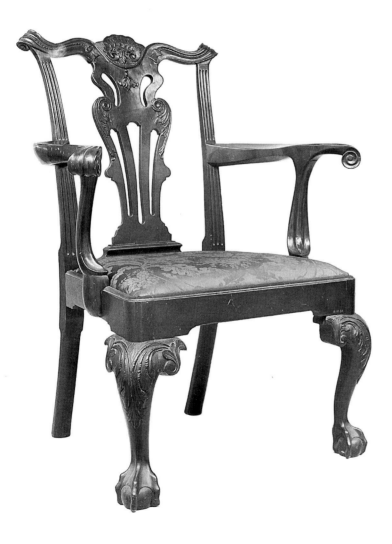

Armchair, cherry, 1750–1775, Pennsylvania or Maryland. Height 39¼ inches. The Metropolitan Museum of Art, Kennedy Fund, 1918 (18.110.54).

Portrait of Joseph Sherburne, ca. 1770, by John Singleton Copley (1738–1815). Oil on canvas, 50 × 40 inches. The Metropolitan Museum of Art, Amelia B. Lazarus Fund, 1923 (23.143).

It may also be an American quality that the women in paintings can be more formidable than the men. Standing close to Copley's portrait of Mrs. John Winthrop, we tend to feel that she is looking at us with profound disapproval and is about to say something so sardonic, so penetrating, and so merciless that we will never quite recover from it. The way she is painted, too, enhances that quality of a formidable material presence. She takes up her position jammed in between the easy chair behind her, with its shiny upholstery, and the wonderfully polished circular hardwood table before her. Her dress gleams with the sheen of silver, and her lace is like the fretwork of a silver basket of the same period. This has now become a positively American way of painting, a further development of the method of Feke. English painting at this time, for example the work of Sir Joshua Reynolds, makes use of fast, illusionistic brushstrokes to conjure up forms dramatically out of light. But Copley doesn't work that way. He works with hard lines, clear planes, and sculptural masses. He seems to carve and chase

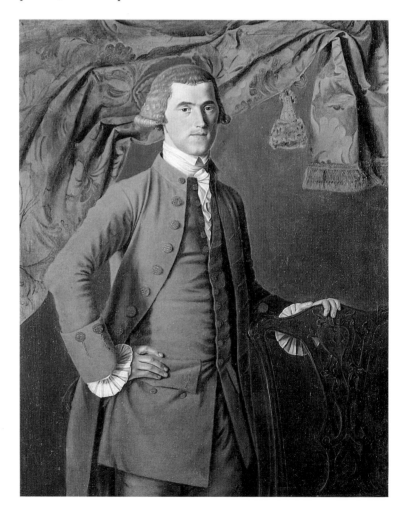

Portrait of Jeremiah Platt, 1767, by John Mare (1739–after 1795). Oil on canvas, 48½ × 38½ inches. The Metropolitan Museum of Art, Victor Wilbour Memorial Fund, 1955 (55.55).

Portrait of Mrs. John Winthrop, 1773, by John Singleton Copley. Oil on canvas, 35½ × 28¾ inches. The Metropolitan Museum of Art, Morris K. Jesup Fund, 1931 (31.109).

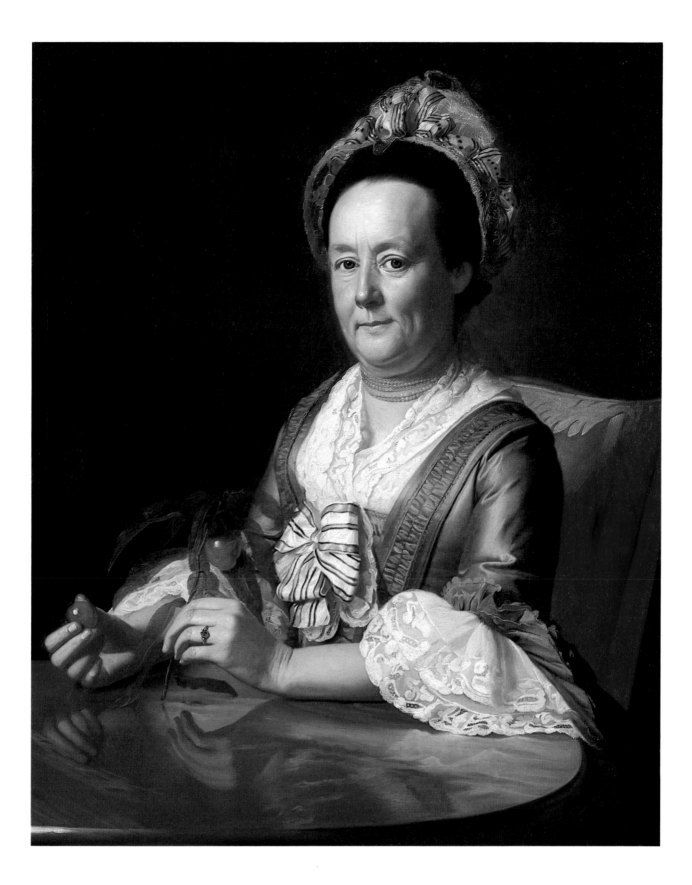

45

his material, and gives it, therefore, a somewhat more primitive, more sculptural, more immediate quality.

Mrs. Winthrop is at home in her environment and controls it; she is the expression of an utterly integrated culture. But it is integrated only at a certain level, that of material reality and material possessions. If we look at her face, so wry and full of wit, we find that it is unlike the faces painted by those much earlier European painters, such as Van Eyck and Memling, who painted somewhat the way Copley does. Their paintings capture a certain spiritual transparency in the sitter, and a kind of humane diffidence. Mrs. Winthrop is hard as nails. She demonstrates the limitations and the strength of the materialist tradition. Her reality is in fact "objective"; she is as wholly realized a sculptural being as her furniture itself.

It seems clear that Copley is concentrating on that quality and drawing his strength from it. For example, his *Paul Revere*, in Boston, is the image of a silversmith; he holds a precious silver object in one hand and his chin in the other. The chin and the teapot have the same solid, objective shape. It is as if Revere knows himself, or reality as a whole, by the hand, by the craftsman's knowing through the hand, through touch. His body, as it is seen here at the table, is truncated and shaped like a pot. He is as potlike as the teapot he holds, and the silvery sheen of his shirt reflects its shine. Copley is making a person like furniture, like silver, like the work of art through which he realizes himself.

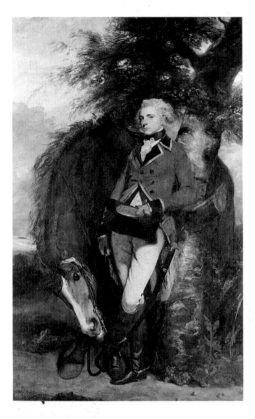

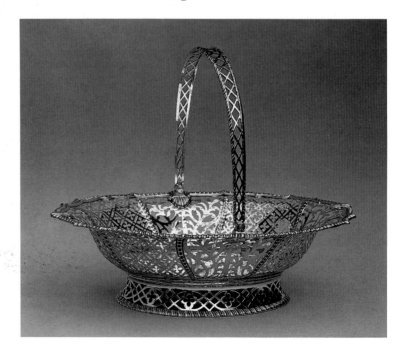

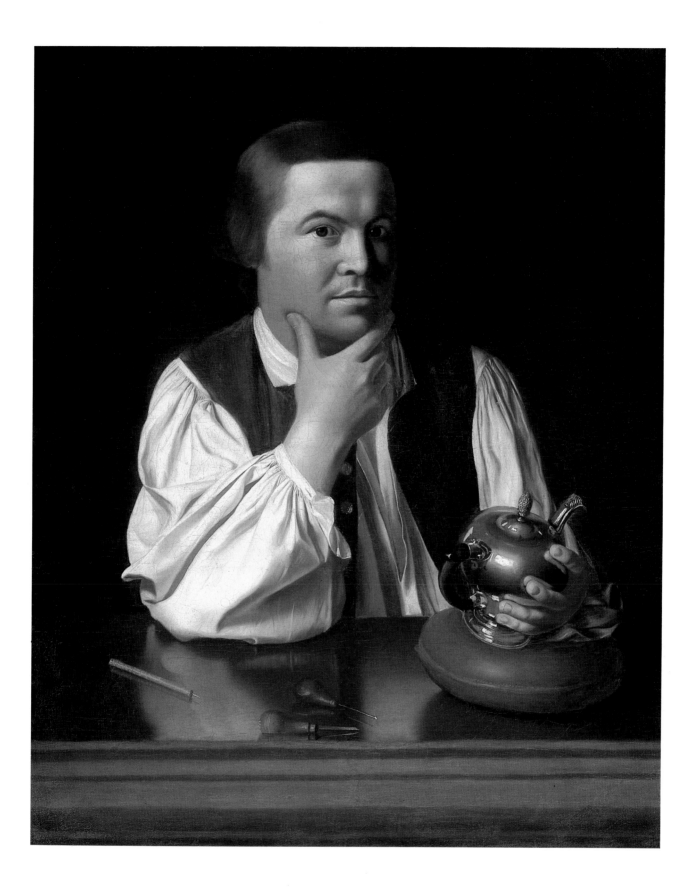

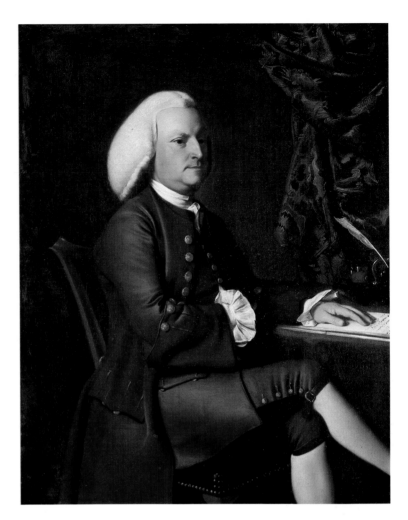

Portrait of Isaac Smith, 1769, by John Singleton Copley. Oil on canvas, 50⅛ × 40⅛ inches. Yale University Art Gallery, Gift of Maitland Fuller Griggs, B.A. 1896.

Copley can do fantastic things with those distortions, which I do believe are – *intentional* is a bad word to use about artists – let's say instinctive. We have anatomical studies by Copley which show that he had complete command of the proportions of the body, but in many of his paintings of men, such as that of Isaac Smith at Yale, he gives his sitters enormous heads, with great, white, merchants' faces. The bodies are very small and all pushed up together, as if the painter is really trying to make the person resemble or take his shape from the chair he is sitting in. At the same time, the bodies have an animal-like vitality that you can feel through the clothes, which are sharp and expensive and beautiful, in the tradition of Feke, but now also as smooth and hard as metal – the merchant's armor. Here they are like the sharkskin suits American businessmen used to wear in the 1940s. And if the man is bigheaded and scheming and restless, the woman, Mrs. Smith, is immovable. She is as solid as her easy chair, with a bunch of grapes in her lap, symbol of her fecundity.

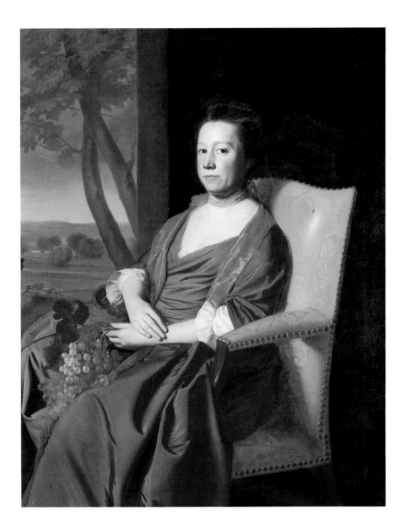

Portrait of Mrs. Isaac Smith, 1769, by John Singleton Copley. Oil on canvas, 50⅛ × 40⅛ inches. Yale University Art Gallery, Gift of Maitland Fuller Griggs, B.A. 1896.

One is reminded of D. H. Lawrence's assertion that Americans were always thinking, My God: my wife. She has certainly become the major household divinity here, and she keeps the others in order, including the chair she is sitting in. She and her husband also embody the two complementary images of the American Realist tradition, in architecture no less than in painting. For Mrs. Smith, relegated to the house, the suburban single-family dwellings of the nineteenth and twentieth centuries were to be built, one of the poles of American invention in architecture. For Mr. Smith, his mighty cranium crammed with business concerns, the center-city office buildings were to be shaped, leaping into American skyscraper form. Within and between those two kinds of buildings, the new American life was to be led.

Copley shows us its beginning, and he predicts the Revolution that would free it to grow. When he paints Samuel Adams, for example, he makes the arm that is pointing toward the document on the table so short that its very shortness causes us to extend it to the document. The

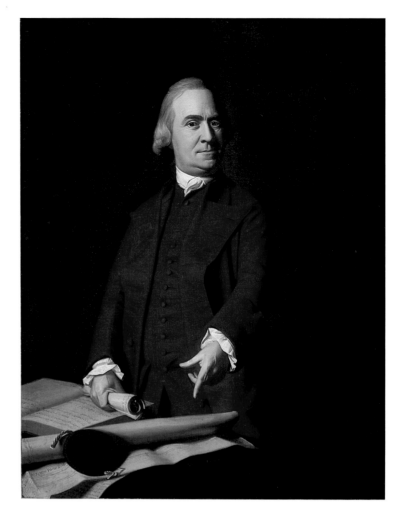

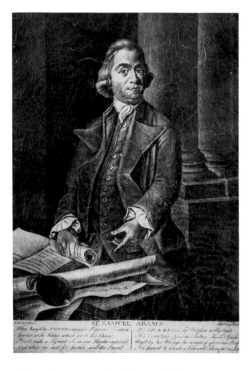

dynamism of the gesture is made more intense by the three-dimensional truncation of its beginning in the arm. Later, another artist copied this painting, and a print was made of the copy. The proportion of the arm was corrected, and the whole image died. But if we compare a Chippendale chair and its staring splat with Adams' face and eyes – indeed, with his whole figure – we see that a similar aggressiveness is built into each, and Copley catches it. Adams' will is bursting free.

Copley also paints John Hancock. He is holding a ledger, showing his handwriting. Soon he would be the first signer of the Declaration of Independence. He seems a slender, gentle man, with narrow, sloping shoulders, exactly like those of the Queen Anne chair in which he sits. But his writing is enormous, bold, exactly as it was to be when he signed the Declaration.

Colonial culture ended at the North Bridge in Concord, Massachusetts. Perhaps the story can be told one more time: on the morning of April 19, 1775, the British redcoats who

had marched out of Boston were massed on one side of the bridge. They had swept the Colonials aside with a single volley at Lexington. Now they were blooded and ready for a fight. The Colonial militia gathered on a hill on the other side of the stream. They marched down to the bridge. Isaac Davis, one of their commanders, said, "I don't have a man who's afraid to go." When the militia came to the bridge, the British fired another of their professional volleys. Men fell. The Colonials still hesitated (hardest of all is to fire a weapon in anger for the first time), until their commander, John Buttrick, cried, "Fire, fellow soldiers, for God's sake fire!" And with that volley the Colonials drove the British regulars from the field.

Emerson was to live in a house right next door. He would write:

By the rude bridge that arched the flood,
Their flags to April's breeze unfurled,
Here once the embattled farmers stood,
And fired the shot heard round the world.

Daniel Chester French's fine *Minute Man*, of 1875, now marks the place.

One remarkable thing from the art-historical point of view is that the man who warned the Colonials of the British raid was that archetypal Colonial craftsman, Paul Revere. We have seen his silver and his portrait by Copley. On the night of April 18, 1775, he arranged for a friend to hang

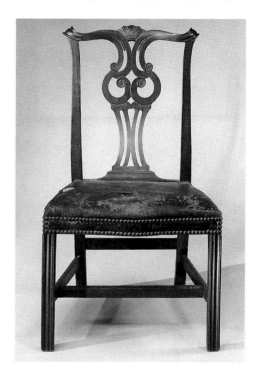

Side chair, mahogany, ca. 1770, Massachusetts. Height 38 inches. The Metropolitan Museum of Art, The Wunsch Foundation, Inc., gift and the Friends of the American Wing Fund, 1975 (1975.269).

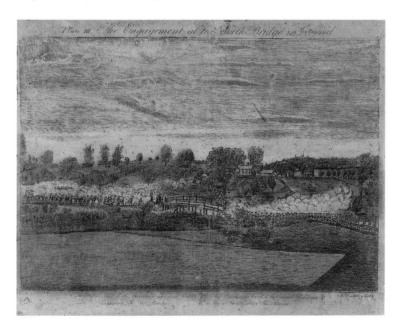

The Engagement at the North Bridge in Concord, *1775, New Haven, Connecticut, printed by Amos Doolittle (1754–1832) after drawings by Ralph Earl (1751–1801). Line engraving tinted with watercolor, 13½ × 18½ inches. Yale University Art Gallery, Gift of Mrs. Rufus W. Bunnell and Miss Cordelia Sterling in Memory of their brother, John Sterling (1920.25 C).*

lanterns in the tower of the Old North Church to signal the British advance: "One if by land and two if by sea." The church spire had been a typically English form since the time of Christopher Wren, and it was the single vertical element that rose out of American Colonial towns. As such, it shaped the seaward profiles of the great ports of Boston and New York, and eventually its pointing tower was to provide the basic concept upon which the incomparably American skyscrapers of New York were formed. In 1775, too, the spire played a key role in the drama of American independence.

With the Revolution, Colonial culture began to be transformed into that of the United States, but Copley himself had gone to England in 1774. He wanted to paint something

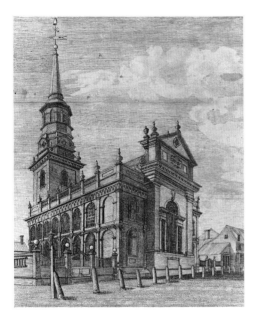

A South East View of Christ's Church, *engraving, 1787, published in* Columbian Magazine *in the same year. Better known as the Old North Church, it was built in 1723 to designs William Price, a print dealer in Boston, had derived from the work of the English architect Christopher Wren. The Henry Francis du Pont Winterthur Museum Libraries.*

other than portraits, which Colonial materialist culture would not permit him to do. Soon thereafter he painted a great proto-Romantic canvas, *Watson and the Shark,* which was later to have a decisive influence on Winslow Homer. Like Benjamin West, who had preceded him in England – and who might be said to have painted the first Neoclassic picture in his *Agrippina,* of 1768, in New Haven, and the first Realist one in his *Death of General Wolfe,* of 1770, in Ottawa – Copley was able to leap ahead of English fashion, perhaps, again like West, because of his previous distance from its center. Right away he learned, at the very least, to paint like Reynolds and the others. And he learned how to do it very well, as his portrait of Midshipman Augustus Brine clearly shows. It is very different from his American portraits.

A South East View of y Great Town of Boston in New England in America, *engraving, ca. 1722, by William Burgis (active in America 1716–1731). The New-York Historical Society.*

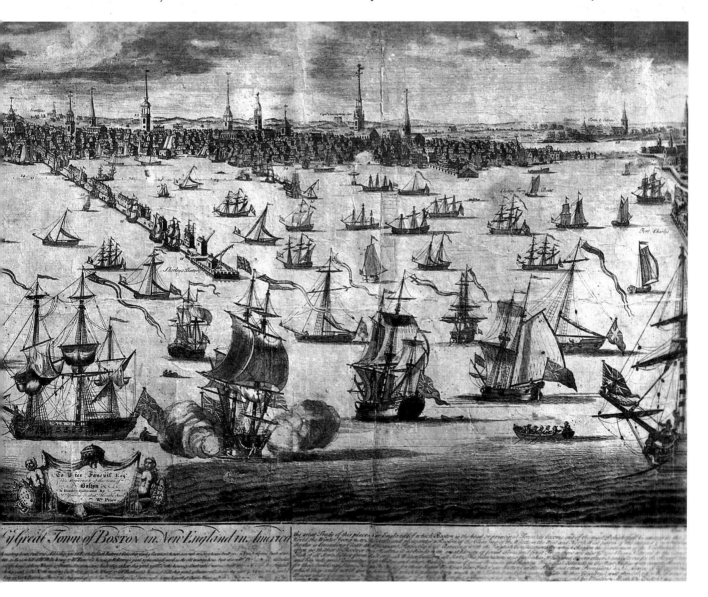

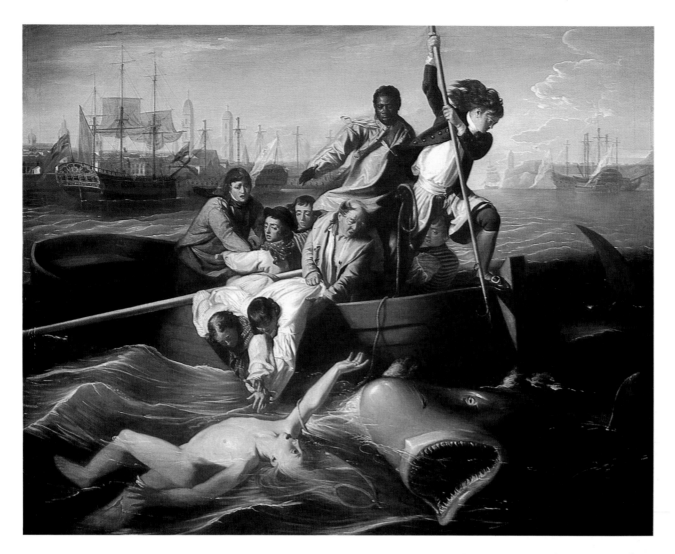

Watson and the Shark, *1778, by John Singleton Copley. Oil on canvas, 72 × 90¼ inches. The Museum of Fine Arts, Boston, Gift of Mrs. George von Lengerke Meyer.*

There is no distortion at all in it, but rather a complete Baroque respect for human anatomy. The subject himself is very un-American, a sprig of the English aristocracy: twelve years old, a midshipman, no doubt ordering around people three times older than himself in a high, clear voice, a stormy sky behind him. Copley had certainly learned how to paint in the English aristocratic tradition.

But right next to the young midshipman in the Metropolitan Museum hangs a portrait that Copley had painted eleven years before in America and which makes us think that perhaps he really did lose something when he went to England, perhaps a degree of intensity, perhaps even that

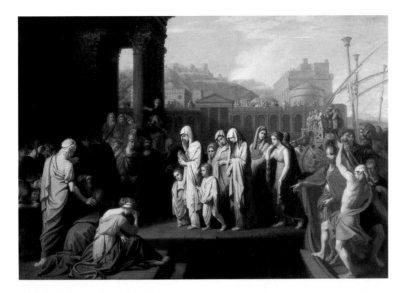

Agrippina Landing at Brundisium with
the Ashes of Germanicus, *1768, by
Benjamin West (1738–1820). Oil on
canvas, 64½ × 94½ inches. Yale
University Art Gallery, Gift of Louis M.
Rabinowitz.*

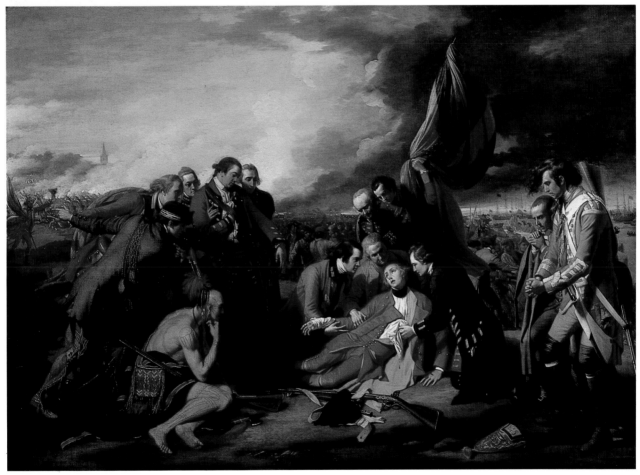

Death of General Wolfe, *1770, by
Benjamin West. Oil on canvas, 60½ ×
84¼ inches. National Gallery of Canada,
Ottawa, Gift of the Duke of Westminster.*

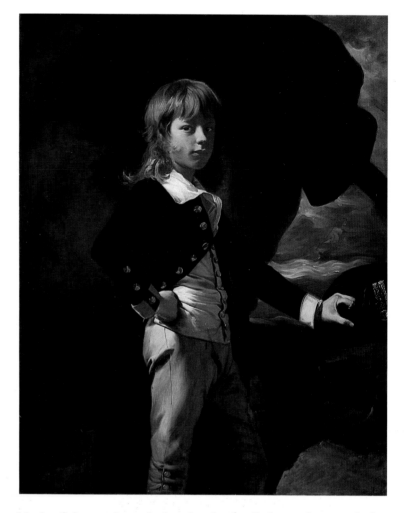

kind of inner knowledge he had of the culture of the
Colonies, of which he had been a part, as opposed to the
culture of England, in which, in a way, he was only a visitor.
It is a portrait of young Daniel Crommelin Verplanck, not a
midshipman already out in public life but a child in the
private world of the middle class. (He is Colonial upper-
class, in fact, but in comparison with an English contempo-
rary he has to be called middle.) He is here with a squirrel,
an animal Copley liked to paint with children. Years earlier
he had painted a portrait of young Henry Pelham with a
squirrel and sent it off to West in England to be judged ("A
little hardness in the drawing . . . ," said Reynolds). There,
Copley had painted the squirrel's eye head-on but the boy's
from the side, so that our own eyes penetrate the latter and
see into a human consciousness. But in this case he paints the
squirrel's eye and the boy's eye almost the same. They are
equally secret and uncommunicative. The child's body, too,
resembles the body of the squirrel, small and bony and all
closed in upon itself. But the head is big and the hair

crew-cut in a rather prophetically American manner, quite the opposite of the long hair on the other side of the Atlantic. And there is something in this relationship of child and animal that is disquieting and a little monstrous. It communicates a sense of some secret life in childhood. We are reminded of Feke. Perhaps most significantly (and this would be very important in the century to come), Copley is perceiving the inwardness of the middle-class child who is embedded for years in the family romance rather than in the actions of public life. It reminds one somewhat of Goya, even though Copley's technique is quite different. I know of no painter of the period other than Goya who can be as disturbing as Copley is here.

It is unfortunate that Copley could not have painted our earliest Presidents. In that case we doubtless would have known something about them that we don't know now. But he never returned to America; he died in England, disappointed and old before his time. All the other most hopeful American painters went to England, too; most of them

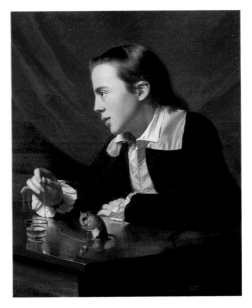

Boy with a Squirrel (*portrait of Henry Pelham*), *ca. 1765, by John Singleton Copley. Oil on canvas, 30¼ × 25 inches. The Museum of Fine Arts, Boston, Anonymous Gift.*

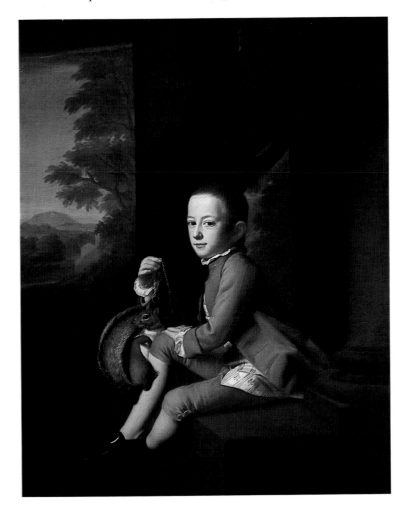

Portrait of Daniel Crommelin Verplanck, 1771, by John Singleton Copley. Oil on canvas, 49½ × 40 inches. The Metropolitan Museum of Art, Gift of Bayard Verplanck, 1949 (49.12).

studied with Benjamin West and became, like him, advanced European painters. The special Colonial realism for the most part disappeared. But there were exceptions. Ralph Earl, for example – who, unlike Copley and West, was an obdurate Tory, and went to England during the Revolution and studied and painted there for a long time – eventually came back to America and painted in a way that resembled the old tradition and was indeed a good deal like Feke's work. Earl has the preoccupation with pattern and frontal plane that Feke had, and he shares Feke's generosity. Manliness and good feeling come out of him; his people are big and generous, simple and powerful.

Portrait of Mrs. Noah Smith and her children, 1798, by Ralph Earl. Oil on canvas, 64 × 85¾ inches. The Metropolitan Museum of Art, Gift of Edgar William and Bernice Chrysler Garbisch, 1964 (64.309).

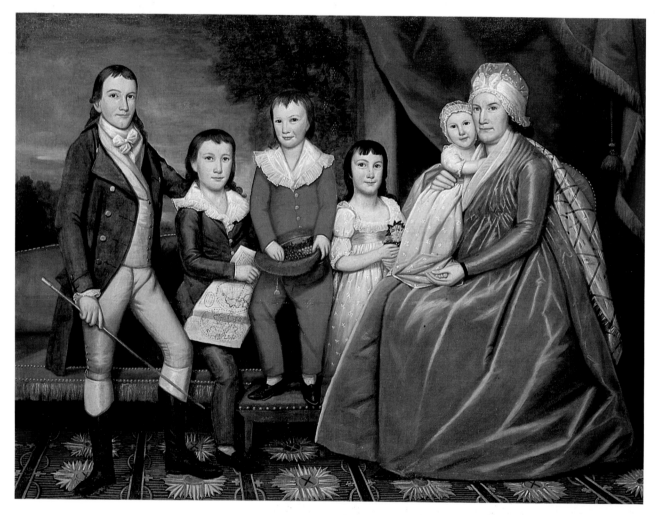

Earl's work also resembles, or perhaps partly inspires, a good deal of late-eighteenth- and early-nineteenth-century folk painting, where the flat linear patterns in the tradition of Feke are flattened and sharpened even further, relating to the mainstream of tradition in painting as a country side chair of this period relates to Chippendale.

58

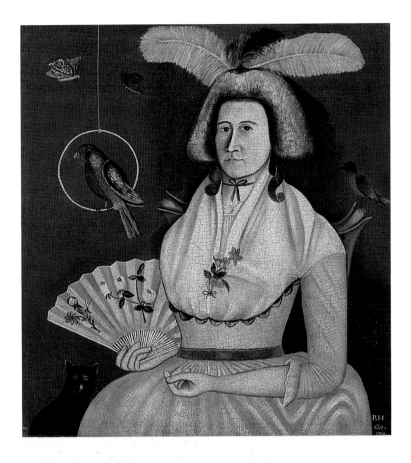

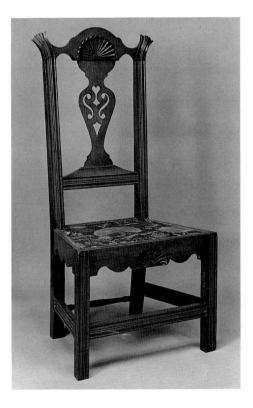

Earl also paints the new, lanky American. It is too bad that he never painted Thomas Jefferson, who was built that way. Earl's *Elijah Boardman* reminds us of Feke's *Tench Francis*, but it has a new kind of sweetness, a new naïveté, a kind of openness. There is of course a long tradition of full-length portraits that goes back to Velasquez and Van Dyck, but Earl's is an Americanization of it, and again, the subject is a merchant with his goods.

Next to *Elijah Boardman* in the Metropolitan hangs a portrait by Earl of his subject's house. Earl painted quite a few such scenes; they continue the Colonial tradition of painting what one owns, but they open it out to include the dwelling, the grounds, the whole man-made environment of villages and fields. They become beautiful documents of the kind of architecture that was common over most of America at the time. How quiet and stable it seems here. And how subordinate to the buildings the road is. It is the preindustrial village, gentle and ordered in agrarian peace just before the whole world changed. It is the materialist craftsman culture still, but now it is a little more open, and it wants very much to take on a rather more heroic stance in celebrating the new America.

Portrait of Elijah Boardman, 1789, by Ralph Earl. Oil on canvas, 83 × 51 inches. The Metropolitan Museum of Art, Bequest of Susan W. Tyler, 1979 (1979.395).

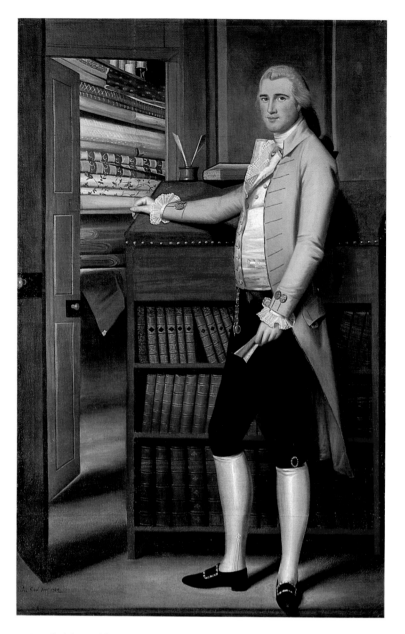

Portrait of Colonel Marinus Willett, 1784–1795, by Ralph Earl. Oil on canvas, 91¼ × 56 inches. The Metropolitan Museum of Art, Bequest of George Willett Van Nest, 1917 (17.87.1).

Earl himself, unlike Copley, is painting the heroes of the Revolution *after* the Revolution, when their heroism has been fulfilled. *Marinus Willett* is another example of the full-length portrait of the English military type, but now gangling and Americanized. These full-length portraits do indeed have a heroic verticality, like the silver Paul Revere himself was making after the Revolution. His forms, too, tend to become quite vertical, with a heroic lift. The creamer and sugar bowl by him, made between 1770 and 1818, seem to reflect a new, rather idealistic aspiration, different from the Colonial materialism that had preceded it.

Creamer and sugar bowl, silver, ca. 1770–1818, Boston, made by Paul Revere (1735–1818). Heights: creamer, 5⅞ inches; sugar bowl (with top), 9¼ inches. The Metropolitan Museum of Art, Clearwater Collection, Bequest of A. T. Clearwater, 1933 (33.120.546–7).

Houses Fronting on New Milford Green, ca. 1796, by Ralph Earl. Oil on canvas, approx. 36 × 60 inches. Collection of Mrs. Cornelia Boardman Service, courtesy of The Metropolitan Museum of Art.

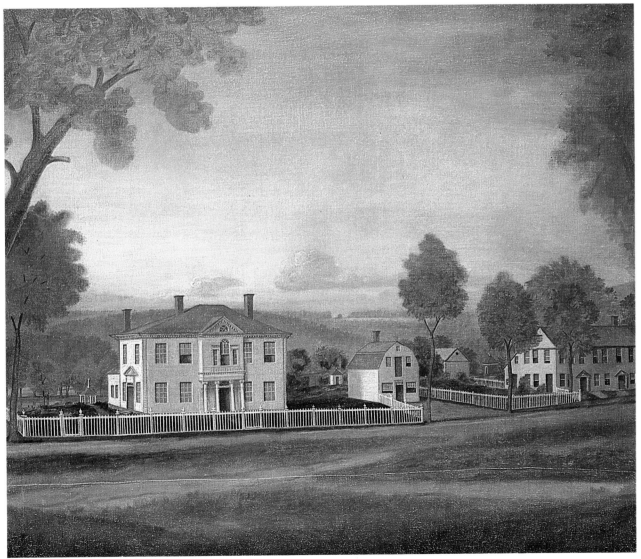

The fundamental icon is Washington. He is himself the symbol of liberty and is seen as such throughout the world: the perfect republican hero of Enlightenment thought. But in America he soon becomes semidivine, filling some deep need for assurance the Revolution had opened up. He is the new Herakles; he cleanses the land so the society of the United States can begin. His portraits show us that transformation from man to demigod taking place, and there is a close connection between the way he is depicted and the general development of a whole post-Colonial style in architecture and furniture as well.

The full-length battle portrait of Washington by Charles Willson Peale is an early one, and somewhat reminds us of Earl's work, though it lacks Earl's sweetness. Peale is clearly manipulating the figure of Washington to create a sense of height and dominance. It is a very tough Washington he gives us here, a big, full-bellied general with plenty of physical brutality in him. He is a cunning, formidable man, a fighter, with a small head and dark, wily eyes; he does not seem, other than in the elongation of his body and the

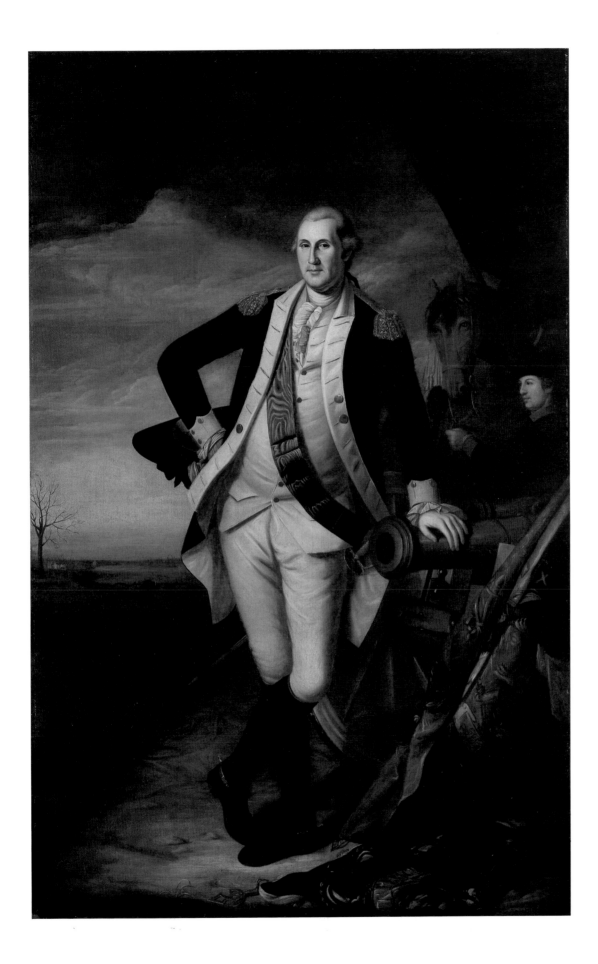

Desk and bookcase, mahogany, satinwood and maple veneers and inlays, eglomise panels, cedar, and poplar, ca. 1811, New York. Height 91 inches. Based on Sister's Cylinder Bookcase, *plate 38 in Thomas Sheraton's* The Cabinet Dictionary *(London, 1803). The Metropolitan Museum of Art, Gift of Mrs. Russell Sage and various other donors, by exchange, 1969 (69.203).*

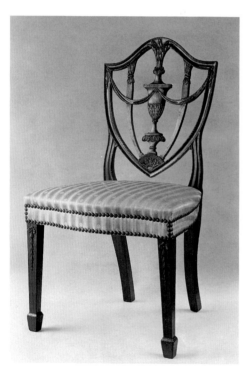

Side chair (one of a pair), mahogany, 1790–1799, Salem, Massachusetts. Height 39 inches. The Metropolitan Museum of Art, Lee Fund, 1937 (37.81.1).

rather doglike devotion of his horse, to be particularly idealized. But other painters soon idealized him to the point of etherealization. When we get to Gilbert Stuart's famous portrait, we find Washington already turning saintly, half free of the flesh, with eyes that have turned a soft sky-blue. And we see him through the elegant glaze of the English portrait tradition, a film of paint that develops the movement of color through the cheeks and under the surface of the skin, showing the blue haze of the shaved chin and upper lip. All of it is very elegant and very thin compared to Copley's linear, sculptural modeling.

The same kind of thing happens in furniture. During the post-Colonial period it becomes an affair of light, elegant surfaces, whose veneers, inlays, and mirrors play with light on the surface, like Stuart's glazes. Whenever possible, the whole piece is made to look delicate, almost without mass. It dematerializes. The joints look as if they can hardly hold it up. It is no longer based on the Colonial tradition, wherein the craftsman's structural connections create a sculptural body. Nor is it any longer Baroque. It is based on new premises that a Hepplewhite chair, for example, can show very well. The chair's pointy little feet hardly touch the ground, and its legs seem to have no structural connection with the seat. But in fact the front legs are spread wide apart in order to focus our attention on the back, where the sides lift up the heraldic shield, in the center of which is the classic urn and the delicate swags draped gently back and hanging down along the sides. The point is not that it isn't beautifully made – it is – but that it is not based primarily upon a craftsman's intention or a Baroque body image. It is conceived fundamentally not as an active physical object but as an emblematic one. Its purpose now is to present the new classical symbol, the symbol of the new republic.

Much the same development occurs in architecture. Federal architecture, so called, tends to become stretched. It gets thinner, higher, like the Pingree House in Salem. The Colonial forms are blown up to serve new republican functions. Bulfinch's State House in Boston is a fine example, with its thin columns and its high, light dome – the dome that in Europe had belonged to churches, and that now in America is turned into the symbol of public building, of government. This is one of the first of the temples of democracy, glowing golden in the sun, weightless, a balloon of air lifting its little cupola out into space. The gold takes

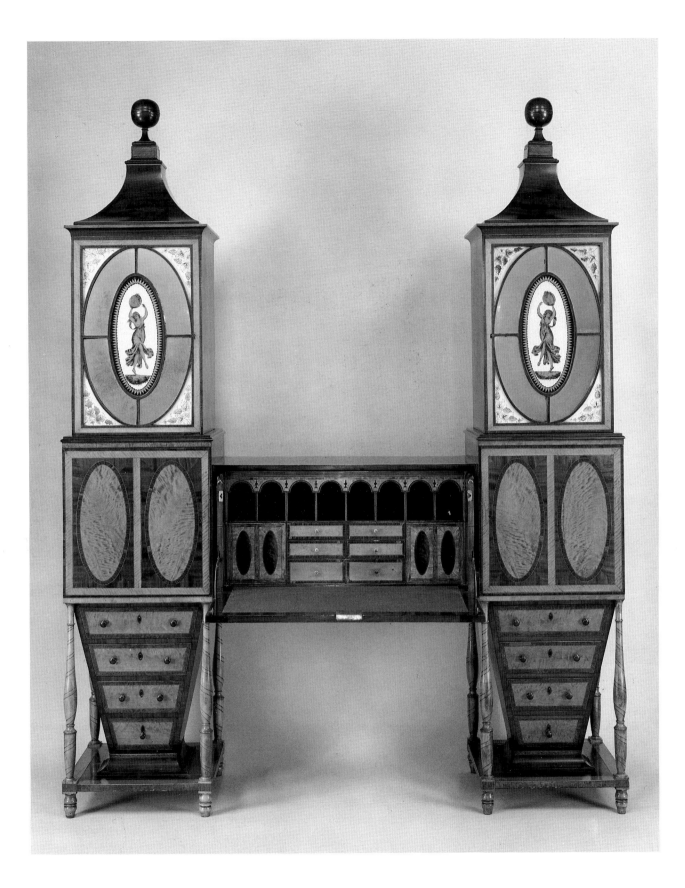

65

Massachusetts State House, 1795–1798,
Boston, designed by Charles Bulfinch
(1763–1844). Photograph by Sandak.

Portrait of George Washington,
1795–1823, by Rembrandt Peale
(1778–1860). Oil on canvas, 36 × 29
inches. The Metropolitan Museum of Art,
Bequest of Charles Allen Munn, 1924
(24.109.86).

even more of the weight off and makes us feel the dome's miraculous thinness and, again, its glaze.

The next phase of portraits of Washington – and we might say the climactic phase – is one in which he is invested with a new Romantic drama and violence. In the portrait of him by Rembrandt Peale, he is set behind a masonry wall of heroic, classicizing scale. He is a classical bust, like that of Andrew Jackson by Hiram Powers, where the ideal conception in blazing white marble is in tension, as it had been in Rome itself, with the tradition of realism in form. Peale's Washington is swelling with the desire to be monumental. He is made superhuman, even to the frame – all cannons, swags, and flags, with the American eagle, the bird of Zeus, rising over all.

The eagle presides over the furniture of the full Classical Revival as well. It finds its superhuman scale in grand

Pingree House, 1804, Salem, Massachusetts, designed by Samuel McIntire (1757–1811) for Captain John Gardner. Photograph by Sandak.

Andalusia, north of Philadelphia, begun 1797–1798, enlarged by the architects Benjamin Henry Latrobe (1764–1820), between 1806 and 1808, and Thomas U. Walter (1804–1887), between 1834 and 1836. Photograph by Wayne Andrews.

favor of heavy mass, classical order, and the marvelous tread of its Doric colonnades. The Roman forms of the Classic Revival now tend to give way to Greek, as to something simpler, purer, more ideal.

The Greek Doric column soon became a major symbol of the new nationalism, the new democracy. Heavy and solemn, it was critically different from most Colonial forms, although, in architecture at least, many of the latter had shared its classical simplicity and clear order. It was an image of solidity and permanence and, most of all, of Greek democracy itself. We can see Doric columns in their full grandeur in New York's Old Customs House, built on the site of the building where George Washington took his oath as the first President of the United States.

It was Thomas Jefferson who best understood the character of classical architecture and who most valued it as a symbol of the democratic virtues he hoped the United States would come to exemplify. His own state capitol in Richmond predates Bulfinch's in Boston by several years, while his house, Monticello, and his campus for the University of Virginia embody the most eloquent dialogue ever sustained

in America between Colonial vernacular traditions and the new classical ideal. And, most significantly, it was because of Jefferson that the capital city of the United States was conceived as the special kind of symbolic structure that it has come to be.

Jefferson was the greatest classicist in the history of the United States, really its first classicist. He was indeed the republic's first artist on a grand scale, attempting no less than to transform it from a Colonial culture into a national one. He strove to use architecture to help create a whole new environment for that nation and to endow it with a new symbolic stance, one that would encourage a truly international culture based upon learning and a new generosity of mind. How disappointed he would be in us now, I think, but that is hardly the point here. A contemporary architect such as Robert Venturi understands Jefferson very well. In one of his projects, Venturi shows us a classical portico, enormous in scale in relation to a little house. Its huge entablature is wrapped around the tiny shack behind it, but, alas, windows must be punched through it under the eaves, so giving us the ideal and the real in a delightful dialogue. Venturi has learned it from Jefferson. At Monticello, Jefferson will have, no matter what, the classical frontispiece and the dome, but the building pushes out and tries to escape from their dominance. So Jefferson ruthlessly binds it with the vast entablature. But the pressures are too great: as at LeVau's Vaux-le-Vicomte, windows pop out in it once they are around the corner and out of sight. There is nothing more

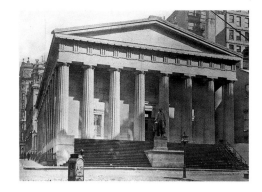

Old Customs House (now called Sub-Treasury Building), 1834–1842, New York, designed by the architectural firm of Town and Davis (active 1829–1844). Yale University Photograph and Slide Collection.

Virginia State Capitol, 1789, Richmond, designed by Thomas Jefferson (1743–1826) and the French Neoclassical architect Charles-Louis Clérisseau (1721–1820). Photograph by Wayne Andrews.

Eclectic House Project, 1977, by Robert Venturi (b. 1925) of Venturi, Rauch and Scott Brown, described by the architect as

> One of a series of imaginary houses, with a program for a minimal vacation bungalow, living-dining, bedroom and bath. It is a theoretical exercise on the idea of the decorated front and the ordinary or "Mary-Anne" behind. Style and function are juxtaposed rather than distorted; the styles are applied to the front, while plan, section, and the other three elevations remain constant.

Illustrations courtesy of Venturi, Rauch and Scott Brown.

incorrect, more licentious, even, than windows in entablatures – nothing more stubborn, willful, subversive, determined. The adjectives multiply, and they are all human ones. This occurs because Jefferson wants everything: the symbol and the substance, too. Palladio's symmetry cannot satisfy him. But he wants Palladio's big scale, or an even bigger scale if he can get it, and most of all he wants the classical orders. He wants them precisely for rhetorical reasons, so that he can say grand and learned things with them that are not possible with the Colonial vernacular, even that of mansions such as Westover. It is at first a spare and rather simple language that Jefferson wants. At Monticello it is based on Palladio's Doric, like Harrison's in the Redwood Library at Newport. Out of that order the rest of the house tries to struggle: Jefferson masks two floors as one to increase the scale, and so the intermediate windows pop out like naughty boys, while on the far side, away from the dome, they march shamelessly along in plain view. On this, the entrance side, as on the others, the pediment receives its half-round window. What a future in American architecture this anomaly, a misprision of Palladio's thermal windows, was to enjoy, culminating in a central cultural exchange between Bruce Price, Frank Lloyd Wright, and Venturi himself.

The general organization of Monticello, though, would lead us to believe that Jefferson had studied the principles of classical planning rather closely, especially as it was practiced in France and in particular at Vaux. As at Vaux, the entrance of Monticello is recessed to pull us in, and the garden side protruded to push us out, while, again as at Vaux, there is a dome over – though at Monticello not integral with – the major garden room. Inside, the simple but relatively enormous classical details enforce that movement from the entrance to the garden side. A big entablature with monumental dentils draws us forward on axis through the entrance hall toward the steep, climactic pediment over the garden door. Beyond that, the white columns of the portico catch our eye and lead it to the flattened top of the hill, where Jefferson's asymmetrical English garden was laid out. But the whole movement has a grander dimension, also suggestive of France but with ancient Mediterranean overtones, in that the dome of the house is the culmination of the dome of the little mountain from which the place gets its name. As in Hadrian's villa, for example, crypto-portici are

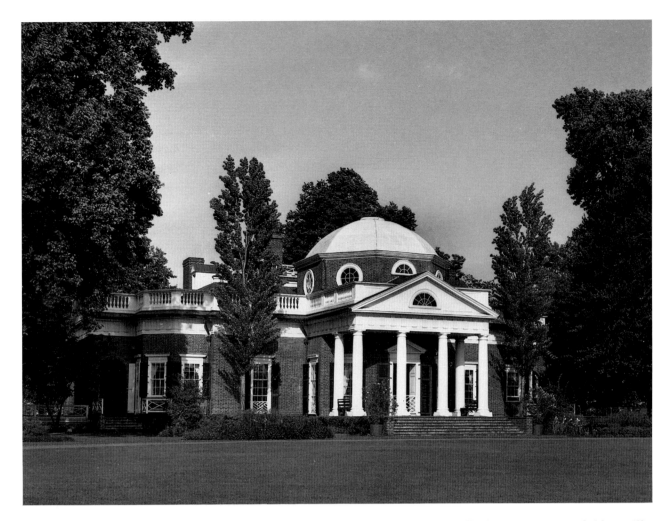

Monticello, begun in 1770, Charlottesville, Virginia, designed by Thomas Jefferson. This garden facade, 1793–1809. Photograph by Wayne Andrews.

Monticello, side facade. Photograph by Philip Gendreau.

employed. They stretch out underground from the main body of the house to embrace the top of the hill, much as elements of Wright's Taliesin were later to do in their own asymmetrical way. So site and building are one. If we are there at night, by candlelight if we are lucky, we can feel the true grandeur and the loneliness of the conception. Here is the ultimate darkness and isolation of the frontier, where this heroic, visionary artist rode his round mountain high above the plain, with the crests of the Blue Ridge looming before him. In that stance, Jefferson evokes the whole structure of Virginia, which he himself describes so exactly in his Notes on the state. He puts himself in its center, on the pedestal of the Piedmont, far out west under the mountains, with the coastal plain sloping eastward from him toward the sea. And down below him, its lights once the major feature of the dark plain, lies his other great work, the University of Virginia, of which he named himself the father. It was the "academical village" of which he was so proud and upon

Lithograph view of the University of Virginia, Charlottesville, built in 1822–1826, designed by Thomas Jefferson. This print of 1856 by F. Sachse and Co. shows Robert Mills' "Annex" of 1851–1853 behind Jefferson's Rotunda, and, on a distant hill, Monticello. Photograph by Sandak.

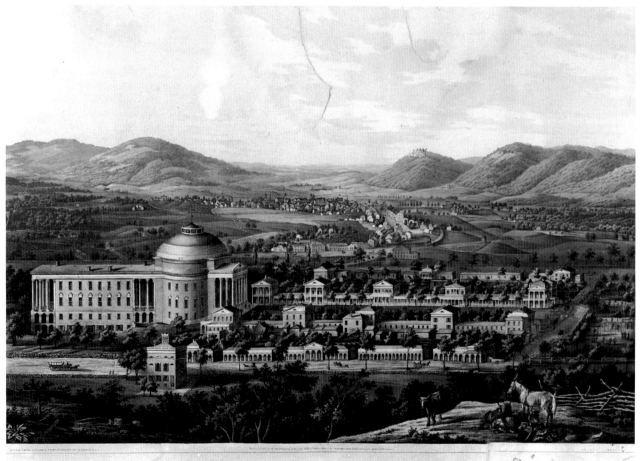

VIEW OF THE UNIVERSITY OF VIRGINIA
CHARLOTTESVILLE & MONTICELLO

whose like he based his hopes for the future distinction of the republic.

Here the plan is purely French; the ultimate model was Marly, built by Jules Hardouin Mansart for Louis XIV in 1679 and visited by Jefferson in 1786. Between Marly and the University, however, several Beaux-Arts *projets* of the Napoleonic period intervened, and one of them was for an institution for the education of a king. This, too, might well have aroused and even piqued Jefferson, but Marly remains the basic source of the image, with the king's house at the head of the axis, like the sun, and the twelve pavilions for the courtiers, like the months, aligned before it, six down each side. Jefferson has only ten pavilions, five on each side, and he connects them with colonnades. At first he seems to project no building at the end. Finally he puts the library there and domes it to culminate the whole grand composition. His forms have become more modern, thus more Neoclassical, than those of Marly. A print of 1856 shows them standing sharply geometrical and starkly juxtaposed like the projects of Ledoux, whose work Jefferson most wholly admired. The engraving after Pugin's drawing of Ledoux's Customs Houses at the Étoile has a similar feeling; it is a harsh and rational architecture, its classicism brutal and stripped.

But the University of Virginia does not produce that feeling at all. It is indeed academic; it is attempting to teach a language. Jefferson is perfectly clear about that objective. In his *Report to the Commissioners of the University of Virginia,* he writes:

> *I would strongly recommend to their consideration, instead of one immense building, to have a small one for every professorship, arranged at proper distances around a square, to admit extension, connected by a piazza, so that they may go dry from one school to another. This village form is preferable to a single great building for many reasons, particularly on account of fire, health, economy, peace and quiet . . . more may be said hereafter on the opportunity these small buildings will afford, of exhibiting models in architecture of the purest forms of Antiquity, furnishing to the student examples of the precepts he will be taught in that art. . . .*
>
> *[I]t should be in fact, an academical village. . . .*

Pedagogically speaking, Jefferson will teach "the purest forms of Antiquity" just as, in his *Report to the Commissioners,* he will begin the curriculum with "Languages, ancient," followed by "Languages, modern," followed in turn by "Mathematics, pure." He puts architecture under that third heading, but he relegates "Belles Lettres and the fine arts" to his tenth category, placing them last of all in it, as if they were afterthoughts. But architecture to him is both "Language, ancient" and "Language, modern," and he builds that distinction into his plan. The distance between the pavilions on each side widens as the plan stretches southward, and the last four pavilions to the south, where the intervals are greatest, all have modern features which the others lack. Pavilion VII, its form at least suggestive of Thornton, has piers instead of columns on the first floor, and a colonnade above. This is an eighteenth-century type,

like Somerset House in London, from which Harrison's
Brick Market in Newport had derived, as well as Bulfinch's
Boston State House. Across the lawn, Pavilion VIII, with the
advances and recessions of its facade, takes its inspiration
from Latrobe, and Jefferson called it Latrobe's Lodge
Front. But next to Pavilion VII stands Pavilion IX, the most
modern of all and directly inspired by Ledoux's Hotel
Guimard, though apparently with some contribution from
Latrobe as well. Alone among the pavilions, the colonnade
here rises only one story, screening the apsidal niche of the
entrance wall. There the columns are Ionic; their volutes
stand out in profile before the modeled light on the curved
plane behind them. The chunky block of the pavilion as a
whole terminates the whole series, and its position at the end
sanctions its one-story colonnade and its lack of a pediment.
Across from it, however, Pavilion x has a colossal order,

Pavilion IX, West Lawn, University of Virginia. Photograph by Robert A. M. Stern.

Pavilion X, University of Virginia. Photograph by Wayne Andrews.

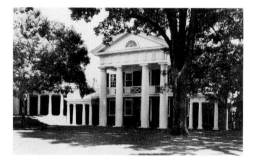

Pavilions II and IV and the range, East Lawn, University of Virginia. Yale University Photograph and Slide Collection.

bigger in scale than all the rest. It uses unfluted Doric columns, without bases. There is at least one Roman precedent for this that Jefferson knew, but the effect is fundamentally more Greek, and unfinished Greek at that, like the temple at Segesta. It also recalls Ledoux once more, so that it, too, is "modern" and already, in peculiarly American terms, prefigures the Greek Revival that was just about to come into its own. Its stripped geometry, set off by the heroically scaled triglyphs of its entablature, is clearly intended by Jefferson to contrast with his other most monumental portico, that of Pavilion III, which employs a lush Corinthian order. The four great capitals were carved in Italy out of Carrara marble and are set on brick and stucco shafts to support the wooden entablature and pediment above. Thus, physical materials of every kind are woven into the ideal image, subordinated to it. Are they ignored or transcended? For a long time one of the canons of modern architecture – growing, as we shall see, out of the moral materialism of the 1840s – demanded that materials should be "expressed," which fundamentally means that in practice their limitations were to be respected, sometimes even celebrated. So the word here should be *transcended*. Jefferson's position in this is an Idealist rather than a Materialist

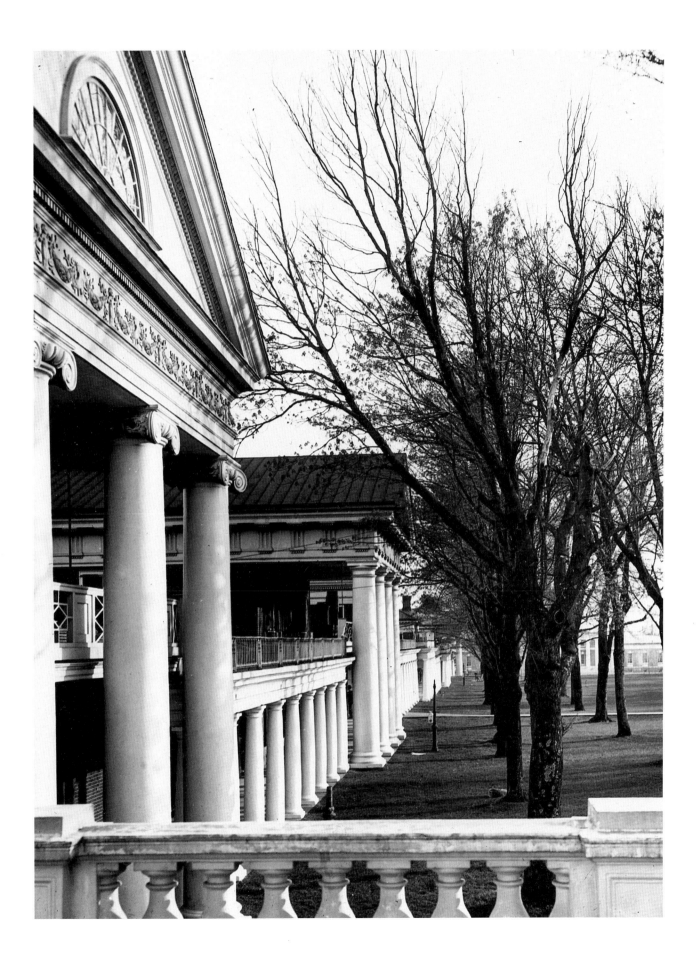

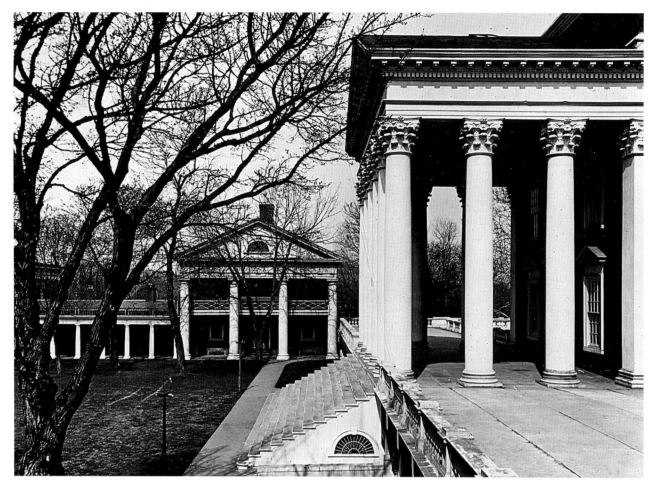

View across the steps of the portico fronting the Rotunda to Pavilion I, University of Virginia. Yale University Photograph and Slide Collection.

or Realist one, and it is the basis of the classical language, whose objectives are always visual.

Finally – or rather, to begin with – Jefferson demonstrates his Palladian Doric in Pavilion I and his Ionic in Pavilion II. So we go, as Palladio himself did, from Doric to Ionic to Corinthian in the pavilions, while Tuscan, which was regarded as the most primitive order of all and which employed a low center of gravity in its entasis, is used for the smaller order of the connecting colonnades. As at Monticello, all the pediments are penetrated by Jefferson's half-round windows. It is strange that he should always have insisted on this feature, considering how "correct" he otherwise wished to be in his big porticoes, which were the very billboards advertising his language. But there it is, perhaps compulsively aerating the wooden structure behind it or simply filling up the blank plane of the pediment, before which, in the best of all possible Attic worlds, great groups of sculpture should have stood.

Last of all – built last and conceived last at the suggestion of Latrobe – is the great Rotunda, Jefferson's masterpiece,

set at the height of the slope as the crown of the whole. It is interesting to note that Mumford objected to it a generation ago, reacting ideologically to its commanding presence and to the symmetrical order it enforced. But it is a human presence; it is based precisely upon the most humanist of all aesthetic theories, which has, since Vitruvius, put the human being in the center of the universe, whose order is conceived of as embodied in the perfect shapes of the circle and the square. That image lies at the very heart of Neoplatonic Idealism, and Jefferson uses it here to shape the body of the building as a whole. His interior circle suggests that of Boullée's cenotaph for Newton, but he fills something less than half its height with two lower floors and endows the resultant open space above them with the proportions of the Pantheon. In that space, now elaborately restored and luminous, we do indeed feel placed in the center of the world. Through the wide windows a great axis is felt, running through our own bodies down the Lawn, while the dome opens its image of the heavens above us in the light.

These exactitudes of conception and placement had to be celebrated by the most developed order, hence Corinthian once more, as in the Pantheon itself. Here the half-round window in the pediment was eventually abandoned, though Jefferson certainly proposed at first to use it, as a drawing by his granddaughter shows. Now, appropriately enough, only Time stands in the pediment, the circle of the clock floating in the grand triangle, set off by its enormous dentils, while behind it looms the ultimate forms of cylinder and dome, resonant with the phantoms of circle and square. Here alone, behind the great shafts, no file of Tuscan columns runs. The Rotunda is lifted above their level on the plinth formed by its crypto-porticus. But down below the Rotunda, the row of Tuscan columns binds the whole together, the smallest, the simplest, the least "formed" of columns passing – not easily, always with some intricate accommodation – behind the colossal orders of the pavilions. The Tuscan columns are small enough to evoke human scale, and they move like persons, like the students themselves, in their long, indeed never-ending file, under the bigger columns and pediments that, embodiments of the institution itself, rise above them. What a music like Mozart's it all is, how full of melodies. It seems hard to believe that it is being played on the same continent that heard the communal chant of Teotihuacán sounding only a few hundred years before.

Now Jefferson's language has achieved its fully realized rhetorical stance in order to instruct us in the relationship between the individual and culture, between the individual and education most of all. As he tells the Commissioners, so Jefferson embodies it here: "Education, in like manner, engrafts a new man on the native stock, and improves what in his nature was vicious and perverse into qualities of virtue and social worth. And it cannot be but that each generation succeeding to the knowledge acquired by all those who preceded it, adding to it their own acquisitions and discoveries, and handing the mass down for successive and constant accumulation, must advance the knowledge and well-being of mankind, not *infinitely* as some have said, but *indefinitely*, and to a term which no one can fix and foresee."

That *indefinitely* is pure Descartes, and it shaped the open axes of the great French classic gardens, as their builders, consciously exploiting the laws of Cartesian optics, extended them outward not "infinitely" but, as Descartes said, "indefinitely." Thus Marly, Jefferson's model here, was open-ended, and so was the University of Virginia designed. The lawn is made to flow down the long, gentle slope in a series of steps, as if beginning to rush faster and faster toward the view, which was of rising hillsides well out in space, with blue mountains beyond them. The University is high; it is an acropolis. It is therefore surely unfortunate that the open end was closed by McKim, Mead and White's building of 1896–1898. One should hasten to add that, as Leland Roth

The Lawn, University of Virginia.
Photograph by Linda Stabler-Talty.

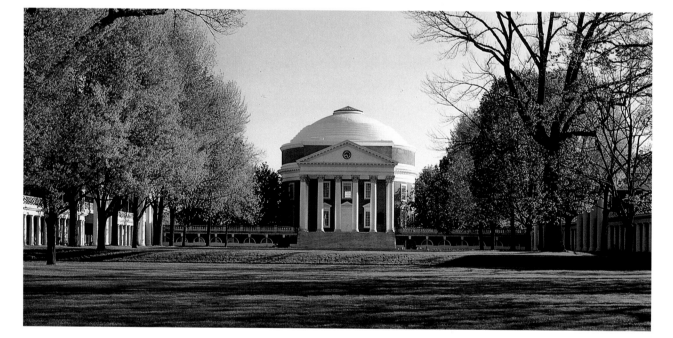

View through columns to the Lawn, University of Virginia. Photograph by Robert A. M. Stern.

has shown, this was not the fault of the architects, who argued against placing a building there. Indeed, several generations of classical architects, right up to the fine historian Fiske Kimball, served Jefferson and the University honorably by continuing to build very well indeed in the classical language appropriate to the whole. Only with the advent of "modern" architecture after World War II did the structure fall apart to produce a number of buildings of an illiterate brutality that is especially shocking – though pedagogically very telling – in that place. Now, at last, Jaquelin Robertson, dean of the School of Architecture there, is beginning to heal or at least terminate the damage with new buildings by architects who understand the problem and are trying to learn Jefferson's ancient and modern language once more.

Jefferson's rhetoric had already triumphed on a larger stage even than that offered by the University: the stage of the national capital of Washington, D.C. It was Jefferson who chose L'Enfant and supported his plan, which was based directly upon the plan of the French gardens of the seventeenth century. Its radiating avenues can be matched by those of the park at Marly, for example; they run across an underlying grid, something Jefferson himself had insisted upon. That grid – New Haven's grid – had thus far been used hardly at all in Colonial America, but, as we have already noted, it was to become the standard American plan. Jefferson foresees all that, even initiates it here, but he also causes the grid to be combined with the radiating avenues that leap across it and project their energies outward into space. The larger historical background of that kind of plan is interesting to trace, and it can be outlined very briefly. It involves an increasing confidence on the part of humanity in its capacity to control the world and to set up a humanly conceived order within it. The development of the plans of sacred sites in Greece is germane here, especially as they show the parallel development of the concept of axis and of man-centered spatial control. The first stage is represented by Delphi, where every individual unit fights its own way into the group after the big, ritual relationships between temple and mountain and temple and sky have been set up. The next stage can be seen at Olympia or on the Acropolis of Athens, where such ritual relationships between the sacred physical bodies of earth and temple are still enormously powerful but where an axis of human movement is also directed right through the center of the site. The final stage is seen at Lindos, where all the architectural elements are disposed off that axis of movement, with its great stair, and are indeed subordinate to it. The Romans, as at Praeneste, entirely regularized that axial dominance and enclosed it, and indeed the whole visible horizon, in one man-made spatial order.

Or, turning back to the planning of towns rather than that of sacred sites, we find the colonial grid as early as the seventh century B.C., as noted earlier. It is systematized and articulated into a complex urban structure by Hippodamos in the fifth century B.C. Again, the Romans regularize it still further, and in those towns, again largely colonial, that derive from the mold of the military camp, the grid is enclosed in a perfect square with two wide avenues, the

84

Cardo and the Decumanus, running through it. In Baroque Rome – and the jump is not too great; it is the natural progression of this classical idea – the avenues that were thrust through the medieval city by Sixtus V radiate out from the great Porto del Popolo to various centers of pilgrimage. The new dynamic of the radiating principle thus came into being, and it achieved its first great victory at Versailles. The initial plans for the garden employed a fairly restricted grid; then, under Le Nôtre, the whole exploded into a series of vast radiating avenues that burst out across the landscape on a comparatively cosmic scale, creating shapes that were indeed called *étoiles*. It was the ultimate liberation of the human will to shape nature according to its own optical and conceptual principles, and it became the image of the new, expanded, and centralized France of which the king was the center and the embodiment. The sacred mountain of ancient ritual had disappeared; the human will and the modern, national state it created were everything. So the avenues stretch out untrammeled under the sky, leading symbolically to nowhere less than the frontiers of the kingdom, under the sun that is the king. Indeed, as in Bernini's great bust, the young king seems carried on his *gloire* through the air, across the world. He is the wholly liberated individual who is now powerful enough to shape a significant portion of the earth to his own will. As such, he is himself the ultimate Man of Perfect Proportions, and the French garden is the most complete embodiment of those Neoplatonic principles mentioned earlier. In it the circle and the square are liberated from gross matter into pure drawing, hence pure Idea. The parterres are drawn tight, removing all sense of weight or depth from the earth's surface, permitting its underlying geometric order to reveal itself and to shape an area vaster than any that human beings had ever felt capable of controlling before.

That is why the plan of Versailles has dominated the major conceptual structures of the modern urban world. It shaped Haussmann's Paris, for example, building out as it did from the grand axis of the Tuileries that Le Nôtre had set up. The major burst occurs, appropriately enough, at the Étoile, where the radiating boulevards drive out through the solid urban fabric as the allées of Versailles cut through the trees. The analogy is not merely a schematic one. The buildings of Paris shape their streets as the trees at Versailles shape the allées. Indeed, with their volumetric mansards,

the buildings themselves are like clumps of trees. It is therefore the ultimate garden of modern times, the city of Paris – the consummate work of art of the modern age. As with all great things, its own inner order also shapes its destruction: Le Corbusier's Ideal City of 1922 is based precisely upon the tradition that produced Paris. In fact, with its avenues radiating over the grid from two major centers, and with its mall-like *"jardin anglais"* stretching out from one side, Le Corbusier's plan recalls that of Washington most specifically. But it destroys that major principle of the garden which Paris had best understood. The Ideal City's radiating avenues, designed for the free movement of the motor car, are intended to destroy the scale and structure of the street – imagine, of those incomparable Parisian streets with their shops, their bars, and their mansards – and to open everything up into superblocks with high-rise buildings isolated in their centers. We have already mentioned the cataclysmic destructiveness of that pattern as it has been put into practice by contemporary redevelopment and urban renewal. But the classic garden is not yet done for. It was obviously Leon Krier's model in his proposal for La Villette, where he brings a preexisting canal rather than a superhighway up the middle and designs his blocks in solid clumps like those of Paris (or of Chicago's Loop) or of the park at Versailles. In this way, the most significant aspect of the present movement against the International Style – that which seeks to heal the urban wounds the International Style created, indeed to stop that destruction of the community which it has helped to bring about – that movement, too, derives in large part from the classic garden.

86

United States Capitol, as designed in 1793 by Dr. William Thornton (1759–1828), modified by Benjamin Henry Latrobe, and completed by Charles Bulfinch between 1817 and 1830. Print by Deroy. Yale University Photograph and Slide Collection.

As, most conspicuously, did Washington, D.C., itself. There, toward the end of the eighteenth century in America, it was not the palace of a king that sought to embrace the new image of dominion, but the capitol building of a new republic, one of the first of the emerging nations of modern times. Of course, it took Washington as a whole a long time to grow up to the full scale of Versailles. The major axis of L'Enfant's plan was confined by the bend of the Potomac, and the Mall he envisaged was to end where the Washington Monument now stands. The capitol building itself grew slowly toward its appropriate massing. The mass stretched out laterally, while the dome rose by fits and starts in project after project, finally leaping up in cast iron to be finished only in 1863, when, in embattled Washington, the image of Freedom was finally placed on its top. The building's vertical continuity, severely injured a few years ago when the east front was pushed forward for dubious reasons, was eventually matched by the untrammeled leap of the Washington Monument as it was most miraculously

completed in the 1880s. Robert Mills' original design for the monument had been much more compromised, and some of the projects of the late 1870s had gone off on a wholly different, Gothic Revival tack which would have been much less effective here. Not classical in origin (though perhaps that is splitting hairs) but later warmly welcomed into all classical urban scenes, the Egyptian obelisk, a cousin of the pyramids, invokes the whole sky in one gesture and directs our attention toward its sovereign lord, the sun. Its acceptance in Washington recalls its presence at the inception of such planning in the center of the Piazza del Popolo in Rome. Closer to home, one wonders if this relationship of an obelisk with a domed and pedimented building would have won favor in Washington if it had not already been suggested by the view of the Chambre des Deputés, with the dome of the Invalides behind it and seeming to rise upon it, as the whole is seen from the Place de la Concorde with the obelisk at its center. But the completion of the Mall belongs to the beginning of the twentieth century and can best be

U.S. Capitol, as redesigned by Thomas U. Walter between 1851 and 1865. Photograph by Sandak.

U.S. Capitol, 1987. Photograph by
C. Lynn.

discussed in relation to the art of that period as a whole. Here we should remain with Jefferson's vision and its embodiment, in the later years of the nineteenth century, in Washington's obelisk and the Capitol's dome. The latter was indeed the major symbol of the nation's unity after the Civil War.

As with architecture, so, finally, with portraiture. George Washington must be made permanently larger than life, a monument and a myth. Leutze's *Washington Crossing the Delaware*, of 1851, seems to climax the whole development. It may be theatrical in conception, a little academic in execution, but the spot where it hangs is one of the places in the Metropolitan Museum where the crowds most often gather. And I think that is because, as in Washington, D.C., the artist lifts the central monumental group into a dome. The action thus culminates in the symbolic architectural image, brought to life by the diagonal of the rising flag. The composition cannot help but remind our generation of the raising of the flag on Mount Suribachi, in the great photograph from which the Marine Corps Memorial in Washington was made.

But then, as the midcentury approached, most American

artists embodied their love for America, which was enormous, not so much in the images of its heroes as in the image of its landscape, the image of its place.

The first important painter of the American landscape is Thomas Cole, who, despite his several predecessors, is the true founder of the Hudson River School. Cole works in traditions that were already long established before his time. But, as in his painting of the Oxbow on the Connecticut River near Northampton, he shapes scenes that have special American meanings. Here is what Fitzgerald was to call the "fresh green breast of the New World." And the painter puts himself right down among its wild greenery and its jumbled rocks. Across it, a storm is just passing away, carrying with it all the savagery and the wildness of the landscape. Off to the right, as the skies clear, a different kind of world is opening up, the world of America as a garden: the gentle, quiet, productive, agrarian world that now, toward the middle of the nineteenth century, was itself just beginning to pass away in the more settled parts of America, or was, at the least, already threatened by the forces of industrialization that were eventually to transform it.

Down there we see the gentle meadows, the farmhouses, the boats in the water. The water is as controlled in the Oxbow as in the *bassin* of a French classic garden. There is

Washington Crossing the Delaware, 1851, by Emanuel Leutze (1816–1868). Oil on canvas, 149 × 255 inches. The Metropolitan Museum of Art, Gift of John Stewart Kennedy, 1897 (97.34).

91

no wind upon it; it reflects the landscape, contrasting with the shadows and darkness on the left. And its light leads our eyes toward a transcendent view that goes on indefinitely – or perhaps the word here should be *infinitely* – into light itself, far off across space. That movement into light becomes the basic structure of the great American landscapes of the nineteenth century, where the continent is seen as smiling, promising great hope, opening to a glorious future as the old savage voices of barbarism retreat.

But the painters also feel a kind of sorrow in that passing, as the fullness of nature gives way before farms and the husbandry of men – this, too, soon to be ravaged by industry's heavy hand. This moment of passage is sanctified by the river's geometric knot, like the old Mediterranean symbol of the goddess of the earth laid gigantic upon the land.

Cole had his European models: Salvatore Rosa for the wild bits, Claude Lorraine for the garden. The Claudian influence is the deeper, because Claude, painting in the seventeenth century, at what was in fact the beginning of the modern age, was the consummate painter of the reconciliation between men and the earth through the continuity of human culture *upon* the earth. His figures are quite small, and they merge into noble, grand, and gentle landscapes through light. Claude's forms touched the greatest nineteenth-century landscape painters, such as the Englishman Turner, to the heart. It was their problem, too, discovering how to deal with a world in rapid change, and it was especially Cole's, because he was required to reconcile Americans with a continent which had not yet become wholly their home but which was already changing out of all recognition around them.

Now Americans reached out for the land, seeking in it an antiquity their cultural institutions did not possess. Their love for it deepened their nationalism in one sense and corrected and civilized it in another, just as it led their art away from the preoccupation with the self that had been the limitation as well as the strength of eighteenth-century portraiture.

Cole's majestic sequence *The Course of Empire*, in the New-York Historical Society, suggests such a corrective, because nature alone is the survivor. Human institutions are transitory. The human city, especially, encourages sin and invites retribution (a somewhat Jeffersonian view). First

Sunrise, ca. 1648, by Claude Lorraine (1600–1682). Oil on canvas, 41¾ × 53 inches. *The Metropolitan Museum of Art, Fletcher Fund, 1947 (47.12).*

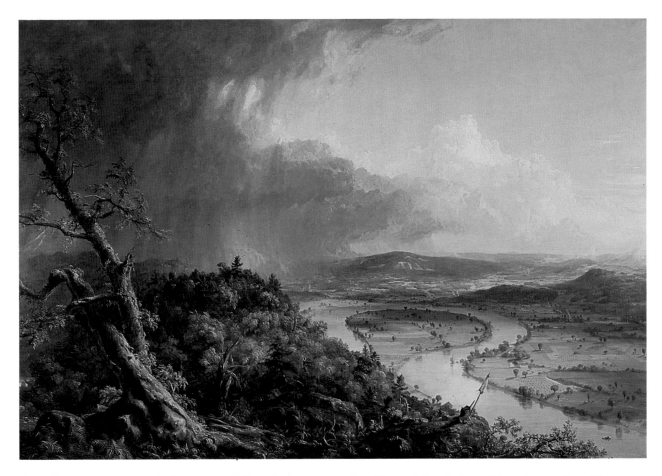

there is a savage state in human affairs where nature is still yeasty with volcanoes and clouds and mist. Indian encampments appear; hunters run down across the front of the canvas, and a sacred, conical headland defines the bay. Then the same site is seen as civilization begins to develop. We enjoy a pastoral state. Stonehenge appears; some sort of sacrifice is taking place within it. Now men are out with their flocks in an idyllic Theocritean landscape, Cole's Romantic reverie on a soft, placid, and essentially innocent past.

All of this culminates in the same spot in a Classical Revival city, gaudy like a dream parody of the cities, such as Washington, that Americans were trying to build at the time, with enormous colonnades and mighty pediments, made to seem the embodiments of inordinate pomp and power. The whole is an image of overweening human pride. Nature's headland is almost obscured. The heroes take their places in relation to the kind of furniture that we saw being made by Lannuier, now blown up into public sculpture on a grandiose scale. It is a feverish view of the classical image of Washington, a precursor of those colossal movie sets of the twentieth century that were set up only to be destroyed.

The Oxbow (The Connecticut River near Northampton), *1836, by Thomas Cole (1801–1848). Oil on canvas, 51½ × 76 inches. The Metropolitan Museum of Art, Gift of Mrs. Russell Sage, 1908 (08.228).*

The Savage State, *1834, first in a series of five paintings,* The Course of Empire, *by Thomas Cole. Oil on canvas, 39¼ × 63¼ inches. The New-York Historical Society, Gift of New York Gallery of Fine Arts.*

The Arcadian or Pastoral State, *1834, second in the* Course of Empire *series by Thomas Cole. Oil on canvas, 39¼ × 63¼ inches. The New-York Historical Society, Gift of New York Gallery of Fine Arts.*

The Consummation of Empire, *1836, third in the* Course of Empire *series by Thomas Cole. Oil on canvas, 51¼ × 76 inches. The New-York Historical Society, Gift of New York Gallery of Fine Arts.*

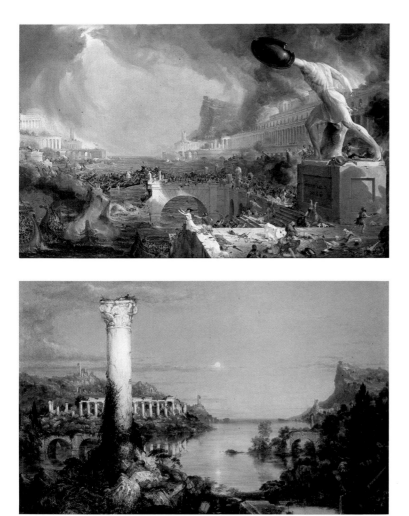

Destruction, *1836, fourth in the* Course of Empire *series by Thomas Cole. Oil on canvas, 39¼ × 63¼ inches. The New-York Historical Society, Gift of New York Gallery of Fine Arts.*

Desolation, *1836, fifth in the* Course of Empire *series by Thomas Cole. Oil on canvas, 39¼ × 63¼ inches. The New-York Historical Society, Gift of New York Gallery of Fine Arts.*

Soon, therefore, history visits its vengeance upon human pretensions. They, the barbarians, have broken in. The magnificent architecture is knocked down and burned. Rapine and murder are deployed deliciously across the surface of the canvas. The implication is that it was all deserved. Finally only Nature is left, in the final dream state of the Romantic sublime. The same headland is out in the sea, free of human encroachment. The water is still, like that of the garden once more. The column is there, the broken column, ancient symbol of memory and loss. Classicism is sorrow. The composition again invokes Claude. Our eyes are led out to sea in the quiet; all is peaceful once again, now that man has passed away. The whole series looks much less fanciful now than it did fifty years ago. Now it seems to ask questions that are worth taking seriously; the last scene in particular seems likely enough.

One important thing about *The Course of Empire* is that it was commissioned by Luman Reed, whose portrait, now in the Metropolitan, was painted by Asher B. Durand, a friend and follower of Cole. Reed was a self-made man, a grocer, and he was different in a fundamental way from those Colonial patrons of Copley who would pay only for portraits of themselves. We recall that this was a major reason why Copley and West and the other Americans went to England: to be allowed to paint pictures on more complicated themes. Now, with the support of men such as Reed, they could begin to explore the character of the landscape and the meaning of human life and of the new nation in a more comprehensive way than had ever been possible for them before.

What they wanted, they and their patrons alike, was a new kind of relationship to the continent, a feeling of belonging to it, a sense of deriving some kind of sustenance and courage from it. Most of all, they hoped to find some way of tapping their "virgin" landscape and themselves into the common memory of all mankind.

It seems to me that the painting by Asher B. Durand

Landscape – Scene from "Thanatopsis," *1850, by Asher B. Durand (1796–1886). Oil on canvas, 39½ × 61 inches. The Metropolitan Museum of Art, Gift of J. Pierpont Morgan, 1911 (11.156).*

96

called *Landscape – Scene from "Thanatopsis"* ("A View of Death") best sums up all those attitudes. The title refers to a poem by William Cullen Bryant, a very strange poem for a young man to write, in which he attempts to reconcile mankind to dying by pointing out that the majority of mankind lies dead in the earth and that when one dies, one goes back home to nature and becomes a part of it. Durand's painting echoes that. Under the trees, there is a quiet burial ceremony. Up to the right, magnificent Alpine masses loom, and castles of great antiquity rest upon them. But then down nearer the light, as in Cole's *Oxbow,* the gentle garden runs out toward its infinite distances. One is made to feel that when one dies, and is put to rest in the earth, the earth itself celebrates the grandeur of that coming, and that out beyond everything, in the distance, the light of transcendence flares.

All of that speaks very much to American needs, it seems to me, at any time. For an American who travels to Europe – particularly to Italy, the special Claudian land – there almost always comes a sudden realization that Europeans have an attitude toward death that is different from ours, one in which death is more natural precisely because the ancestors from so many generations past sleep in the earth around them. And it is with this, with the attempt to reconcile Americans to death, to the common fate of all mankind, that "Thanatopsis," both the poem and the painting, deals. The poem concludes in that vein:

To him who in the love of Nature holds
Communion with her visible forms, she speaks
A various language; for his gayer hours
She has a voice of gladness, and a smile
And eloquence of Beauty, and she glides
Into his darker musings with a mild
And healing sympathy that steals away
Their sharpness ere he is aware. When thoughts
Of the last bitter hour come like a blight
Over thy spirit, and sad images
Of the stern agony, and shroud, and pall,
And breathless darkness, and the narrow house
Make thee to shudder and grow sick at heart,
Go forth, under the open sky, and list
To Nature's teachings. . . .
So live, that when thy summons comes to join

97

The innumerable caravan which moves
To that mysterious realm where each shall take
His chamber in the silent halls of death,
Thou go not like the quarry slave at night,
Scourged to his dungeon, but sustained and soothed
By an unfaltering trust, approach thy grave
Like one who wraps the drapery of his couch
About him and lies down to pleasant dreams.

It was that kind of assurance Americans were trying to find in the continent: that natural peace, that past, those fathers' graves. They wanted to belong here, with the Indians either gone or only ghosts around them. It was not pride of possession any longer. The silver, the great chests, the glossy clothes with the bright buttons of the Colonial period did not speak to them in those years. They sought transcendence through the landscape and the light. They wanted to have been in this place forever.

The domestic architecture of the period serves that intention. It tries to fit in with nature and to look as if it had grown up where it stood over many centuries of time, like the castles on the mountain heights in *Thanatopsis.* On the inside, it tries to call up an ancient baronial past that had never existed in America, even along the Hudson. Its furniture is as emblematic as that of the Classical Revival that had preceded it, but now in all likelihood it invokes the symbols – like A. J. Davis's rose windows in his marvelous chairs for Lyndhurst – that are suggested by medieval forms. On the outside, it is just the opposite of the closed, protective box of Colonial architecture. The massing is heavier but at the same time very irregular, so that it accords with that of the trees around it – which, in the English tradition of picturesque garden design, are planted in such a way as to complement it and to extend its form. To that end, a porch opens widely from the house to lead on out to nature once more.

Out of this general development came what can properly be called the new American domestic architecture of the later nineteenth century. It is primarily an architecture of wood, in the American Colonial vernacular tradition. But earlier American sheathing had normally been of horizontal clapboards; in the 1840s, vertical boards and battens began to be used as well, in order to express on the outside the skeletal character of the structure inside, and especially of

WEST FRONT.

PAULDING
& MERRITT
GOULD.

Watercolor drawing of the west front and plan of Lyndhurst, late 1870s, Tarrytown, New York, by Alexander Jackson Davis (1803–1892). The watercolor shows enlargements made by Davis in 1865 for Philip Paulding of the Gothic-style house, Knoll, that the architect had designed in 1838 for Paulding's father. The Metropolitan Museum of Art, Harris Brisbane Dick Fund, 1924 (24.66.81).

Table and one of a pair of wheelback chairs, oak, probably 1841, designed by A. J. Davis for Lyndhurst. Chair height 37¼ inches. National Trust for Historic Preservation, Lyndhurst in Tarrytown, New York.

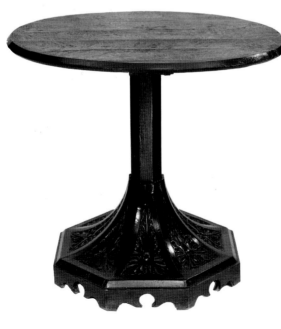

Bracketed Veranda from the inside, *figure 45 in* The Architecture of Country Houses *(New York, 1850) by Andrew Jackson Downing (1815–1852).*

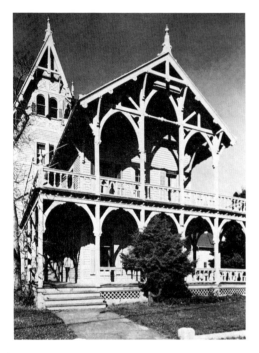

Villa Vista, 1878, Connecticut, designed by Henry Austin (1804–1891). Photograph by Frederick L. Hamilton.

the vertical studs. That feeling for the expression of the skeleton – one where the new realism or materialism of the nineteenth century is making itself felt – then began to open the house out into wood-framed porches. These might be said to have evolved first from the Gothic *portique,* where the wood is treated rather sculpturally and there is not much open space. Then it all started to lighten up. The frame structure became more skeletal and voluminous, until it finally developed into the full, open pavilion of the mature American Stick Style. The writings of the landscape architect Andrew Jackson Downing initiated this development in America and offered its most persuasive images. A fully realized Stick Style house celebrates wooden construction; everything expresses the character of the wood frame, with all its verticals, horizontals, and diagonal ties. Up above, in the gable, a Gothic *colonnette en dèlit* – normally a compression element but now made to look as if it is under tension – ties the whole skeleton together. Then, across the sheathed walls, where there is a closed surface, the phantom of the frame is brought forward in stripping to show a complete expression of the frame everywhere. The porch, most of all, is a wonderfully tense skeleton – giving out, if possible, on the sea. Out there, an incomparable light on the water may well be seen; the New England light of October,

with the glint of the sun low down, the blinding gleam of the sun on the sea.

Such porches shaped the basic frame for the new American experience of landscape. Indeed, they are a link with the very essence of *Thanatopsis,* as we look out through them to the transcendent light on the water. As we have noted, Cole and Durand both wanted to persuade us that it is from nature that we learn and to nature that we must give ourselves, and that the shapes of nature ought to be sacred to us. In his painting *In the Woods,* Durand brings us deep among trees, with the old birches falling in upon themselves. It is very much an Eastern forest of boggy, swampy undergrowth, a tangle of second-growth timber. Durand leads us into its shadows, with only a little spot of light showing in the distance.

Then these so-called Hudson River School painters lead us westward across the continent, out as far as the Rockies in the footsteps of the pioneers. Indeed, the work of a painter such as Albert Bierstadt seems to embody the nation's widespread belief in its "manifest destiny" to rule the

Two houses built by James Monroe, the left in 1850, the right in 1860, on Fair Street in Guilford, Connecticut. Photograph by C. Lynn.

continent as a whole. His canvases become enormous in size to reflect the immensity of the western scene. As he and other painters followed the pioneers out west, they were certainly affected by the photographers, the champions of a great new art, who were out there as well, capturing the vast new landscapes with their photographic lenses.

But when Albert Bierstadt comes to paint his great view of the Wind River Range in Wyoming, *The Rocky Mountains, Lander's Peak,* he has an advantage over those photographers. He is not limited to the size of the plate; he can exercise the painter's magnificent prerogative to make it all look, through illusion, more real than it really is. So he leads us in and has us focus deep in there across the glassy pool to the one percent of light right in the middle of the canvas. As he does so, our eyes are also picking up, as they in fact do in nature, a whole 180-degree arc of vision as the mountains open up around us and rise above us to the magnificent peaks. Bierstadt pulls us into the picture. He makes us part of it, and he did so even more by the way he had the picture exhibited. In the forward plane of the painting he lays out

In the Woods, 1855, by Asher B. Durand. Oil on canvas, 60¾ × 48 inches. The Metropolitan Museum of Art, Gift in Memory of Jonathan Sturges by his children, 1895 (95.13.1).

Black Cañon, From Camp 8, Looking Above, No. 80, *1871, photograph by Timothy H. O'Sullivan (1840–1882), published 1872–1873 by the United States War Department's Army Corps of Engineers in* Photographs . . . of the Western Territory of the United States . . . Season of 1871. . . . *Gold-toned albumen print from a collodian negative, 7 ¹⁵⁄₁₆ × 11 ⅛ inches. The Metropolitan Museum of Art, Purchase, Joseph Pulitzer Bequest and The Horace W. Goldsmith Foundation Gift, 1986 (1986.1054.19, p. 43).*

an encampment of Shoshone Indians going about their everyday tasks; when he exhibited the picture, he placed an encampment of real Indians in front of it, so that the viewers would go from the real into the illusion of the real. Step by step, they walked into the painting and were finally out there in the mountains themselves, in Eden – that renewed Eden of an unspoiled continent which the Americans of the day clearly desired very much. They want its "unspoiled" grandeur still, even today, even as they are being encouraged by the national administration to despoil it one last time.

The western movie, for example, has without question owed an enormous part of its popularity not only to its simplistic heroic themes, but also to the fact that it gets

Cathedral Rock, 2,678 feet, Yosemite, Cal., *photograph by Carleton E. Watkins (1829–1916), published by I. Taber, San Francisco, ca. 1866. Albumen print wet-mounted on pulp board, 15⅞ × 20⅝ inches. The Metropolitan Museum of Art, The Elisha Whittelsey Collection, The Elisha Whittelsey Fund, 1972 (1972.643.6.#21).*

On the Little Bighorn – Apsaroke, *photograph by Edward S. Curtis (1868–1952), from the portfolio of oversized photogravure plates published by John Andrew and Son as a supplement to the fourth in the forty-volume series* The North American Indian, *copyrighted 1908. The Metropolitan Museum of Art, Rogers Fund, 1976 (1976.505.4, pl. 114).*

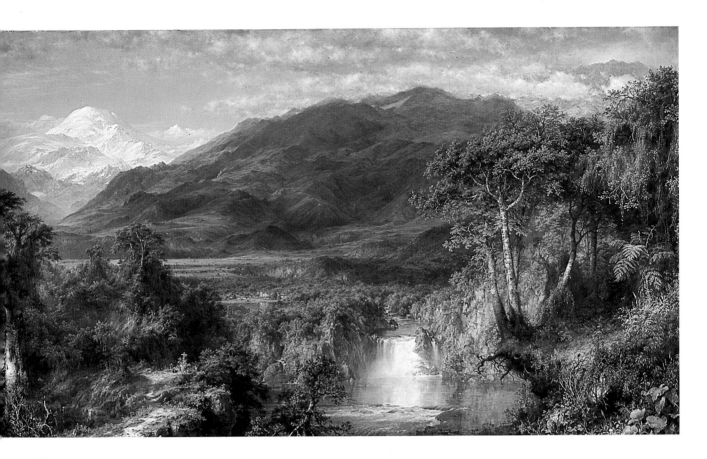

Americans "west," out into those great landscapes. Once again, of course, the Indian was regarded as the intruder there, and his last great nations were finally swept away – and given short shrift in the classic cowboy films. But some nineteenth-century photographers, such as Edward Curtis, made splendid records of them, of their beautiful lodges and of their faces, on a grander scale than ours, and Bierstadt himself painted his Indians more or less ethnographically. By the middle of the nineteenth century, Americans generally seemed to want the scientific, realistic strain to dominate the romantic or religious note they had injected into their landscapes earlier. They wanted to travel to far places, and they wanted those places to be as they "really" were. The epic trips of pioneering naturalists such as Humboldt and Darwin had fed that attitude.

The great painter of all this was Frederick Edwin Church. His painting *Heart of the Andes,* of 1859, was shown in his studio with real palm trees and special lighting and sound effects to encourage the viewer to feel that he was actually traveling to and into the place – the same sensation Bierstadt tried to promote. The spectators were given tubes of paper to be used as spyglasses so that they could, for

Heart of the Andes, *1859, by Frederick E. Church (1826–1900). Oil on canvas, 66⅛ × 119¼ inches. The Metropolitan Museum of Art, Bequest of Margaret E. Dows, 1909 (09.95).*

Black Eagle – Nez-Percé, *photograph by Edward S. Curtis, from the portfolio supplementing the eighth volume in the same series (see page 104, bottom). The Metropolitan Museum of Art, Rogers Fund, 1976 (1976.505.8, pl. 265).*

Coups Well-Known – Apsaroke, *photograph by Edward S. Curtis from the same portfolio (see page 104, bottom). The Metropolitan Museum of Art, Rogers Fund, 1976 (1976.505.4, pl. 144).*

The Rocky Mountains, Lander's Peak,
1863, by Albert Bierstadt (1830–1902).
Oil on canvas, 73½ × 120¾ inches. The
Metropolitan Museum of Art, Rogers Fund,
1907 (07.123).

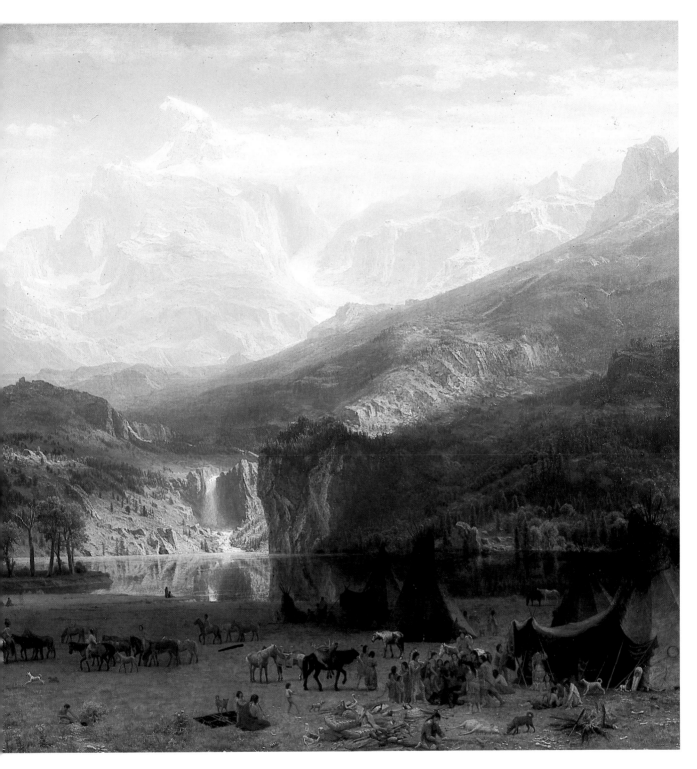

Heart of the Andes, *by Frederick E.*
Church (detail, lower right corner).

Hot-water kettle and stand, silver, 1850,
New York. Made by John Chandler Moore
for Ball, Tomkins and Black for
presentation to Marshall Lefferts, president
of the telegraph companies that ran the first
lines from New York to Boston and Buffalo.
Height 17⁵⁄₁₆ inches. The Metropolitan
Museum of Art, Gift of Mrs. F. R. Lefferts,
1969 (69.141.1).

example, amble down to the little shrine, right along the path to it, and then go beyond it to the wonderful ranch or village, far off beyond the pool. Or they could go up the narrow river, deep into the very heart of the Andes, and climb up beyond it across the purple slopes of the mountains with the clouds just over their heads. They might then descend from the windy heights to the quiet, shiny pool in the foreground of the canvas and then penetrate from it into the shadows among the trees, to the one bright little bird there in the darkness.

That is also the way the eye is intended to travel over some of the most characteristic furniture of the period: in and through its naturalistic vegetable growth. Some, in metal, is intended to be taken out to the porches or into the landscape itself. The silver service, too, is covered with the bounty of the garden.

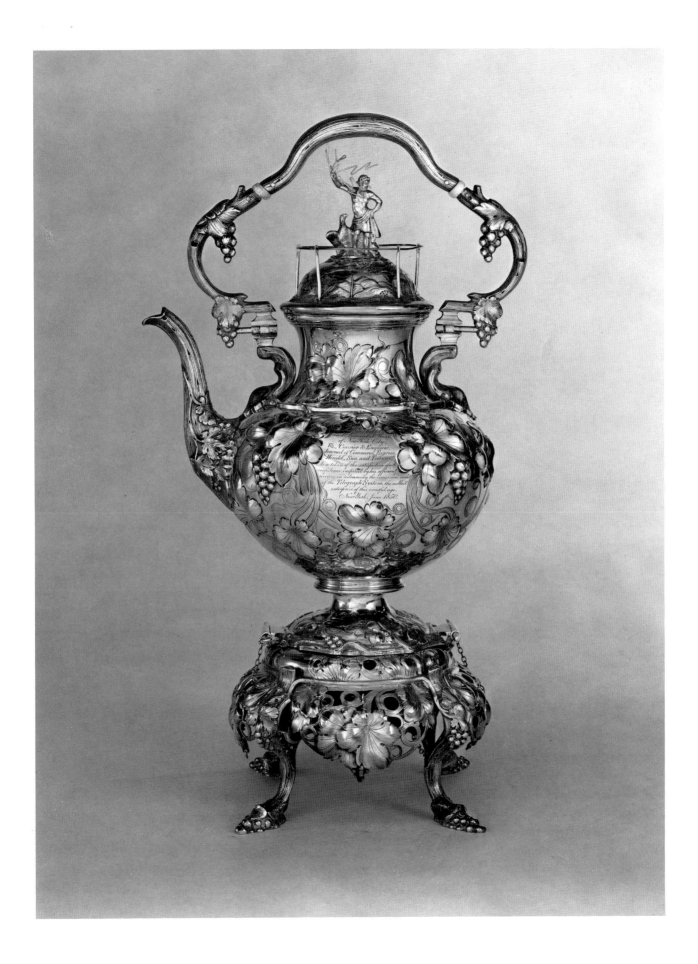

109

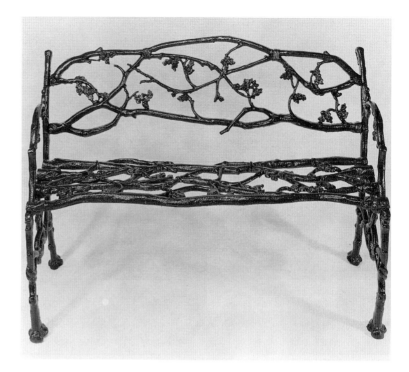

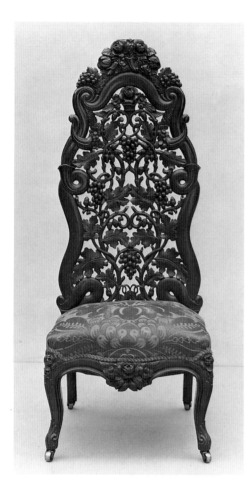

Rustic settee, cast iron, of a type designed in the mid–nineteenth century and made in Boston and New York from the 1850s into the 1890s. Length 48 inches. The Metropolitan Museum of Art, Edgar J. Kaufmann Charitable Foundation Fund, 1969 (69.158.2).

Slipper chair (part of a parlor suite of eleven pieces), rosewood, mid–nineteenth century, New York, attributed to John Henry Belter (1804–1865). Height 44¼ inches. The Metropolitan Museum of Art, Gift of Mr. and Mrs. Lowell Ross Burch and Miss Jean McLean Morron, 1951 (51.79.9).

There could hardly be a more realistic preoccupation, and Church sums it up. He enables us to travel through the painting as if it were not a painting at all but a real three-dimensional landscape at full scale. That journey is everywhere directed by light. It is true that Church's technique is hard and linear, like that of Copley, in a way. He is, after all, painting materialist landscapes, the American successors to Copley's portraits. But his light is also strong and clear, and it is that interest in light that dominates the most important landscape developments of the middle of the nineteenth century in America, even though they may not be best seen in these great operatic constructions by Church himself.

Indeed, in order to understand those paintings that so many scholars have described as Luminist, we need to travel not to South America or even to the vast valleys of the Rockies but back home to the Eastern Seaboard. Luminism in fact seems to develop not primarily from the grand tradition of landscape painting but from the topographic and genre traditions that sought to portray landscape in its simplest form and everyday people in workaday situations. This leads to a kind of landscape painting that is very different from that of Church and Bierstadt, which was full of neo-Baroque drama and set in exotic places out on the frontier or in South America. Genre stays home, and instead

of the imperial promptings of Manifest Destiny there is one's own soul to listen to in one's own place. Thoreau at Walden, in a basic intellectual and even a visual sense, is the model here.

America had at least two magnificent genre painters in this period before the Civil War: William Sidney Mount and George Caleb Bingham. Mount is the more touching of the two. His *Long Island Farmhouses* (where Mount lived) focuses on common buildings in the thin, wooden American architectural tradition. There is some drama in the sky, but the light is the clear, silver light of winter. We can feel the temperature, and what it is like on that day, right there, rather breezy as the light fails, with the tree casting a shadow on the shingled wall.

Mount also paints black people in the most beautiful way. The woman in his *Eel Spearing, Setauket* has a noble calm. Once again, the landscape is a common, everyday one, such as we might see from one of those Stick Style porches. It is all very still, reflecting the continuing American desire for a

Long Island Farmhouses, *1854–1860, by William Sidney Mount (1807–1868). Oil on canvas, 21⅞ × 29⅞ inches. The Metropolitan Museum of Art, Gift of Louise F. Wickham, in memory of her father, William H. Wickham, 1928 (28.104).*

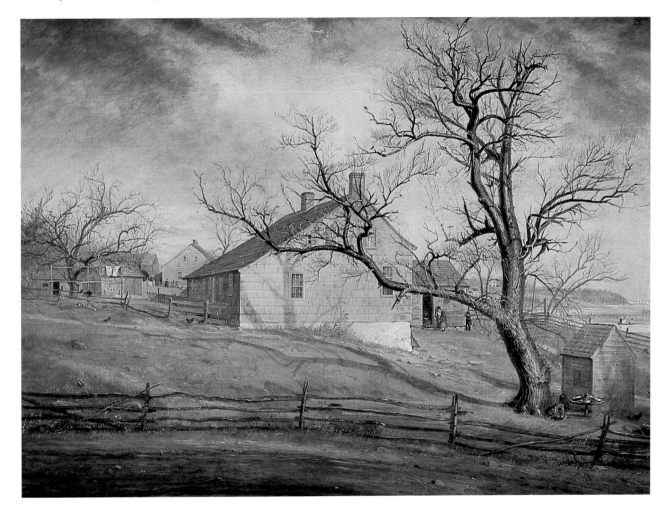

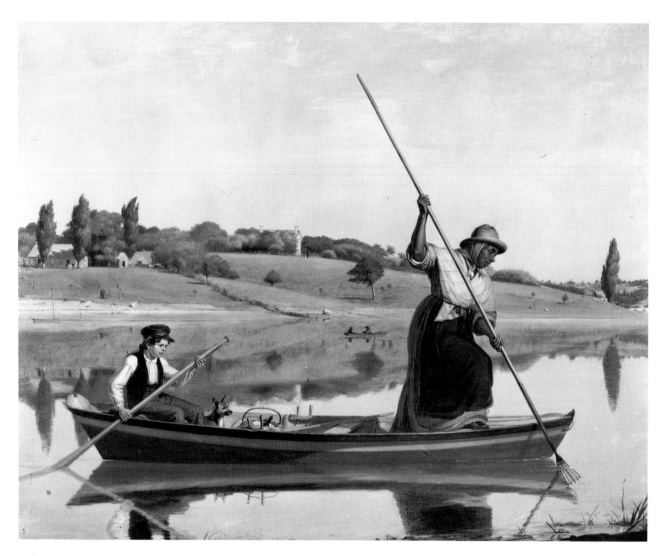

Eel Spearing, Setauket, 1845, by William Sidney Mount. Oil on canvas, 29 × 36 inches. New York State Historical Association, Cooperstown.

tranquil garden. The water is a mirror, like Cooper's Lake Glimmerglass. In this silence, this innocence, there is the monumental, magnificent black woman and the little boy, whose life is being lived most fully right here in this relationship with this woman and with her common occupation, eel spearing. Mount organizes the whole thing into a pyramid which holds our eyes steady but which he then breaks, letting our vision slide off silently to the sheen of the water.

There is an echo of that composition in one of the most haunting pictures of the nineteenth century, Bingham's *Fur Traders Descending the Missouri.* Bingham didn't give it that title; he called it *French Trapper and His Half-Breed Son,* and that is what we see: two human beings, one old, one young, floating in the mist, looking out at us but all alone in the wild, in the silence. That image is much the same as the one Mark Twain was going to use in *Huckleberry Finn.* There the

112

ages would be reversed, but the meanings seem almost identical. It is an image of two human beings in America who are able to get away from racial difference only when they are in the wild. When they get to the settlements, all the horror emerges. We remember that word, *half-breed*, as it was used in cowboy movies right into the late twentieth century: a word full of doom and contempt. But here the half-breed boy in the center of the painting doesn't know that. He is young, innocent, and everything is focused on him.

A shaft of light breaks through the block of foliage behind him and leads our eyes to his face. Right next to him is a duck, shot through the breast: another American image. The boy, as a young half-breed, will also be a dead duck when they reach the settlements – as Jim would have been in *Huckleberry Finn* if he had been recaptured, and indeed as

Fur Traders Descending the Missouri, ca. 1845, by George Caleb Bingham (1808–1879). Oil on canvas, 29 × 36½ inches. The Metropolitan Museum of Art, Morris K. Jesup Fund, 1933 (33.61).

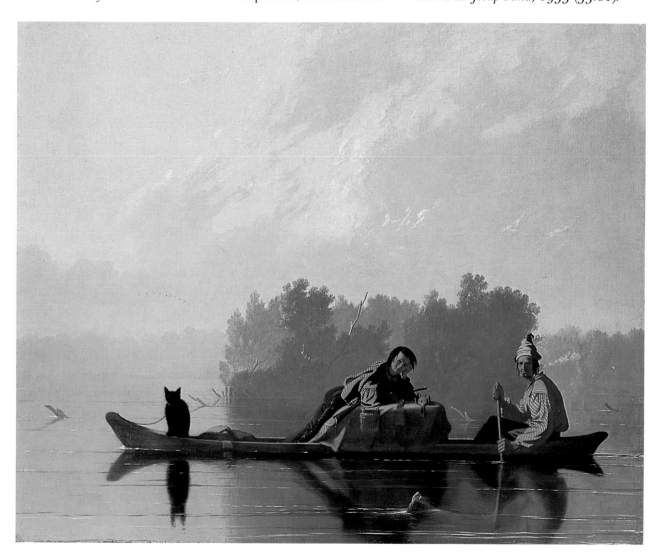

Lake George, *1869, by John F. Kensett
(1816–1872). Oil on canvas, 44⅛ ×
66⅜ inches. The Metropolitan Museum of
Art, Bequest of Maria DeWitt Jesup, 1915
(15.30.61).*

he symbolically was when he finally came to the settlement and, in cruel play, was thrown into chains by Huck himself at the suggestion of the fundamentally conformist Tom Sawyer.

Next to the two human beings in Bingham's painting, involved in their complicated relationships to each other and to society, there is a purely animal image off to our left, a little black bear cub they are bringing back with them from the north. He is reflected in the water much more clearly than the human beings are, as if he fits into the wild more completely than they do. They are in an ambiguous position. Their lives are full only when they are on the water, which is flowing fast, beautifully painted in transparent layers of light, but which is at the same time frozen; it and the boat upon it are timeless and silent.

Light and silence lead us to the full sweep of Luminism, which it might be fair to say quiets down and distills the Hudson River School with the essence of the genre tradition. Out of that chemistry a very evocative kind of landscape takes form. It has neither the drama of Cole nor the grandiosity of Church; it is static, silent, dreaming.

Kensett's painting of Lake George seems to me a very important one in this regard. We are on the shore of a lake, looking out across it, and just there in the shadows, so that it won't distract our eye too much, is an Indian canoe. We are at exactly the point Cooper takes us to in *The Deerslayer*, when, as so many critics of American literature, following the great D. H. Lawrence, have insisted, the new American is symbolically born. He is christened when he kills the Iroquois warrior who, dying, names him Hawkeye.

Then, in *An American Tragedy*, of 1925, which is perhaps the greatest of all American novels and the author's most searching, Dreiser shows us Clyde Griffiths, the spoiled Adam who has killed off his tacky Eve and their unborn progeny in order to climb higher on the social scale. Nemesis pursues him at last across just such a lake as this in upper New York State. That chase, haunting and terrifying, is resonant with far-off echoes of Cooper's interminable pursuits. It marks the end of the American hero, at the place where he was born.

The lake is without wind: Lake Glimmerglass, the mirror. That, I think, is what gives Luminism its power. It deals with the fundamental American image of the birth of the new Adam through the ancient magic of the mirror. So it needs the water, not only because it is the baptismal element but because as we look into it, we are also looking into the sky, which is reflected by it. We merge with the cosmos and are reborn to the wholeness of things.

Or again, a painter like Fitz Hugh Lane is fundamentally a topographic artist who wants things to be clear and sharp. There is something in this that goes right back to the Colonial tradition of linearity, with its obsessive precision of form – to be found, as we have seen, in the work of Feke and Copley no less than in silver. Now, the water is like silver.

There is no doubt that, as a number of scholars have shown, some Luminist paintings resemble those of the English Pre-Raphaelites in their concern for linear clarity; yet the American paintings look rather different from them and from the other Northern European landscapes that can be cited in this connection. The water in Luminism is somehow more gleaming, and much more still. The lines are smoothed out into sheets of light coming out to infuse us with a special sense of transcendence, release, and expansion. Or perhaps it only seems so to me as an American. Association plays an enormous part in our experience of

works of art, after all. And these Luminist paintings do seem to embody the most lasting peace that Americans have yet been able to find – right there at home, sitting on their porches, looking out across the water, perhaps in Darien, Connecticut, where Kensett painted Long Island Sound. We have at least the feeling that something we have perceived from the beginning as deeply American, in architecture, furniture, and painting, is intensely present here.

It was the American Realist tradition that, despite Jefferson's Classical Ideal, shaped the core of the later nineteenth-century American experience as embodied in literature, architecture, and painting. The Stick Style is part of this tradition, as is much of the folk architecture of the middle of the century, especially that of the utopian religious group called the Shakers. It is like Luminism. In a Shaker Community Retiring Room such as the one in the Metropolitan, all the furniture is utterly simple and beautifully made. But unlike Colonial furniture, which was huge in a small space, this furniture is tiny in an expansive space, a space that is shaped by gleaming white plaster and defined by thin wooden stripping. We are in an environment that is plain, calm, quiet, linear, and light-filled: very much like Luminist painting.

Stage Fort Across Gloucester Harbor, 1862, by Fitz Hugh Lane (1804–1865). Oil on canvas, 38 × 60 inches. The Metropolitan Museum of Art, Purchase, Rogers and Fletcher Funds, Erving and Joyce Wolf Fund, Raymond J. Horowitz Gift, Bequest of Richard de Wolfe Brixey, by exchange, and John Osgood and Elizabeth Amis Cameron Blanchard Memorial Fund, 1978 (1978.203).

Shaker Retiring Room: woodwork from the North Family Dwelling House, built ca. 1835, New Lebanon, New York. Shown as installed in the American Wing, with a collection of furniture made in several Shaker communities. The Metropolitan Museum of Art, Purchase, 1981.

We can find that same bareness, thinness, spareness in many other American vernaculars, too, from the black cabins of the South with their narrow porches to the bungalows of California and even the Territorial adobes of the southwest, whose papery details are so different from those of their massive Hispanic-American forebears. All European visitors to America remark upon the lightness of its common architecture and the sense of touching imper-manence it imparts. The Shingle Style of the later nine-teenth century, no less than the renewed Classical Revival of which it was more or less a part, was to react against that thinness, as were the painters of the period, but in the midcentury, with Luminism and the Stick Style, it was the very breath of American art.

It is true that the Luminist world could have its own depths, its own menace, sometimes looking almost surreal to

The Coming Storm, *1859, by Martin Johnson Heade (1819–1904). Oil on canvas, 28 × 44 inches. The Metropolitan Museum of Art, Gift of Erving Wolf Foundation and Mr. and Mrs. Erving Wolf, 1975 (1975.160).*

twentieth-century eyes. *The Coming Storm* by Martin Johnson Heade, of 1859, shows black water with bright sunlight on both sides. It seems unreal, but water is indeed black, even in direct sun, when it is reflecting, according to our line of sight, a dark cloud beyond it. The whole feeling here is of the coming of violence. How that mast would act as a lightning conductor if one were caught under it, and how the boatman is frozen in place as he tries to row toward those strange figures on the shore with their backs to us. Only a man and his dog, but what is the actual scale of that strange, vaguely nautical object beside them? We are made to feel disoriented as the pressure changes before the storm.

How well named it was, Heade's painting, for 1859. The storm of the Civil War changed the United States forever. Some of its battlefield memorials tell its story well; Gettysburg, the climax, is the most moving of them all, and the National Park Service has turned it into one of the most affecting works of American art. Cemetery Ridge is the key. Across from it, five hundred yards away on the other side of the wheatfields, are the Southern guns, lined up behind General Lee on Traveller. Over there we feel the unity of an agrarian region in arms. But along the Union lines, the

monuments are different. Every one is special to itself – Irish, German, regiments from Pennsylvania, from New York, from all the Northern states. This is the heterogeneity of the new Union, the world of immigrants, of mass democracy, a whole new order taking shape. But what we feel most of all on Cemetery Ridge is the terrible butchery of this war, which culminated right here at the so-called Angle, where Pickett's great and terrible charge came directly across the fields and broke at the wall, where friends, old friends, wounded and killed each other.

How savage this war was, and sometimes how noble. For example, the few Confederates who got to the wall were led by General Lewis Armistead. The Union troops were commanded by his oldest friend, Winfield Scott Hancock. Armistead got as far as the guns, and laid his hand on one of them, and was shot down. As he lay dying in the arms of the Union officers who were doing their best to keep him alive, he asked for Hancock, and they told him that Hancock had just been hit. And he said something like, "Convey my regrets to General Hancock; tell him I'm very sorry."

The other thing we see at Gettysburg, in relation to the post–Civil War period, is the impoverished South: very few monuments. Just the guns coming up out of the woods, Lee up there on Traveller, and then that terrible distance across the fields, the path of Pickett's charge against those rich, those opulent, Union lines.

All of that can be felt in Winslow Homer's painting *Prisoners from the Front.* The Northern officer is clearly very well-meaning, well-fed, beautifully dressed, not very in-

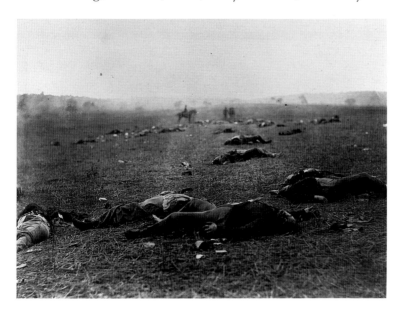

The Harvest of Death, *1863,*
photograph made at Gettysburg by Timothy
H. O'Sullivan. Yale University Photograph
and Slide Collection.

119

East Cemetery Hill, Gettysburg,
Pennsylvania, with artillery emplacements
and equestrian statue of General Hancock.
Photograph by David Muench.

Prisoners from the Front, *1866, by*
Winslow Homer (1836–1910). Oil on
canvas, 24 × 38 inches. The Metropolitan
Museum of Art, Gift of Mrs. Frank B.
Porter, 1922 (22.207).

volved. Facing him is a group that embodies every aspect of
the Southern experience. It is a marvelous confrontation
between North and South, of the kind Homer, as a war
correspondent for *Harper's,* had experienced firsthand.
There is the absolutely intransigent, lean soldier in his short
cavalry jacket, wholly unforgiving and dangerous as hell.
Behind him is the old man, ragged, cunning, the old soldier
who has been through a lot. But last of all is a figure that was
to haunt Homer later, and which he was to turn into the
image of the hunter, the young killer, the post–Civil War
Hawkeye. It is a boy, a lout of a boy, with big feet, big hands,
and his hat turned up in front. He is the hunter who keeps
appearing in all of Homer's later work. (That is the image
the young John Wayne, with a sure instinct for the arche-
type, was consciously or unconsciously to model himself
upon, even to the idiosyncratic hat and, in the hunter, the
double-breasted army shirt.)

 After the war, in Homer's painting *Veteran in a New Field,*
the veteran is still in his uniform, trying to adjust to scything
hay rather than men. He is wearing his old army trousers,
and we can just make out the insignia of the Army of the
Potomac on his knapsack, which is lying on the ground. It is

much the same with people after any war, after World War II or Vietnam. But it is as if, for Homer, only children can truly be at home in this new world of the after-war. Among all the scenes Homer paints, in these first years after the war, the most moving and convincing are those of children. That preoccupation with childhood is constant in America from this time on. It was not so before. Twain's *Tom Sawyer* was to set the tone in literature, addressing the lost childhood innocence of prewar days. Homer's *Snap the Whip* had already captured the visual image of Tom Sawyer, the barefoot small-town boy. But the whip snaps out with a control of space that reminds us of Poussin's classical figures dancing, even though Homer's space is defined by the typically American light wood structure, the schoolhouse, behind it. We feel the openness of the environment, a soft primitivism, setting off the classical garland of figures that Homer throws into it.

Homer also painted the new resort world of the post–Civil War period, with people bathing. His painting of three women and a dog on a beach reminds us a good deal of French Impressionist paintings of the same period, especially in the blond light and the beautiful color that runs through the sand. Moreover, the figures don't really seem to

Snap the Whip, *1872, by Winslow Homer. Oil on canvas, 12 × 20 inches. The Metropolitan Museum of Art, Gift of Christian A. Zabriskie, 1950 (50.41).*

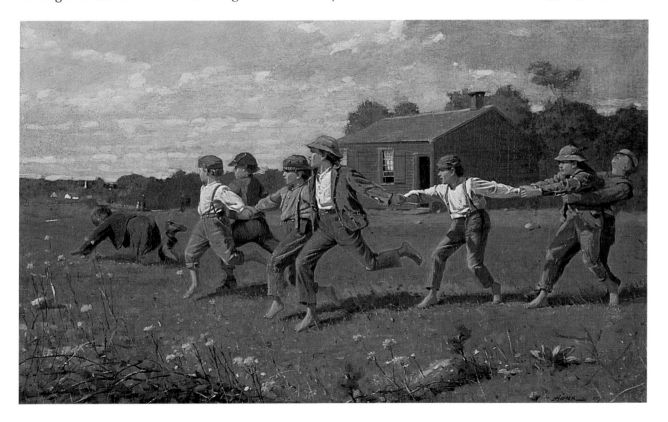

have any rational relationship to each other, and this curious disorientation can often be found in Impressionism as well. The girl in front is looking nowhere. The one in black is shrouded and turning away. The third bends over and seems to frighten the dog as she wrings out her skirt. Now we begin to understand why Homer normally called this painting *High Tide,* because we sense the depth of the water, not very great but still palpable. It has come in and deposited these giantesses on the sand, strange sea creatures, rather ominous, so that the dog starts back before a sea-nymph's hair.

One curious thing about Homer is that he worked out his mature relationship with nature in England. He went there in the early 1880s and stayed for two years. The watercolor *Inside the Bar,* in the Metropolitan, derives from his life in English fishing villages. Here Homer develops the image of a heroic humanity that stands up to nature as an adversary – nature that comes rolling in upon mankind in the force of the storm. That is the relationship Homer explores all the rest of his life. It is not the old Luminism, where one sits and quietly contemplates a calm lake or harbor. Rather, it is men confronting, most of all, the old sea, which crashes in upon them with unappeasable power. Thoreau had felt it and heard it pounding on the outer beaches of Cape Cod. He

Inside the Bar, 1883, by Winslow Homer. Pencil and watercolor on paper, 15⅜ × 28½ inches. The Metropolitan Museum of Art, Gift of Louise Ryals Arkell, in memory of Bartlett Arkell, 1954 (1954.183).

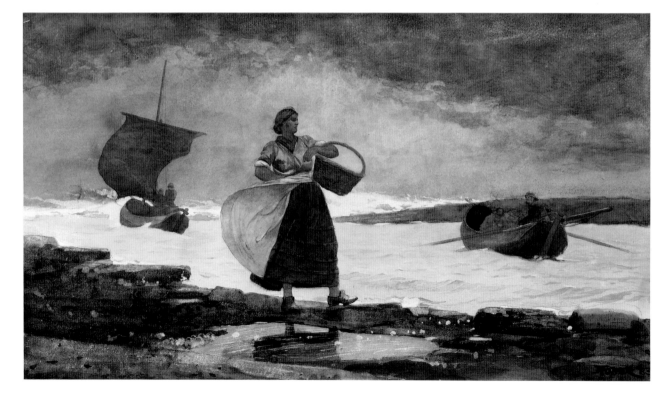

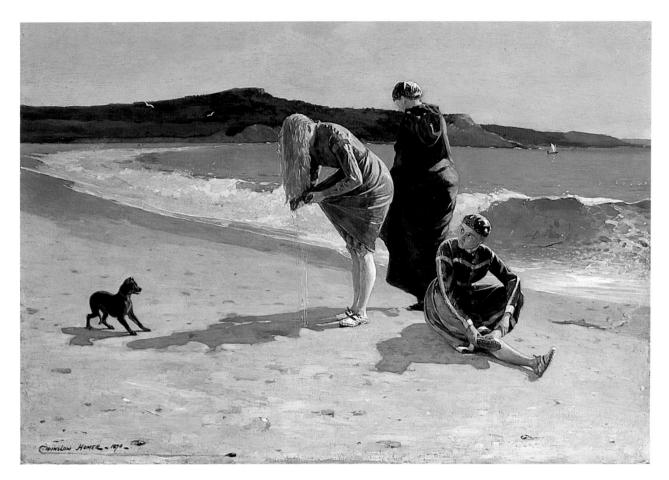

quoted the other Homer in order to describe it, the Homer who wrote of the *poluphloisboio thalasses,* the many-voiced, roaring sea.

Out of that background come Homer's great paintings of work, after he retreats from New York to Prout's Neck in Maine. Out on the sea's waste the dories of New England balance, and the fishermen ply their trade. Homer paints them in all the grandeur of human labor. In *The Herring Net,* in the Art Institute of Chicago, they are giant, faceless beings, rising together with the boat like a heavy pediment out of the sea, the herring shining in the net, the dory displacing a certain volume of water, the sea-swells lifting and carrying the whole great weight along, through, almost out of, the canvas. A sea shimmer flickers over everything, and indeed light becomes Homer's major concern in later paintings. That concern eventually leads him to the Caribbean, where his watercolors become electric, incandescent.

The Caribbean is also the setting for Homer's most famous – and most problematic – painting of men and the sea, *The Gulf Stream,* of 1899. Homer was clearly trying to

Eagle Head, Manchester, Massachusetts *(also called* High Tide: The Bathers), *1870, by Winslow Homer. Oil on canvas, 26 × 38 inches. The Metropolitan Museum of Art, Gift of Mrs. William F. Milton, 1923 (23.77.2).*

The Herring Net, *1885, by Winslow Homer. Oil on canvas, 30¼ × 48½ inches. The Art Institute of Chicago.*

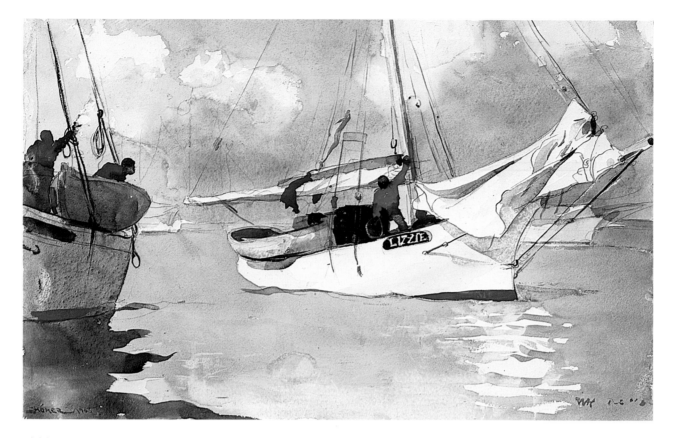

Fishing Boats, Key West, *1903, by Winslow Homer. Watercolor and graphite on paper, 13⅜ × 12½ inches. The Metropolitan Museum of Art, Amelia B. Lazarus Fund, 1910 (10.228.1).*

work here at the very limit of his conceptual and technical powers, and whenever he was asked about the picture, he returned markedly snappish replies. The theme he set out to explore obviously tormented him: he casts a black man on the deep billows of the sea. His painting of black people reminds us that William Sidney Mount and others had painted blacks with sympathy and gentleness in the pre–Civil War period. Homer's treatment is different, not quite so gentle. There is one painting in the Metropolitan called *Dressing for the Carnival,* in which a young black man is dressing up in costume. Behind him are little children carrying American flags, their faces open and full of hope, and the figure of the mother; she holds the whole thing together. We feel, in that hot, dappled Southern light, that Homer has a sense of the limitation of opportunity for the black man in America: he has only the fancy dress, though the children still have hope and the mother power over her own.

In *The Gulf Stream,* Homer takes that young black man and puts him in a boat. We are reminded of Bingham, in the issue of race, but most of all of *Moby Dick,* where Melville has all the brown and black races dragged down into the sea in the white man's ship, a kind of sacrifice to the white man's

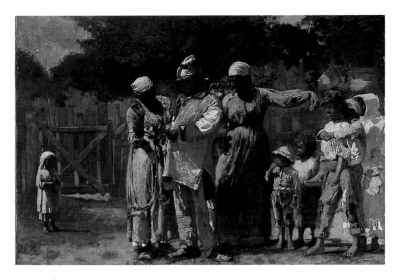

Dressing for the Carnival, *1877, by Winslow Homer. Oil on canvas, 20 × 30 inches. The Metropolitan Museum of Art, Amelia B. Lazarus Fund, 1922 (22.220).*

ambition and his ruthlessness. The black man in *The Gulf Stream* is not actually bound but lying on a tangle of rope that suggests binding and thus slavery. Below him, in the sea, the sharks and the streaks of red, like blood, clearly show that Homer is trying to deal with his theme in an epic, tragic, and violent way. Copley's *Watson and the Shark* (page 54) and Turner's *The Slave Ship* are both recalled here, but Homer paints the sea in a way those painters could never have done. He paints it coming at us, as if it is about to flood

The Gulf Stream, *1899, by Winslow Homer. Oil on canvas, 28⅛ × 49⅛ inches. The Metropolitan Museum of Art, Wolfe Fund, 1906. Catharine Lorillard Wolfe Collection, 1906 (06.1234).*

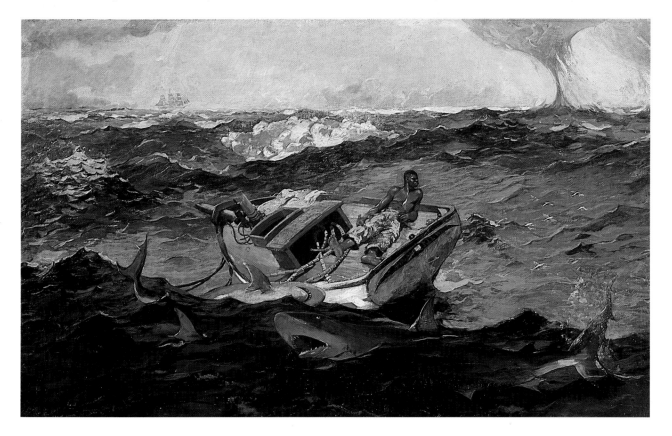

out of the frame and spill the sharks upon us. But the figure of the black man on the diagonal, and the boat set back in the trough, carry our eyes back into the picture and so hold the deep water there, flooding up just behind the frame. And we, the spectators, are just barely preserved from the sea.

But in the two paintings next to *The Gulf Stream* in the Metropolitan, the sea does seem to rise up and inundate the room. In *Northeaster* it beats against the rocks in a shower of white and purple spray. Then the undertow pulls back and seems to go up behind the frame. Indeed, as the paintings are hung in the museum, the sea seems to go behind the wall of the gallery itself and to rise up on the other side, behind the V of *Cannon Rock,* in a great body of water that culminates in a roller high above our heads, aimed at us, coming forward to drown our world. We could hardly be further from Luminism. The garden is gone, and the pact of friendship between man and nature, which Americans had desired so intensely, is no more. Only elemental threat remains: the Deluge.

Northeaster, 1895, by Winslow Homer. Oil on canvas, 34½ × 50 inches. The Metropolitan Museum of Art, Gift of George A. Hearn, 1910 (10.64.5).

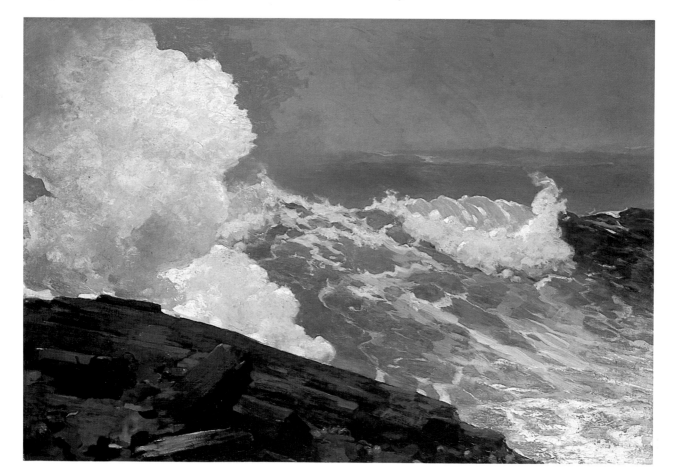

Cannon Rock, *1895, by Winslow Homer.*
Oil on canvas, 40 × 40 inches. The
Metropolitan Museum of Art, Gift of
George A. Hearn, 1906 (06.1281).

William Watts Sherman House, 1874–1875, Newport, Rhode Island, designed by Henry Hobson Richardson (1838–1886). Photograph by Sandak.

Archway, Ames Gate Lodge, 1880–1881, North Easton, Massachusetts, designed by Henry Hobson Richardson. Photograph by Sandak.

That embodiment of the power of the earth, that dark power, was shared by American architecture during those decades. It dealt with forms evoking those of nature, and of a natural awesomeness. The buildings tend to be dark and pebbly, like the Watts Sherman House in Newport, by Henry Hobson Richardson, of 1874. The Watts Sherman House has a vast, open area of interior space, which is expressed by the strong horizontality and the big, frontal gable of the exterior. The whole becomes expansive, continuous. The space flows horizontally and pulls us into its shadows, just as Homer pulls us into the sea. The majestic gable is a great triangle, an inverse of the one in Homer's *Cannon Rock,* and like the wave in that painting it rises over our heads above the entrance, an image of engulfment, once more in classically pedimental form.

The Shingle Style in general, of which the Watts Sherman House was the first example, is distinguished from the articulated skeleton of the Stick Style of the previous generation by precisely that continuity of surface, that

130

spatial engulfment, and that monumental geometric power. All of it seems in the end to represent an attempt to get closer to the elemental wildness of nature, and to its force.

Elsewhere, Richardson uses great boulders and cavernous arches to achieve those same effects and to give the impression that the building is as old as time. Earlier Americans, as we have noted, attempted to achieve antiquity; Richardson makes us believe in it. The Colonial Revival, which began in the early 1870s and gained decisive impetus from the time of the Philadelphia Centennial of 1876, had similar objectives, and Richardson and his followers were involved with it. McKim, Mead and White's Bell House, for example, is simply a Colonial house to which Oriental porches and French towers have been added. But all is made to flow together by the new, dark shingle covering, warm and changing as if it were a natural growth. The sense is one of nature and human geometry working in unison to enhance

Isaac Bell House, 1882–1883, Newport, Rhode Island, designed by McKim, Mead and White. Photograph by Wayne Andrews.

131

the potency of things. Homer's and Richardson's works are alike in this.

Albert Pinkham Ryder's paintings in the Metropolitan should also be seen in the context of the Shingle Style. They geometricize and abstract in an architectural way, markedly more so than Homer's paintings do. The patterns they make recall the shapes of contemporary houses, as do their rich textures, their darkness, and their magical evocation of the sea.

Homer's greatest contemporary in painting was Thomas Eakins of Philadelphia. Unlike Homer, Eakins was primarily interested not in wild nature but in human character in the city. So when he paints his friends, such as Max Schmitt in his scull, he puts them in nature but still in the city, rowing on the calm waters of the Schuylkill in Philadelphia. Eakins wants to do very traditional things here. Like a Renaissance master, he wants to lay the scene out in clear linear perspective, and there are beautiful drawings by him which show that. Then he wants to place a visually real and at the same time sculpturally solid image of mankind – for exam-

Max Schmitt in a Single Scull (*also called* The Champion Single Sculls), *1871, by Thomas Eakins (1844–1916). Oil on canvas, 32¼ × 46¼ inches. The Metropolitan Museum of Art, Alfred N. Punnett Fund and Gift of George D. Pratt, 1934 (34.92).*

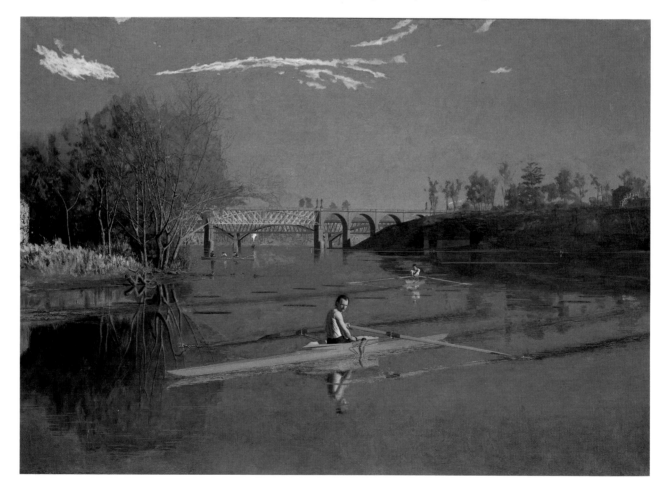

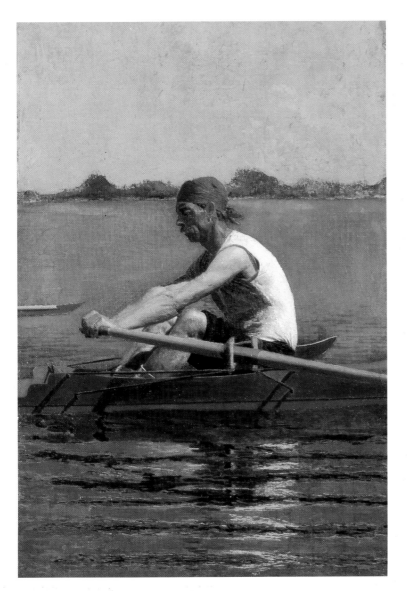

John Biglin in a Single Scull, *1874, by Thomas Eakins. Oil on canvas, 24¹/₁₆ × 16 inches. Yale University Art Gallery, Whitney Collections of Sporting Art, given in memory of Harry Payne Whitney and Payne Whitney by Francis P. Garvan.*

ple his friend John Biglin – right in the middle of the space, in the center of an ordered world. He wants it all absolutely still, as still as a Luminist landscape, and as bright. It is also heroic – not in Homer's violent way but once again in the old, classic, academic manner Eakins had been taught by his master, Gérôme, at the Beaux-Arts in Paris.

On the one hand the subject is just people sculling, with Max Schmitt sliding across the surface of the water while another shell, marked *Eakins* on the stern, is being rowed, beat by beat, behind him. But it is all frozen in a composition that makes it timeless. The thin clouds echo the shape of the bridge, and their two arcs resonate off the blond figure of the man poised in the center on the water's shining plane.

Certainly one reason Eakins' paintings tend to look frozen

Moonlight Marine, *1870s or 1880s, by Albert Pinkham Ryder (1847–1917). Oil and possibly wax on wood, 11½ × 12 inches. The Metropolitan Museum of Art, Samuel D. Lee Fund, 1934 (34.55).*

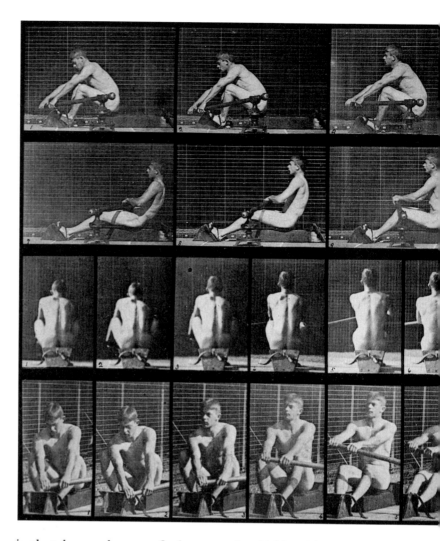

Nude Male Rowing, *photographs by Eadweard Muybridge (1830–1904), published in his* Animal Locomotion, *1887.*

is that he made use of photographs. Eakins himself took many spectacular photographs, most of them of human beings carefully posed, often in the nude, in order to achieve classical or realist effects. While it is true that the photographs of Eadweard Muybridge, which Eakins also used, are in one sense the foundation for the idea of the motion picture, they themselves in fact *freeze* motion by giving us absolutely still, sequential images of it.

But Eakins' work is not really photographic. He is traditionally, pictorially, academic, perhaps more wholly so than any American painter before him. Because of that, he looked very dated to many of us not so long ago. Now, however, some of the most advanced European painting of the period looks rather flimsy in comparison. What strikes us now is that Eakins' paintings, which for him were a representation of the human figure in space, are completely realized. They are three-dimensionally solid. They are *there,* exactly as he wanted them to be. We should look at his little

134

Chess Players in that regard. Again, it is a figural triangle, as solidly pedimental as anything from Greece. But Eakins' figures are not defined by line and plane in clear light; rather, as in Rembrandt's work, they are shaped by the optical modeling of light and shade, by chiaroscuro. Such modeling out of darkness is precisely that of the late-nineteenth-century urban interiors Eakins knew. The carpets are heavy, and the drapes are closed against the outside. The furniture stands massive, filling up the space, dominating the environment; the household divinities are consuming the room. Eastman Johnson's *Hatch Family* records that condition, but Eakins' painting is a deeply poetic evocation of its atmosphere, excavating the darkness with flecks and facets of light that flicker on the glassware and then fall on the heads, shaping them into their composition: a dark jewel, glowing in the center of the deeper darkness. So out of that little picture comes an enormous power, and that power is one of light.

135

The Chess Players, *1876, by Thomas
Eakins. Oil on wood, 11¾ × 16¾ inches.
The Metropolitan Museum of Art, Gift of
the artist, 1881 (81.14).*

The Hatch Family, *1871, by Eastman
Johnson (1824–1906). Oil on canvas, 48
× 73⅜ inches. The Metropolitan Museum
of Art, Gift of Frederic H. Hatch, 1926
(26.97).*

Most of all, Eakins uses every skill he has to explore the character of human beings, to describe them truly and with desperate human love. In his painting of his father, the same pyramidal organization employed in *The Chess Players* creates formal stability and grandeur. But it is a pyramid that is internal, turned inside. The father's head is down; he doesn't look at us. It is his hands that are in the forward plane, and we feel that those hands are loved by Eakins. He looks at them, with pitiless scrutiny, for the decay of age. They are so expert, those hands, but all blotched with time. Again, the face, with all its accidents of aging, is turned down, away from us. This skillful old man is in his own world, set apart from us. We feel the desire of the son to try

The Writing Master (*portrait of the artist's father, Benjamin Eakins*), *1882, by Thomas Eakins. Oil on canvas, 30 × 30¼ inches. The Metropolitan Museum of Art, John Stewart Kennedy Fund, 1917* (*17.173*).

to make contact with his father, but the utter impossibility of achieving it.

Eakins also painted his fiancée Katherine Crowell, who died before they could be married. Her portrait at Yale should be compared with Copley's of Mrs. Isaac Smith, in the same gallery. They mark two poles of American materialist culture, and of American realism. In Copley's portrait (page 49), as we have seen, Mrs. Smith is as real as her furniture, and dominates it; she sits right at the beginning of the middle-class immurement of the woman in the house, and of her deification as its goddess, both of which were to become fundamental to the family structure of the nineteenth century. Poor Katherine comes along toward the climax of that development. Now the furniture looms up and dominates *her*. The arms of a chair, like the paws of some monstrous animal, reach around her shrinking body, which seems to have lost all corporality, and a high bookcase looms dark above her. She is eaten up by the enclosure, by

Girl with a Cat – Katherine *(portrait of Katherine Crowell), 1872, by Thomas Eakins. Oil on canvas, 62¾ × 48¼ inches. Yale University Art Gallery, Bequest of Stephen Carlton Clark, B.A. 1903 (1961.18.17).*

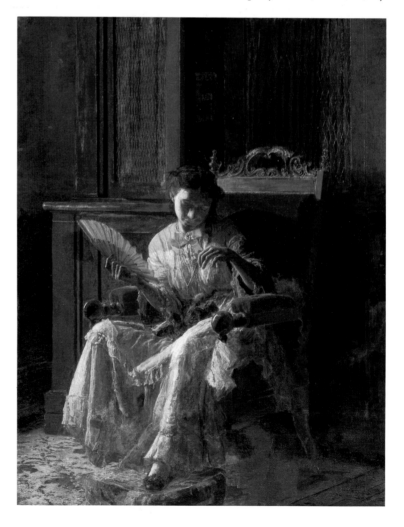

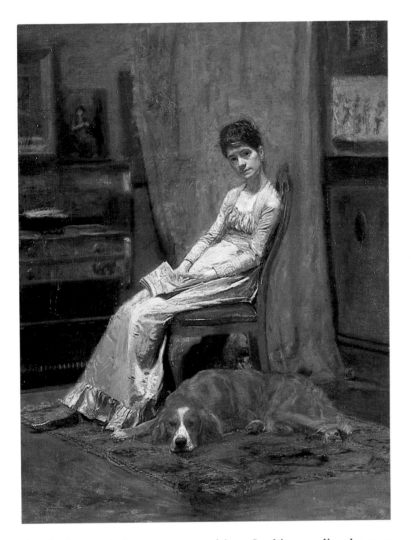

The Artist's Wife and His Setter Dog, 1885, by Thomas Eakins. Oil on canvas, 30 × 23 inches. The Metropolitan Museum of Art, Fletcher Fund, 1923 (23.139).

the darkness. Eakins sees everything. Seeking reality, he sees into it, behind it.

When, later, Eakins paints his wife, he puts her in a Queen Anne chair, or perhaps a Queen Anne Revival chair. We remember the way Feke used the lively curves of such a chair in the lively curves of his figures (page 32); here Eakins uses those lines in just the opposite way. He has his wife lean back into the backward curve of the splat as if she had no capacity to stand upright at all, as if she had found her last resting place. We know that she was young when he painted her, but as he worked on her portrait he progressively aged her and made her thinner and thinner until finally she too, like Katherine, seems to have almost no body at all. Her eyes are dark, deeply shadowed. Her hand rests on her knee like an old woman's hand, corded and powerless. Down below her weightless figure lies Harry, their dog, all red and warm, an animal presence on the rich Turkey rug. But the top of the pyramid is that figure of exhaustion in her icy blue dress,

The Thinker: Portrait of
Louis N. Kenton, *1900, by
Thomas Eakins. Oil on canvas,
82 × 42 inches. The Metropolitan
Museum of Art, John Stewart
Kennedy Fund, 1917 (17.172).*

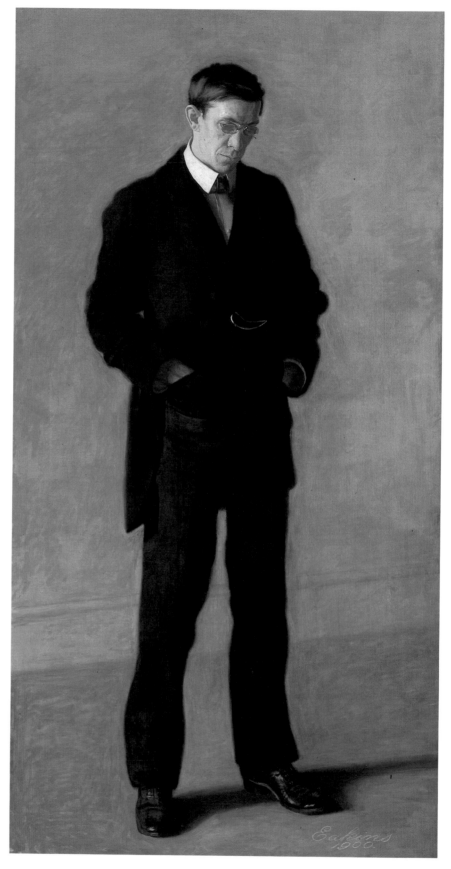

with just one touch of coquetry exposed in the red stocking. It is as if Eakins wanted to go in and lift her up, weightless as she is, but was driven to look and record, to imagine. He is painting his fears about the inevitable realities of the human condition, about the fact that organisms run down.

In so doing, it seems to me, he becomes the greatest painter of love and mortality that America has ever produced. He stands with Rembrandt in the portrayal of loss and aging. He sees it most agonizingly in those he most loves: his father, his lost fiancée, and his wife.

Somewhat later, like Ralph Earl, he paints the lanky American. But times have changed; if the woman seems worn, the American hero just seems worn out in Eakins' portrait of his brother-in-law, Louis Kenton, a painting that is sometimes called *The Thinker*. Again, the subject is very thin. But the marvelous thing is that Eakins, who has only the outline of the suit to work with, can make us feel the way the clothes hang on the body and, within that, how the bone and skinny ripcord muscle is all slumped on its skeleton in space. This person is just as real as any Copley painted, but he is not a confident, furniture-like mass in space, as Copley's figures were. Eakins' Kenton is articulated, highly suffering, a tired human being.

In all that, Kenton differs from similar standing figures by Eakins' contemporary Whistler, such as the portrait of Théodore Duret. Both were inspired by Velasquez, but the Whistler is decoratively, and the Eakins psychologically, conceived. Duret is kept flat; Kenton is tilted forward to put some weight on his knees and to shift him forward into our space. Duret goes very well with similar semiclassical, semi-Japanese pieces of furniture from the same period, such as the elegant wardrobe by Herter Brothers in the Metropolitan.

But it is not overstatement to say that Eakins' work marks the climax of American realism; as such, his Kenton can be compared to the skyscrapers of Louis Sullivan. The light, thin, vertical skeleton inside Kenton is a good deal like the steel skeletons inside the skyscrapers Sullivan was designing at just this time. They both grow out of the reality of the American situation – for Sullivan, the reality of the office-building program for Mr. Smith. From that point of view, nothing could be more obvious and apparent. It is a thin, metal skeleton that Sullivan sheathes with masonry or terra

Arrangement in Flesh Colour and Black: Portrait of Théodore Duret, *ca. 1883, by James McNeill Whistler (1834–1903). Oil on canvas, 76 ⅛ × 35¾ inches. The Metropolitan Museum of Art, Wolfe Fund, Catharine Lorillard Wolfe Collection, 1913 (13.20).*

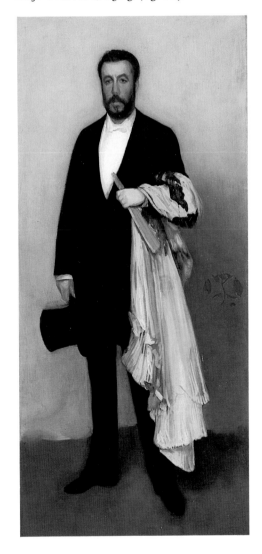

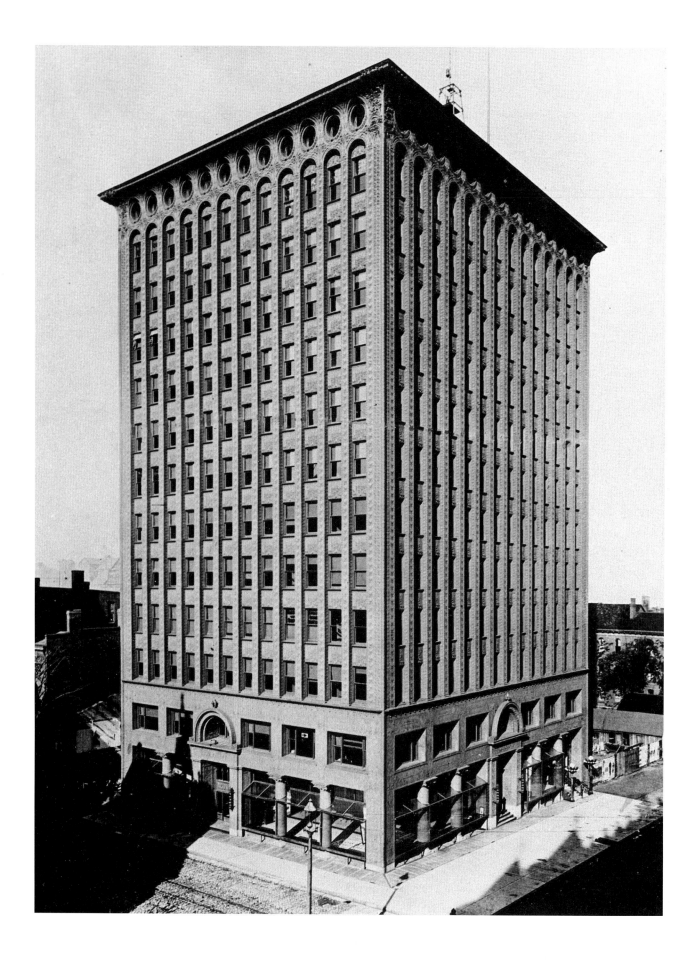

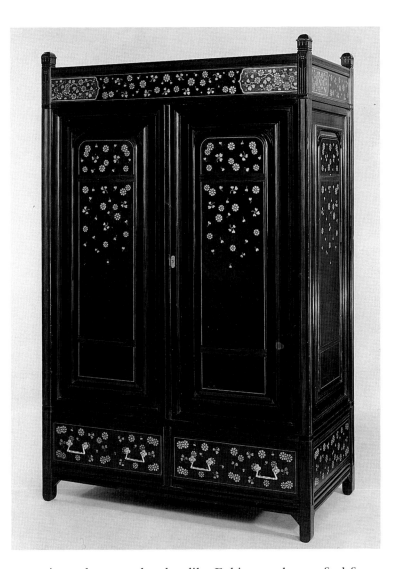

Guaranty Building, 1894–1895, Buffalo, New York, designed by Adler and Sullivan. Photograph, ca. 1933, by Fuermann.

Wardrobe, ebonized cherry with inlaid woods, 1880–1885, New York, made by Herter Brothers. Height 78½ inches. The Metropolitan Museum of Art, Gift of Kenneth O. Smith, 1969 (69.140).

cotta, in such a way that he, like Eakins, makes us feel from the outside what the interior structure is like.

The Wainwright Building is as common as Downtown – clad in common midwestern red brick, as ubiquitous in the American business district as is the rusty business suit that Louis Kenton wears. It is as much a product as Kenton of the American realist tradition, now probing down into the skeletal structure shared by man and skyscraper alike.

We feel it even more, this human tallness, in the Guaranty Building, where the sheathing looks thinner and lighter because it is of terra cotta rather than brick and masonry. Its forms are fluid, like those of the metal surface of Sullivan's stairs from the Chicago Stock Exchange, now in the Metropolitan: enormous virtuosity in metal, the forms curving continuously through and past each other, all on one plane, like energy running up and down the stairs through a slender body.

Wainwright Building, 1890–1891, St. Louis, Missouri, designed by Adler and Sullivan, as illustrated on the cover of the magazine Historic Preservation *for October–December 1974.*

Sullivan welcomed that reference to the human figure because he believed in what nineteenth- and early-twentieth-century critics called empathy (I believe in it too, which should be obvious), whereby we experience buildings, and indeed all works of art, in part through our association of them with our own bodily stance. We stand on our two feet. We carry weight. And Sullivan once said of a building by Richardson: "Here is a man for you to look at . . . who stands on two feet, stretches and stirs." That of course is preeminently what Sullivan's skyscrapers do. They stand right on the American sidewalk, filling the blocks that are created by the American grid plan. And this is what Kenton does as well, standing in our own space, in his scuffed old shoes. Those shoes are significant enough, historically speaking, because at the very beginning of European Realism Baudelaire had called upon painters to "make us heroic in our varnished boots." Here are badly shined shoes, through which we feel the weariness of the feet inside them: the exhaustion of those late-nineteenth-century feet walking not on the bare earth but endlessly up and down on miles of hard urban pavement, as feet had never been required to do before.

The major point of the skyscraper, too, is not its structure or even the individual building itself, but rather the building in relation to the city as a whole, the building as a type out of which the city can be shaped. Here, in the Chicago skyscraper, the basic fact is the American grid plan. The Loop is the old grid compacted, wholly built up, with all open spaces, except those of the streets, squeezed out of it. The Chicago architects, in part through the realistic demands of economics, did just the right thing with that grid. They filled each lot, defined the street, and shot upward – but only to a certain height. The Monadnock's sixteen floors were close to the maximum, and they were also the most completely expressive of the new vertical impulse and its resultant continuities. But the Monadnock remained a traditional palazzo: solid, able to shape the street and to keep the whole fabric of the city strong. The Home Insurance Building, the first example of the new skeletal skyscraper construction, is of course much less attractive and grand than the Monadnock – underscoring the point that structure is not the main issue here – but it basically tries to do the same thing, to keep the block dense and to define the street in the traditional way. It strives to do so primarily with

horizontal stringcourses, and perhaps not too unsuccess-fully. Sullivan, who took the vertical route in the Wainright and the Guaranty, finally emphasized the horizontal with great power in the Carson-Pirie-Scott Store, where the velocity of the modern street and the dynamism of its corners are embodied without having their traditional order destroyed. The building still wholly respects and indeed dramatizes the structure of Chicago's Loop. That is some-thing all the buildings in the Loop have continued to do until this day – when those by Helmut Jahn, eccentrically designed and blasting diagonally across the Loop's blocks, are beginning to blow its structure apart.

Sullivan was very good at all this and clearly understood the urban issue perfectly well. Paradoxically, through an accident of commissioning, we can best see him at work in St. Louis. His Wainwright Building there, which we have already considered largely for itself alone, is, in fact, de-signed to be seen as part of a group of buildings placed flush with the street. The determination of the city of St. Louis to develop an open mall has resulted in the demolition of the two buildings to the south of the Wainwright (as well as the one to the north) and has destroyed that calculated relation-ship. It has exposed the Wainwright to a vast open space for which it was never intended and has left it in the company

View of downtown Chicago fronting Lake Michigan, showing the formal garden designed in 1909 by Daniel H. Burnham (1846–1912), the Loop, and the western suburbs. Yale University Photograph and Slide Collection.

145

only of the revolting parking garage next door. As it all stood a few years ago, the relationships were eloquent ones. Each building was a similar block, but each was decorated in a different way. This is the traditional, classic solution to the problem of urban building; again, it is a question of type. Palladio does no more or less in Vicenza. Each palazzo defines the street and gets along with all the others, but each is an individual because each has its own special decoration. The most brilliant of Palladio's variations is the one he employs on the Palazzo Valmarana, where the base seems actively pushed down, and the attic pushed up, by the colossal flat pilasters. This is exactly what Sullivan does with the Wainwright, thus causing it to stand out among its neighbors as the Valmarana does among its own. With the densely grouped vertical piers, Sullivan is also able to give a sense of the skeleton without at the same time destroying the solidity of the palazzo block. The Wainwright remains a solid chunk. Or rather, it did so until the buildings around it were torn down in a well-meaning but misguided attempt to set it off in space.

Though the jury (of which I was a part) strongly recommended that no more buildings be removed, it did select a proposal that did not provide for filling in the space left by a building that had already been demolished, so that, coupled with new demolitions, a grave urban mistake now stands fully revealed. The Wainwright loses everything; it is seen as being only a couple of bays deep at the ends, with undesigned brick walls behind those bays. Its majestic block is gone. The wonderful midwestern alleys, places of great urban drama between buildings, have been replaced by trivial, decoratorish open spaces. It is sad to realize that the very best intentions in the world ended up delivering the Wainwright over to sensibilities fundamentally in accord with those of the International Style, which has consistently destroyed that very urban compact between buildings upon which the Wainwright depended and which it so brilliantly expressed. The Lever Brothers Building pretty much started the destruction by tearing a hole in Park Avenue and turning its slab against the plane of the street in order to stand out willfully in a void. *Look at me, look at me,* it cried, in the manner of the Bauhaus, which despised the traditional urban fabric and maintained that the objective of all design was the building itself. Wrong, of course; the objective is the city as a whole. So Lever was clad in shiny plastic and glass to

Lever Brothers Building, 1952, Park Avenue, New York, designed by Skidmore, Owings, and Merrill. Photograph by Sandak.

*Public Services Building, 1982, Portland,
Oregon, designed by Michael Graves
(b. 1934). Photograph courtesy of Michael
Graves.*

stand out against the brown masonry buildings around it.
Now they have all been replaced by equally glassy slabs, so
that the only building that stands out now is the solitary
survivor of the holocaust: McKim, Mead and White's solid
brown Racquet Club next door. That seems fair enough,
but the anti-urbanism so effectively initiated by Lever Broth-
ers has proved to be a deeply destructive one everywhere. It
has torn apart the centers of our cities all over the country.
Denver is an especially moving example; its old office
buildings were so solid and good, and its new ones, begin-
ning with Pei's Mile High Center, are ultimately so destruc-
tive of the urban structure as a whole.

In Portland, Oregon, the process of disintegration has at
least been arrested by Michael Graves' Public Services
Building. Here Graves has tried to design a center-city
building in the traditional way, as a palazzo block, deco-
rated. In so doing, he has endeavored to pick up the scale,
the colors, and some of the details of the Sullivanian
survivors of Portland's downtown, which was an especially
distinguished one. In this, Portland is blessed with both a
splendid topography and an intimately scaled, square grid.
Each block is small enough to suggest occupation by one
building, which thus becomes a true palazzo, since *"fare un*

giro del palazzo" is to go around the block. Graves' building is the natural completion of that grid. Even in plan, its formal adherence to the urban order can be seen, in contrast to the anarchic antics of the International Style buildings around it. Here moderate height, too, is important: Portland's downtown occupies a narrow strip of land between the Willamette River and the bluffs beyond it. Those bluffs are of moderate size, and their chunky masses are crowned with houses. Graves' building gives the impression of reflecting the bluffs' scale, and the little village he projected for its summit would have echoed the houses on theirs. His conception is thus doubly contextual, both with the existing man-made place and with the natural environment. One could in fact have done no more at Teotihuacán. Graves' building on its site also shows us that in some places buildings can be too high, as the International Style high rises around it now seem to be. His is the right size and shape for the place.

To return to 1900, the city of cities was New York. There the painters of the so-called Ashcan School of the early twentieth century were the first to respond to the new urban conditions in which an increasing number of Americans now lived. They were perhaps also the last champions of American Realism before abstract art began to affect American painting in fundamental ways after the Armory Show of 1913. Sloan's curious little painting of a storm on Fifth Avenue shows a world in turmoil under the rising prow of the Flatiron Building, by Richard Morris Hunt, of 1902.

Dust Storm, Fifth Avenue, *1906, by John Sloan (1871–1951). Oil on canvas, 22 × 27 inches. The Metropolitan Museum of Art, George A. Hearn Fund, 1921 (21.41.2).*

The Flatiron Building itself was based on a Sullivanian model – a Chicago model, that is – but it was transformed into something very different by the converging street systems of downtown New York. It became a prow, or a spire. Indeed, from the very beginning the skyscrapers of New York were determined to leap high into space, unlike those of Sullivan and of the other Midwestern architects, which were simple cubes of moderate height. The New York skyscrapers wanted to break out of the cube and to point, like the church spires of Colonial America, like those that had formed the urban profiles of Colonial Boston and New York. Trinity Church near the tip of Manhattan is a good example of the type as it was rebuilt many times on into the nineteenth century. And, perhaps unconsciously, its combination of bigger, lower block and pointing tower became a kind of type model for the earliest tall buildings, from Hunt's Tribune to LeBrun's Metropolitan Life and Flagg's Singer.

Cass Gilbert's great Woolworth Building is the climax of that, with a wonderful continuity from sidewalk to tower, which gestures splendidly to the river and the bay. It was then joined by other towers leaping upward to a whole new world of urban fantasy that has since become, despite everything, the admiration and delight of all mankind – seeming to fulfill, with wonder, the promise of a new freedom, a new joy, that the Statue of Liberty, a gift from France, so proudly makes as it lifts its torch above the harbor.

We have already seen how, when they found in the twenties that they must go higher yet, the skyscrapers of New York invoked the setbacks of the oldest American tradition and leaped to the sky gods like the temples of Tikal. But the Empire State and Chrysler buildings and Rockefeller Center were later all cast into absurd critical doubt by the flat slabs of the International Style, such as the United Nations Secretariat to the east, Chase Manhattan and the World Trade Center downtown, and the Pan Am Building smothering Park Avenue. The destructive reign of these abstractions is now being challenged everywhere, by Johnson's decisive AT&T on Madison Avenue and by Pelli's majestic Battery Park at the very tip of Manhattan. The setbacks have returned, along with the strong stance on the street and the lifting sky-profiles.

Between the office building and the suburban house, a

151

Madame X (portrait of Madame
Pierre Gautreau), 1884, by John
Singer Sargent (1856–1925).
Oil on canvas, 82⅛ × 43¼
inches. The Metropolitan
Museum of Art, Arthur Hoppock
Hearn Fund, 1916 (16.53).

Skyscrapers at the tip of Manhattan Island, 1932. Yale University Photograph and Slide Collection.

new social pattern was created. By the late nineteenth century, the American way of life was getting very rich indeed for some people. Their pride of possession recalls Colonial materialism, but now there was so much money, and pride in the status symbols of position had become so exaggerated, that the word *society* assumed a character it had never really had before.

With Sargent's *Madame X* we are not dealing with American realism at all. A critic of the time said that Sargent was turning a woman into an idol in this painting, and indeed he is. He gives her the half-moon of Artemis to wear in her hair. She is seductive, wielding power through her sex. Sargent turns her into a dangerous goddess. In that guise, she is then related to the new type of the society hostess of the late nineteenth century. Painting the hostess that way, Sargent has her take a kind of woman's revenge on those men who, throughout the entire century, had in fact done their best to shut her up in the house.

The painting of Mr. and Mrs. I. N. Phelps Stokes was originally intended to be of Mrs. Stokes with a Great Dane dog. Sargent had a great deal of trouble painting her, especially in finding the proper costume. But one day when she came in from tennis he liked what he saw, and he painted her in the white duck skirt and the mannish jacket and tie. Then he substituted her husband for the dog. The husband is in the background, a pallid shadow compared to her, brilliant in the foreground. Her hand was originally

The Wyndham Sisters, *1899, by John Singer Sargent. Oil on canvas, 115 × 84⅛ inches. The Metropolitan Museum of Art, Wolfe Fund, Catherine Lorillard Wolfe Collection, 1927 (27.67).*

intended to be on the dog's head, but in the recast painting it seems to be blocking her husband's sex with her hat. So there is some sense here that Sargent is making an image of the dominant female, the hostess in her house, and of the husband of late-nineteenth-century American mythology who treads softly in that house and is subservient to her. It is all very reminiscent of Henry James, with his vibrant women and lackluster men. But there is a poignancy in it, too, as it deals with marriage, loneliness, and loyalty.

In *The Wyndham Sisters,* of 1899, the women have it all to themselves. They are in an enormous room that is dominated by a portrait, not of their father but of their mother. The descent is matrilineal. It is the mother goddess and the Three Graces, or the Three Fates, or Freud's "Three Caskets" (which he wrote about later from materials he was putting together in exactly these years). Most of all, it is an image of the woman, the society hostess triumphant, dominating her environment, which is now an extension of her

Lady at the Tea Table, *1885, by Mary Cassatt (1844–1926). Oil on canvas, 29 × 24 inches. The Metropolitan Museum of Art, Gift of the artist, 1923 (23.101). Photograph by Geoffrey Clements.*

own grandeur. Mary Cassatt was also painting dominant, if rather less flamboyant, women at this time: mothers, quiet, nurturing goddesses. But Sargent is painting witches, flooding out in a magical flow of white oil across the canvas.

Like Copley's people, Sargent's consume space. They eat it up; they take it over. But now it is no longer a restricted Colonial domestic space but the vast imperial spaces of the late nineteenth century. Moreover, Sargent's brushstroke resembles the treatment of silver during this period; it has a sheen and a thickness that are almost oily, all fluid and shiny. Silver becomes a thick liquid stream in the great pieces made by the Gorham Silver Company, of the type it called martelé (hammered) – not at all like the hard, tight sheets or the stretched surfaces of the earlier silver.

So we cannot help but feel that there is another kind of climax and a new kind of integration in the materialist tradition just before World War I. It is different from the tradition carried on by Eakins and Sullivan, but it, too, is

Ewer on plateau, silver, 1901–1913, Providence, Rhode Island, made by the Gorham Silver Company. Length 11⅛ inches. The Metropolitan Museum of Art, Gift of Mr. and Mrs. Samuel Schwartz, 1976 (1976.196.1 a, b, c).

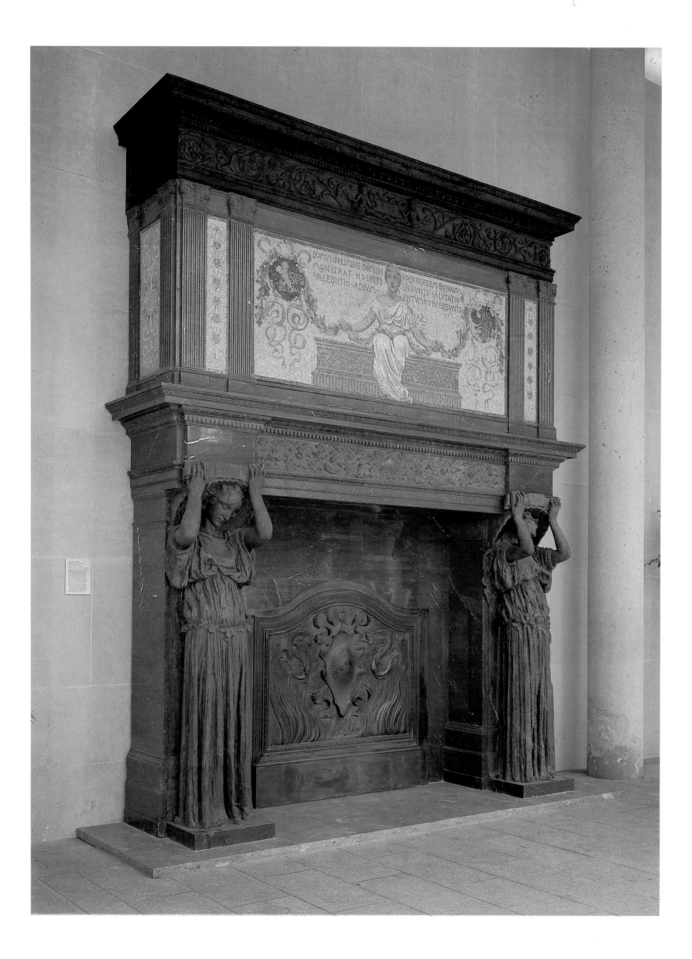

DOMVS IN LIMINE DOMINI
MONSTRAT HOSPITI VOLVNTATEM BONAM
VALEDICTIO ADIVM INEVNTI SALVTATIO
ENTVMVS EXEVNTI

158

capable of creating a powerful architectural environment of its own. Out of it comes the great classical burst of the late nineteenth and early twentieth centuries. As can be seen in the Vanderbilt mantelpiece in the Metropolitan, this development created interior spaces that were at the scale of *The Wyndham Sisters*. It could well have stood behind the sisters themselves, like the portrait of their mother, this great hearth with its vestals holding up the mantel. But the movement goes far beyond interiors, giving us some of our greatest public buildings, conceived in the grandeur of a Baroque revival. The Metropolitan Museum itself, as we see it today, is a product of that. Its facade has the same kind of neo-Baroque bravura, explosion of scale, and pride of position that the painting of the Wyndham sisters possesses. These qualities may not always be personally desirable, but they can make great public buildings if their energy is directed outward, toward the public realm. In the late nineteenth century, unlike the late twentieth, that energy was in fact so directed. It is the grandeur of its public spaces, I think, that is the positive side of this push toward money and power. It created our greatest railroad stations, such as Pennsylvania Station, now tragically demolished and scurvily rebuilt, and Grand Central Station, along with the splendid shape of Park Avenue running down toward it and around it.

Out of that same energy came some wonderfully expressive public sculpture, perhaps the first great public sculpture

Mantelpiece, 1882, with sculpture by Augustus Saint-Gaudens (1848–1907) and mosaic designed by John LaFarge (1835–1910). Height 15 feet 4½ inches. From the house built between 1879 and 1883 by Cornelius Vanderbilt II at Fifth Avenue and Fifty-seventh Street, New York City; Richard Morris Hunt and George B. Post, architects. The Metropolitan Museum of Art, Gift of Mrs. Cornelius Vanderbilt, Sr., 1925 (25.234).

Fifth Avenue Facade, The Metropolitan Museum of Art, New York, as it looks today. Photograph courtesy of The Metropolitan Museum of Art.

Park Avenue, New York, as it appeared in the mid–twentieth century. Yale University Photograph and Slide Collection.

we ever had in America. So in his *Sherman* on Fifth Avenue Augustus Saint-Gaudens was able to embody some of the major truths about modern America – the power, the nerve, the overriding will.

But it is Saint-Gaudens' Shaw Memorial in Boston that is very likely America's most touching public sculpture. Its subject is a regiment of black troops and their white commander in the Civil War. In 1863, the young Robert

Pennsylvania Station, 1910, New York, designed by McKim, Mead and White. Yale University Photograph and Slide Collection.

160

Gould Shaw raised a volunteer regiment of black infantry and led it south to war. They marched right down Beacon Street, just as they are doing here, opposite the State House. When they passed the Somerset Club, it closed its blinds, disapproving of black troops on principle. The Confederates had suggested that Union officers leading black troops might well be shot; so all of them together were hazarding their lives even more than most soldiers do when they go into combat. Most of them, as it turned out, including Shaw, were killed and thrown into a ditch together. Robert Lowell, in his beautiful poem about the memorial, wrote, "Their monument sticks like a fishbone in the city's throat." And indeed, right there in the center of Boston is the city's past and its present, all amalgamated into one image of a people bound up in a common destiny. On the relief, Saint-Gaudens originally inscribed the legend, "He gives up everything to serve the republic." But Lowell wrote, "They

General William Tecumseh Sherman Memorial, 1892–1903, Fifth Avenue at Central Park South, New York, by Augustus Saint-Gaudens. Photograph by Sandak.

Shaw Memorial (detail). Photograph ©
1987 by Bobby Kramer. Courtesy of the
Boston Art Commission.

Robert Gould Shaw Memorial, 1884–1897, Beacon Street facing the State House, Boston, by Augustus Saint-Gaudens. Photograph by Sandak.

Grant Memorial (detail), 1922,
Washington, D.C., by Henry Shrady
(1871–1922). Photograph by C. Lynn.

give up everything to serve the republic." And in fact they all move together as one great force in the relief, made up of many ardent bodies, faces, moving feet, and rifle barrels.

The greatest achievement of the grand public architecture of the early twentieth century was the completion and enhancement of the plan for Washington by the Beaux-Arts architects of the City Beautiful movement, Charles Follen McKim foremost among them. In that plan the iconography of the Mall was dominated by the Civil War; the Grant Memorial played a very important part in it. Grant is placed there, on his horse, as he used to direct his battles: implacable, motionless, the very embodiment of war and determination. He is protecting the Capitol as he did in war. As in war, he is looking down the length of the Mall toward Virginia. Cavalry is coming up on one side of him, artillery on the

other. He sits in the center, with the whole axis of movement going from him toward the Washington Monument, and beyond that to his commander-in-chief, Lincoln, in his own Memorial.

The long, broad reflecting pool carries our eyes along it to that white temple today. It was designed by Henry Bacon and was chosen from many entries in the final competition of 1912. As it stands, it recalls, like Jefferson's work, the chunky, abstracted, classical forms of Ledoux. But, though turned sideways to terminate the vista as a frontal building could not have done, it is still the very essence of a Greek temple, pure, clear, cool, rational on the outside, gleaming white and beautifully made, while inside the great cult image broods, filling the wide doorway with a ghostly presence, vast and just half seen in the shadows of the interior. It is Lincoln as only the architecture and sculpture of the classical tradition could have made him.

Classical architecture has the double capability of creating a timeless, ideal setting for human action and at the same time of commenting upon that action through the associations that have gathered around its forms over the centuries. It is human history made palpable, and history of a special kind: public, religious, involved with grand political combi-

Lincoln Memorial, 1914–1920, Washington, D.C., designed by Henry Bacon (1866–1924). Yale University Photograph and Slide Collection.

Lincoln Memorial. Photograph by C. Lynn.

nations, with sacrifice, and with myth. So Lincoln sits in majesty in a temple, like Zeus. Washington points with his obelisk to the sun. The dome floats over all. In the presence of these forms, the political life of any age is connected with the deepest meanings of that life across time.

In our generation those meanings have been rich and tragic: from the Kennedy funerals, which in this classic setting were those of the Gracchi, with the assassinated Lincoln brooding over them; to the mighty speech of Martin Luther King about his dream: ". . . all our children, black men and white men, Jews and gentiles, Protestants and Catholics, will be able to join hands and sing, in the words of the old Negro spiritual: 'Free at last, free at last, thank God almighty, we are free at last!' "; to the mass demonstrations against Vietnam. Truly, Washington's monuments hold the conscience of America, its memory, the image of its aspiration, and its hope.

View from the Lincoln Memorial to the Washington Monument, designed in 1848 by Robert Mills (1781 – 1855), completed in 1885. Yale University Photograph and Slide Collection.

Statue of Abraham Lincoln by Daniel Chester French (1850 – 1931), in the Lincoln Memorial, Washington, D.C. Yale University Photograph and Slide Collection.

That is our garden, for what it may be worth. Maya Lin understood this supremely well when she brought her Vietnam Memorial up out of the earth to reach toward Lincoln on one side and toward Washington on the other. She is right; no other modern nation has so wholly classical a setting for its capital, so burning a classical ideal to look outward upon. It is our garden, entirely different from the materialist world we have otherwise made. It is a balance for that world, and a test of it, and it is the living complement to our vernacular traditions as we now begin to value it and them once more.

In contrast to the symbolic grandeur of public architecture and the skyscraper's vertical thrust, there was, by 1900, the horizontal calm of domestic architecture and the climax of the suburban tradition in the work of Frank Lloyd Wright, stretching out across the prairies of the Midwest, as in his Robie House in Chicago, of 1909, reaching out with a determination, beyond that even of Richardson, to enclose, indeed to engulf, the whole of the wide continent, the whole of ourselves.

It is moving in this regard to recall how Frank Lloyd Wright himself began: with the engulfing frontal gable of the Shingle Style. His models were three houses at Tuxedo Park by Bruce Price, which Wright took as they were

View of Washington, D.C., showing the Vietnam Memorial, 1980–1984, designed by Maya Lin (b. 1959), with the Capitol in the distance. Photograph by Charles Pereira, US Park Police.

Frederick C. Robie House, 1909, Chicago, designed by Frank Lloyd Wright (1867–1959). (From Ernst Wasmuth, Frank Lloyd Wright: Ausgeführte Bauten, *Berlin, 1911.)*

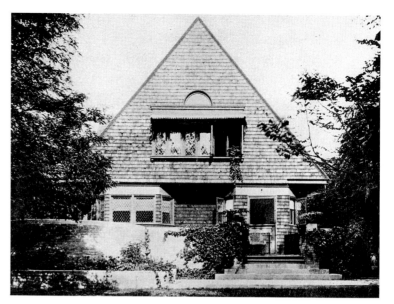

Wright House, 1889, Oak Park, Illinois,
designed by Frank Lloyd Wright.
Photograph by Chicago Architectural
Photographic Co.

W. H. Winslow House (entrance detail),
1893, River Forest, Illinois, designed by
Frank Lloyd Wright. (From Ernst Wasmuth,
Frank Lloyd Wright: Ausgeführte
Bauten, Berlin, 1911.)

published in *Building* and elsewhere in 1886 and condensed into one clear, pure form. It is touching, I think, that Price's frontal houses, lifted on their symmetrical bases, had clearly been inspired in large part by Charnay's book, *Les Anciennes Villes du Nouveau Monde,* of 1885, which had been subsidized by Price's major client at Tuxedo, the founder of that woodland colony, Pierre Lorillard. Charnay's rendering of the Temple of the Sun at Palenque might have served as a model for Price's rendering technique for all the houses at Tuxedo, while Lorillard's own house there was patterned directly upon it. Did Wright know of this? Perhaps he did. He surely saw the models of Mayan buildings that were built at the World's Columbian Exposition of 1893, and, as Rebecca Stone has shown, he clearly built Mayan masks into the entrances of his two great masonry houses, the Charnley of 1892 and the Winslow of 1893. The latter, with its smooth lower and richly decorated upper floor, strongly recalls the elevation of Mayan buildings, such as the Governor's Palace at Uxmal. That inspiration from the original inhabitants of the continent was felt here by Price and Wright for, to my knowledge, the first time in European-American culture, well predating, of course, its great climax in the Art Deco skyscrapers of New York. It then went underground, to come forward again for Wright exactly when he needed it, after his personal disaster of 1914. It was never again to leave his work entirely, and its presence can be felt most movingly at Taliesin West, where the strong shadow lines of Wright's desert concrete call up the American divinity of earth and sky once more.

Taliesin West, near Scottsdale, Arizona, begun in 1938 by Frank Lloyd Wright.

Taliesin West: reflecting pool, boulder with Anasazi petroglyphs, and drafting room with mountain background. Photograph by P. E. Guerrero, New York.

It was Robert Venturi who, just as he understood Jefferson, best appreciated the sources of Wright's power, and Venturi's house for his family, of 1962, is based on Wright's own house of 1889. Again, it is at once the northern vernacular and the southern temple alike, condensed in the frontal gable, which is then stretched laterally to pull its lintel taut, to split the center, and to explode the phantom of a Neoplatonic circle around its companion square. So it is schematic as well, like a model. It is clearly intended as a graphic symbol, apparently very simple but actually deeply complex, referring at once to the thinness of the American vernacular and to the intersection of that thinness with the similar linearity and planarity of the International Style.

Venturi's work has always retained those highly intelligent tensions. But it has also ushered in the full revival of what Leon Krier calls the vernacular and classical traditions. In our context, I think it may best be regarded as a revival of the American Realist tradition after its temporary eclipse under the canonical modernism best exemplified in architecture by the ruthless Idealism of the International Style.

Venturi's Trubek and Wislocki houses on Nantucket, now more than fifteen years old, represent the full revival of the Shingle Style, always salted by Venturi's lively comment and invention. The Wislocki house, on the right upon entrance to the Luminist site, indeed goes further back than Wright's own house – which it, however, also recalls – citing the house of 1887 that Wright built for his aunts at Spring Green. The gable, the bay below it chamfered out only on one side, the big vernacular window with cross-axis mullions, and the ubiquitous half circle in the gable can all be found there. Venturi distorts his model to accord with the demands of his own site and to release the potentially large scale of these elements. The Trubek house, in contrast, draws itself up into a tight, pointing shape in which the small cross-mullioned windows are deployed like eyes. How taut and lively the relationship between the two houses is, and how the vernacular elements, like the porches, become tense, living things, here suggestive of sharp bird-beaks. It is a language not unrelated to that of classical architecture, but it is still the language of the American craftsman most of all. In that sense, the buildings are at once temples and rational vernacular types.

Trubek–Wislocki houses, 1971, Nantucket Island, Massachusetts, designed by Venturi, Rauch and Scott Brown. Described by the architects as

two vacation cottages on a moor by the sea in Nantucket for a Yale professor and his family and for a related family. The larger house is complex and contradictory; the smaller house is more ordinary. The houses are sited so as to look toward the water. First seen from the rear, they are set far enough apart to create a sense of openness, yet close enough to be perceived as a pair. They fit into the environment because they are like the old fishermen's cottages of that island in some ways and like 19th-century shingle style vacation houses of New England too – weathered grey to meld into the grey-green foliage and soft blue seascape.

(House and Home, *May 1973.*)

173

Living room from the Francis W. Little House, 1912–1914, Wayzata, Minnesota, designed by Frank Lloyd Wright. Shown as installed in the American Wing. The Metropolitan Museum of Art, Purchase, Emily Crane Chadbourne Bequest, 1972 (1972.60.1).

The living room of Wright's house called Northome, of 1912, which is the latest period room in the Metropolitan Museum of Art, can stand as a kind of central image of American domestic architecture as a whole, summing up as it does its Colonial and nineteenth-century past and at the same time helping to shape its future. There is the deep hearth, like that of the Colonial Hart Room, where we began, as well as the taut wooden frame, now become space-making and expansive. Here is furniture scaled to architecture and built like it, as was seventeenth-century Colonial furniture; it, too, is solidly put together and closely related to furniture that was called Craftsman in its time. In fact, as we have noted, the Colonial Revival of the 1870s and 1880s, as interpreted by the Shingle Style architects, did much to lead Wright to these forms, as did the architecture of the older America as well. It is all one more aspect of that reinterpretation of the past, once again so central to our

present, out of which the Metropolitan Museum itself was conceived. But Wright's room has a special magic, a unique scale. It turns us into giants, domestic Titans looming over the fireplace and carried by the horizontal moldings to unimpeded ranges of space.

It also embodies not only Colonial memories, as well as folk traditions such as those of the Shakers, but nineteenth-century transcendence, too. It is a landscape, as open, quiet, linear, and full of light as those of the Luminist painters, and like their work, it carries our eyes out beyond it to the lighted horizon – to silence and light in the sky. Finally, Wright leads us westward, as our painters did long ago, and we look out with him on the western desert at last. Wright's work was therefore a synthesis of almost everything that had preceded it in the American craftsman and landscape traditions. Its intention was also a very American one: to gather into a new unity all the diverse elements that had gone into its making, to integrate them into what Wright called "a great peace."

There has never been anyone to equal Frank Lloyd Wright, but the tradition in which he played so distinguished a part has never died, and American sculptors, painters, and photographers, no less than American architects, are exploring it with renewed respect and passion at the present time. Luminism somehow seems to reside at the center of it all. So Louis I. Kahn, a great architect and Venturi's mentor, defined architecture as the material realization of "silence and light."

Is there some genius of the American place which sustains that vision, some breath of this widowed continent with its clear evening skies? Surely it is there in us, beyond our material concerns but making use of them, some enduring love of the soul's still voice, of light and silence.

Taliesin West. Photograph by Sandak.

Bibliographical Note

The bibliography in a book of this kind should be highly selective and personal. So I feel free to say at the outset that the most illuminating book ever written about American art actually deals with American literature. It is D. H. Lawrence, *Studies in Classical American Literature* (London, 1922). R. W. B. Lewis, *The American Adam* (Chicago, 1955) is one of the best among numerous distinguished descendants. Lawrence was the first critic to perceive a special structure of American symbolism, and all of us since that time, whatever our own special interests, have more or less followed his general line, which has proved no less fruitful for the visual than for the literary arts.

Another pathfinding book of a different kind is Francis Jennings, *The Invasion of America* (New York, 1975), which radically altered the traditional way in which the Indian presence on the North American continent had come to be treated by modern historians. I hope that my own *Pueblo: Mountain, Village, Dance* (New York, 1975) works in a similar direction; and see in general Gordon R. Willey, *An Introduction to American Archaeology*, vol. I, *North and Middle America* (Englewood Cliffs, 1966). New research by younger scholars is now strongly modifying our view of pre-Columbian Mesoamerican civilization, as in Linda Schele and Mary Ellen Miller, *The Blood of Kings: Dynasty and Ritual in Maya Art* (Fort Worth, 1986), and in two excellent general texts with useful bibliographies: Michael D. Coe, *The Maya* (London, 1966, rev. ed., London, 1986), and Mary Ellen Miller, *The Art of Mesoamerica from Olmec to Aztec* (London, 1986).

An ambitious bibliography for American art as a whole is Bernard Karpel and Ruth W. Spiegel, eds., *Arts in America:*

A Bibliography (4 vols., Washington, D.C. [Smithsonian Institution], 1979).

For architecture there is the Historic American Building Survey of the National Park Service, which is always prepared to supply, for a nominal sum, data, photographs, and measured drawings of some sixteen thousand buildings (address: Chief, Prints and Photograph Division, Library of Congress, Washington, D.C. 20540). Even more comprehensive is the National Register of Historic Places of the Department of the Interior; its collections are administered through a historical preservation officer in each state. There are also general histories such as John W. Reps, *The Making of Urban America: A History of City Planning in the United States* (Princeton, 1965); my own *American Architecture and Urbanism* (New York, 1969; rev. ed., with an expanded bibliographical note, New York, 1988); and Leland Roth, *A Concise History of American Architecture* (New York, 1979) and *American Builds: Source Documents in American Architecture and Planning* (New York, 1983).

For the architecture of Colonial and early-nineteenth-century America, thoughtful pioneering studies such as Fiske Kimball, *Domestic Architecture of the American Colonies and of the Early Republic* (New York, 1922), and older texts such as Hugh Morrison, *Early American Architecture from the First Colonial Settlements to the National Period* (New York, 1952), have been augmented by works such as William Pierson, *American Buildings and Their Architects,* vol. 1, *The Colonial and Neo-Classical Styles* (Garden City, 1970); and Abbott Lowell Cummings, *The Framed Houses of Massachusetts Bay, 1625–1725* (Cambridge, Mass., 1979). For the later nineteenth century: my book *The Shingle Style and the Stick Style: Architectural Theory and Design from Downing to the Origins of Wright* (New Haven, 1955; rev. ed. 1971), also with an extensive bibliographical essay; William Pierson, *American Buildings and Their Architects,* vol. 2, *Technology and the Picturesque: The Corporate and the Early Gothic Styles* (Garden City, 1978), and in the same series, vol. 3, William Jordy, *Progressive and Academic Ideals at the Turn of the Twentieth Century* (Garden City, 1971), and vol. 4, also by Jordy, *The Impact of European Modernism in the Mid-Twentieth Century* (Garden City, 1972).

For Frank Lloyd Wright, among many studies, Henry-Russell Hitchcock, *In the Nature of Materials: The Buildings of Frank Lloyd Wright, 1887–1941* (New York, 1942); E. Kauf-

mann and B. Raeburn, *Frank Lloyd Wright, Writings and Buildings* (New York, 1960); and my own *Frank Lloyd Wright* (New York, 1960). For Louis I. Kahn: my book of that name (New York, 1962); Romaldo Giurgola and Jaimini Mehta, *Louis I. Kahn* (Boulder, 1975). The very best introduction to the present state of architecture remains Robert Venturi, *Complexity and Contradiction in Architecture* (New York, 1966). For recent points of view by many architects, historians, and critics: David G. DeLong, Helen Searing, and Robert A. M. Stern, eds., *American Architecture, Innovation and Tradition* (New York, 1986); also Dolores Hayden, *Redesigning the American Dream: The Future of Housing, Work, and Family Life* (New York, 1984).

For painting and sculpture, Edgar P. Richardson, *Painting in America: the Story of 450 Years* (New York, 1956); John McCoubrey, *American Art 1700–1960: Sources and Documents* (Englewood Cliffs, 1965); Jules D. Prown, *American Painting from the Beginnings to the Armory Show* (New York, 1969); Wayne Craven, *Sculpture in America* (New York, 1968); John Wilmerding, *American Art* (Harmondsworth and New York, 1976); the Metropolitan Museum of Art, *A Bicentennial Treasury: American Masterpieces from the Metropolitan* (New York, 1976); Albert Ten Eyck Gardner and Stuart P. Feld, *American Paintings: A Catalogue of the Collections of the Metropolitan Museum of Art, I: Painters Born by 1815* (New York, 1965); Doreen Bolger Blake, *American Paintings in the Metropolitan Museum of Art, III: A Catalogue of Works by Artists Born between 1846 and 1864* (New York, 1980); and The Metropolitan Museum of Art, with texts by John K. Howat, Natalie Spassky, et al., *Nineteenth-Century America: Paintings and Sculpture* (New York, 1970).

For the Colonial period, Neil Harris, *The Artist in American Society: The Formative Years, 1790–1860* (New York, 1966). For the nineteenth century, Barbara Novak, *American Painting of the Nineteenth Century: Realism, Idealism and the American Experience* (New York, 1969); and for Luminism in particular, a brilliant work by the same author: *Nature and Culture: American Landscape Painting, 1825–1875* (New York and Toronto, 1980).

For the decorative arts, a general compendium is Marshall B. Davidson, ed., *Three Centuries of American Antiques*, 3 vols. in one (New York, 1979); for Colonial furniture and silver in relation to the other arts: Charles F. Montgomery and Patricia E. Kane, eds., *American Art, 1750–1800: Towards*

Independence (Boston, 1976); and more generally, Marshall B. Davidson and Elizabeth Stillinger, *The American Wing at the Metropolitan Museum of Art* (New York, 1985).

Other basic works include Joseph Downs, *American Furniture in the Henry Francis du Pont Winterthur Museum: Queen Anne and Chippendale Periods* (New York, 1952); Charles F. Montgomery, *American Furniture: The Federal Period, 1788–1825* (New York, 1966); Jonathan Bates and Elizabeth Biddle, *American Furniture: 1620 to the Present* (New York, 1981); Oscar P. Fitzgerald, *Three Centuries of American Furniture* (Englewood Cliffs, 1982); John Kirk, *Early American Furniture* (New York, 1970) and *American Furniture and the British Tradition to 1830* (New York, 1982); David A. Hanks, *The Decorative Designs of Frank Lloyd Wright* (New York, 1979); Catherine Lynn, *Wallpaper in America* (New York, 1980); and Doreen Bolger Burke et al., *In Pursuit of Beauty: Americans and the Aesthetic Movement* (exhibition catalogue, The Metropolitan Museum of Art, New York, 1986).

Index

Designed by Douglass Scott and Jeanne Lee at WGBH Design

Copyedited by Dorothy Straight

Editorial Coordination by Patricia Adams

Production Coordination by Amanda Wicks Freymann

Set in Baskerville types by Black Dot, Inc.

Printed and bound in Italy by Arti Grafiche Amilcare Pizzi, S.p.A., Milan